SPACE PROGRAM
Mission Guide and Experience Report

PREPARED BY

Ground Support New York, McDonald Facility

APPROVED BY

Tom Sachs

Tom Sachs
Flight Director, Space Program

GAGOSIAN GALLERY

456 North Camden Drive
Beverly Hills, CA 90210

September 8 – October 13, 2007

Published on the occasion of the exhibition

TOM SACHS
SPACE PROGRAM

September 8 – October 13, 2007

Gagosian Gallery
456 North Camden Drive
Beverly Hills, CA 90210
T. 310.271.9400
www.gagosian.com

Publication © 2008 Gagosian Gallery

Trade edition distributed by
Rizzoli International Publications
300 Park Avenue South
New York, NY 10010
www.rizzoliusa.com

All artwork © Tom Sachs

Voyage to the Moon: Tom Sachs's Space Program © 2008 Arthur C. Danto
Art in Space © 2008 Buzz Aldrin, Tom Sachs and Louise Neri
LEM Systems Manual © 2008 Mark Van de Walle

Editor: Alison McDonald
Design by Garrick Gott, New York
Photography by Joshua White/JWPictures
Additional photography by Genevieve Hanson, Graham Judson, Farrah Karapetian, and Brad Kaye
Copy editor: Jennifer Knox White
Color separations by Echelon, Venice, CA
Printed and bound by Shapco Printing, Minneapolis, MN

ISBN: 978-0-8478-3226-2

Buzz Aldrin

Buzz Aldrin was the Lunar Module Pilot of *Apollo 11* for the first lunar landing and he was the second man to walk on the surface of the Moon. He has received numerous decorations and awards, including the Presidential Medal for Freedom in 1969, the Robert J. Collier Trophy, the Robert H. Goddard Memorial Trophy, and the Harmon International Trophy in 1967. He now lives and works in Los Angeles, California.

Arthur C. Danto

An influential art scholar and philosopher of today, Arthur C. Danto is the author of more than twenty books, together with many important shorter texts including the 1984 essay, "The End of Art." He is the Emeritus Johnsonian Professor of Philosophy at Columbia University and is currently working on an upcoming book on Andy Warhol as well as a philosophical essay that shows the connection between his aesthetics and that of Immanuel Kant.

Louise Neri

Louise Neri is a New York-based editor, writer, and curator working in the visual and performing arts and a director at Gagosian Gallery.

Tom Sachs

Tom Sachs is most well known for his bricolage technique, a "do-it-yourself" ethic that he uses in sculpture, painting and video. His re-purposing of found materials is not limited to the physical nuts and bolts of hardware but includes the popular icons of advertising and politics. His work is placed in permanent museum collections around the world. Sachs lives and works in New York City.

Mark Van de Walle

Mark Van de Walle writes about culture and design for various publications, including *Departures*, *Parkett*, and *Men's Vogue*. His first book, a history of trailer parks in America, is forthcoming from Picador Press.

TABLE OF CONTENTS

THIS PAGE INTENTIONALLY LEFT BLANK.

VOYAGE TO THE MOON: TOM SACHS'S SPACE PROGRAM

ARTHUR C. DANTO

Why did we come to the Moon?
The thing presented itself to me as a perplexing problem.

—H. G. Wells, *The First Men in the Moon*

We choose to go to the Moon in this decade and do other things,
not because they are easy, but because they are hard, because that goal
will serve to organize and measure the best of our energies and skills,
because that challenge is one that we are willing to accept, one we are
unwilling to postpone, and one which we intend to win, and the others, too.

—John F. Kennedy, September 12, 1962

We're going to the Moon, Alison, we're going to the Moon!

—Tom Sachs

Tom Sachs's art is distinctive in two connected ways, one of them having to do with the objects or the complexes of objects he creates, and the other with the practice through which he makes or builds these objects. Characteristically, the objects are modified versions of things that belong to forms of life that most of us actually live: they are parts of our world, and we relate to them through various needs, hopes, and attitudes. Sachs's purpose in part is to bring these needs, hopes, and attitudes to conscious awareness through his modifications, so his work serves as a kind of mirror, to use the well-known Shakespearean image, in which we see ourselves reflected. The work is in this sense about us, and of course about the artist himself, who participates in the same form of life the rest of us do, though he is perhaps more conflicted about doing so than most.

The practice, visible in and integral to his art, is what he speaks of as *bricolage*, or "do-it-yourself," and at the very least its presence in his work underscores the distinction, central to his philosophy of art as he at least practices it, between the artwork and the real objects his sculptures represent. It is, for example, thinkable that someone might undertake to make a viable spacecraft in his garage—a lunar module, say—that could, under actual circumstances, transport human beings from an orbiting spacecraft to the surface of the Moon and safely back again. It would be a formidably demanding undertaking, financially and technically, requiring an engineering competence in rocketry, electronics, and aeronautical design. And, of course, that person would lack the resources of a governmental space agency if the vehicle were intended for liftoff into orbit. Sachs's Lunar Excursion Module (LEM), also known as *Dionysus*—a replica of the lunar module *Eagle,* used in the *Apollo 11* space mission—has no such ambitions. It is intended, as Sachs explained to the curator Germano Celant, to show "every detail of how something works—how each thing is made: the screws, the glue, the fragility of it all."[1] It does indeed show these things, but it is a work of art and not the real thing, so in addition to showing the real thing and how it works, it shows that it could not conceivably do what the real lunar module did. It flaunts its identity as *bricolé* through the materials used to make it: plywood, tape, foamcore board, and the like. That is part of how the work is to be experienced. The work thus stands to reality in the kind of relationship in which a theatrical performance does, where there are various cues that alert an audience that what they see onstage is not in fact happening.

The use of the name *Dionysus* emphasizes the difference between his project and the Apollo project through the traditional contrast between the deities Apollo and Dionysus that goes back into ancient times. As Sachs puts it, "Apollo represents rational thought and Dionysus irrational thought, wine, revelry, and intuition." Apollo may be understood to emblematize science, and Dionysus art, as if the two were somewhat parallel systems, like science and magic, according to a conjecture of Claude Lévi-Strauss that Sachs has made his own.

My aim in this essay is first to give an account of Sachs's work, as well as its place in the history of contemporary art, by analyzing the kinds of objects it consists of and the practices that are salient in experiencing them as works of art, and then to explain where, in this body of work, his Space Program fits, in particular its centerpiece, the sculpture that replicates, give or take certain details, the lunar module used in the *Apollo 11* mission—the first mission to put men on the surface of the Moon, carried out in July 1969, when Sachs was all of three years old.

Tom Sachs's oeuvre primarily represents objects drawn from the American vernacular culture in which he was born and grew up, and it derives, art historically, from the great Pop art movement of the 1960s, which licensed artists to make art out of manufactured products used by ordinary people in everyday life. Though certain of his artistic heroes, like Andy Warhol, belonged to that movement, or, like Marcel Duchamp, were among the movement's predecessors, Sachs's work has little to do with the ideas and ideals that inspired them. He is, for example, too much committed to the idea of making things—to "doing it himself"—to find much relevance to his projects in Duchamp's ready-mades: industrially produced objects and utensils singled out as artworks primarily through their aesthetic neutrality. On the other hand, he has not hesitated to preempt found objects and materials, such as striped Con Edison barriers, yellow plastic tape, telephone directories, used lumber, and the like. Nor is Sachs driven by many of the concerns the Pop artists invoked: to overcome the gap between art and life, for example, the way Claes Oldenburg did in his *Store* of 1961, which he filled with painted plaster effigies of commonplace things, like frocks, underwear, automobile tires, running shoes, and edibles like slices of pie and cakes, which he sold over the counter, as if they were the merchandise they clumsily resembled. And Sachs has no interest in the reverse agenda of Roy Lichtenstein, to overcome the boundary between high and low art by getting comic strip panels and advertising logos onto the walls of upscale art spaces in the face of deep prejudice on matters of their artistic suitability.

Those struggles were largely over in the 1990s, when Sachs began his career as an artist; those victories had long since been won. Sachs had

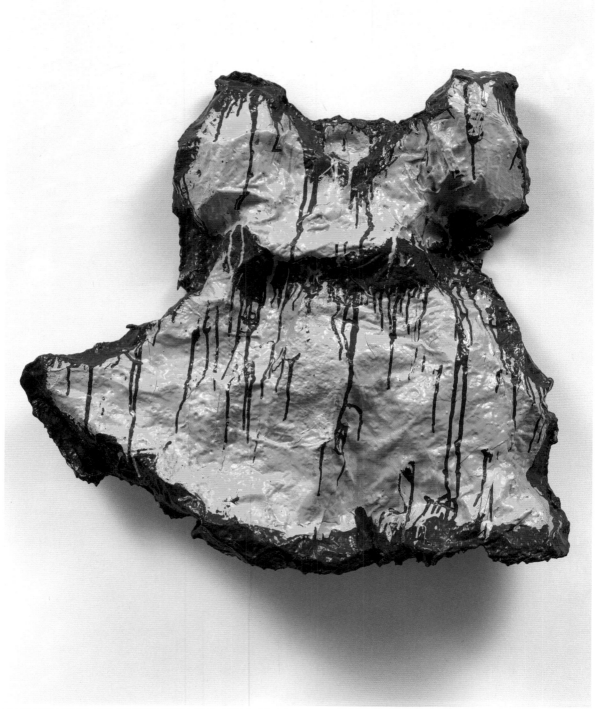

CLAES OLDENBURG, *YELLOW GIRL'S DRESS*, 1961, MUSLIN SOAKED IN PLASTER OVER WIRE FRAME, PAINTED WITH ENAMEL, 31 1/4 X 32 X 6 INCHES (79.4 X 81.3 X 15.2 CM). PRIVATE COLLECTION. PHOTO COURTESY THE OLDENBURG VAN BRUGGEN FOUNDATION.

his own agendas. The objects that engaged him tended to come from sectors of vernacular culture toward which he had certain moral and political reservations and ambivalences connected to class differences and values. Consider the case of logos—those marks and emblems that appear on products, serving to identify them in the consciousness of consumers and to facilitate product loyalty. Lichtenstein was charmed by these from the perspective of impishness, incorporating them into paintings as part of his assault on high art. Warhol was attracted to them because of their uniformity and repeatability in the aesthetics of display—in rows of soup cans in supermarkets or printed boxes in stockrooms and warehouses—or he simply reproduced them because they were there, like the trademark "True Temper" on the tools he used as motifs in the *Hammer and Sickle* paintings of 1977. Sachs's attitude was more hostile and uncertain; he viewed certain brands as seductive, but also as manipulative and invidious. But that is because the brand names that particularly concerned him were associated with social status and a certain kind of snobbery. Warhol was made famous by his use of famous brand names—Campbell's and Brillo. Sachs, by contrast, was preoccupied with the logos of high fashion—Hermès,

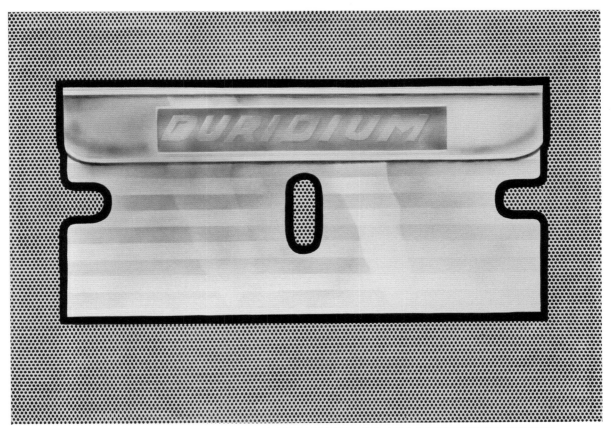

ROY LICHTENSTEIN, *DURIDIUM*, 1964, MAGNA ON CANVAS, 26 X 36 INCHES (66 X 91.4 CM). © ESTATE OF ROY LICHTENSTEIN.

Prada, Chanel, and the like. Ironically, he became fashionable almost by contagion. The brands that engaged him were attributes of what the social theorist Thorsten Veblen famously called "conspicuous consumption." They belonged to the lingua franca of privileged consumers, in whose form of life brands evoke an aura of desirability and proclaim a certain worth for the person who displays them; no one believes others think more highly of him or her for eating Campbell's soup or using Brillo pads. The philosopher Ludwig Feuerbach said, somewhat cynically, *"Mann ist was mann isst"*—man is what man eats. For Sachs, the danger is that we think of ourselves as what our brands tell the world we are. The Pop artists really liked vernacular culture; their animus was directed against an art world that rejected it. Sachs, by contrast, is of two minds, so he uses brands polemically and aggressively. At times this makes him, as an artist, something of a *mauvais garçon*.

These attitudes do not especially inflect his Lunar Module, let alone his Space Program, of which *Dionysus* is the central part, but it is worth-

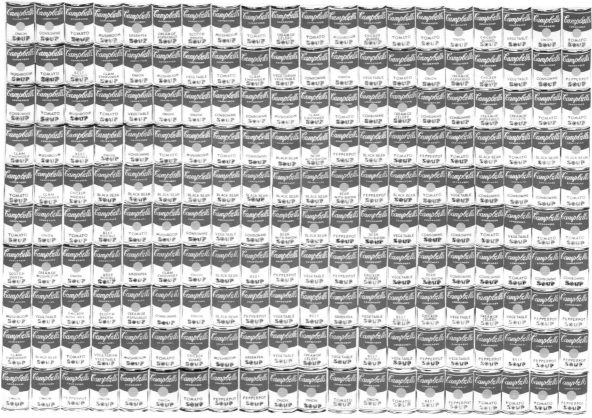

ANDY WARHOL, *200 SOUP CANS*, 1962, SYNTHETIC POLYMER PAINT ON CANVAS, 72 X 100 1/4 INCHES (182.9 X 254.6 CM).

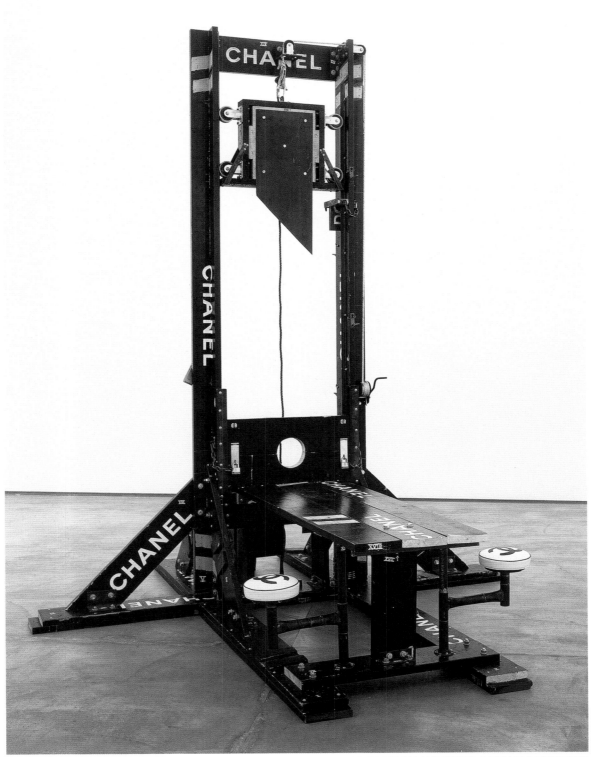

TOM SACHS, *CHANEL GUILLOTINE (BREAKFAST NOOK)*, 1998, WOOD, STEEL, LEATHER, NYLON, AND RUBBER, 147 X 122 X 125 INCHES (373 X 310 X 317 CM). © 1998 TOM SACHS.

while describing a few of the objects that made Sachs's reputation. A good example is his *Chanel Guillotine (Breakfast Nook)* of 1998. To be sure, guillotines are not exactly part of everyday life, but we all know what guillotines are and what they look like. In this respect, they are something like Warhol's electric chairs, part of the inventory of modern consciousness. But whereas Warhol was satisfied to use silkscreened images of electric chairs in death chambers, Sachs built an actual guillotine entirely capable of beheadings, like its Jacobin prototype in the Place de la Concorde. In its time, the guillotine was celebrated for its efficiency as an instrument of capital punishment, an ingenious improvement over the executionary axe, which it superceded, in terms of swiftness and exactitude of lethal dispatch. Sachs gave it the ultimate accolade by painting it a chic black, branding it with the Chanel logo, and transforming it into an amusing domestic accessory by placing stools on either side of the platform whose original function was to receive severed heads: the guillotine's blade would now be perfect for cutting your morning baguette and delivering it directly to your breakfast table. It could, if commercially produced, be illustrated in *Elle Décor* as just the thing for your fashionable *pied à terre* on the Boulevard Saint-Germain. The *Chanel Guillotine* is a masterpiece of savage satire, a metaphor for the follies of fashion.

Sachs's *Prada Toilet* of 1997 exhibits the shallowness of high-brand consumption by imagining a demand that Prada expand its design empire to include bathroom furnishings, so that one's guests, in using one's facilities, would be impressed by one's taste, and one's willingness to spare no expense to be among the select, fashion-wise. Obviously, the labels enhance the operations of the toilet in no way whatsoever. *Prada Toilet* is, like *Chanel Guillotine,* a brilliant emblem of somewhat bitter satire—and incidentally a brilliant piece of bricolage, fashioned as it is out of cardboard and thermal tape. Sachs made a Hermès plunger of the same materials, as well as a number of "Value Meals," in which Hermès and Tiffany designs were used to mock-upgrade trays and paper containers for Big Macs, Coca-Colas, and french fries—again using chic brand names to give airs to the commonest products of common culture. He got in hot water when he exhibited *Prada Death Camp*—a model of a German death camp mounted on some Prada shoe boxes—in *Mirroring Evil* at the Jewish Museum in New York in 1998. The *Hermès Hand Grenade* did not, for perhaps obvious reasons, generate the same degree of controversy, but the death camp evidently did not strike Prada itself as beyond the pale, perhaps because Miuccia Prada felt something of the same ambivalence about brands as Sachs himself. "Very often I feel culpable for being a brand," she said in a 2006 interview:

> *I'm very sensitive to the subject. I want to understand myself*
> *if I'm so bad. I've been reading a lot of [Sachs's] interviews.*

In one he talked about how at some point something that was against a brand became a brand—for himself. So everybody wanted this kind of art because it was a brand. And so he decided not to do it anymore. And then he confessed that "sometimes I prostituted myself and did some." I am aware of all these people who don't like brands.[2]

Sachs explained his appropriation of brands to David Rimanelli in *Artforum* in 2004:

The power of using brands—in my case, from fashion—and mixing it up with violent iconography lies in merging two things together to form a third. What's important to me about Pop is that using brands and other identifiable, everyday things gives you the opportunity to communicate. You're speaking a common language. I think part of the reason my work with fashion brands in the nineties really took off was because of an anxiety between the rich and everyone else. Another reason was that regardless of whether the work was critical of fashion itself, it still traded on the value of the brand. Like Prada. It's a death camp, but it's a Prada death camp.[3]

A preoccupation with brands continues to color Sachs's thought and conversation, and it enters Space Program in an oblique way. Alongside his re-creation of NASA's control center that monitored the *Apollo 11* expedition, the artist brandishes Tyvek space suits for the astronauts and Prada-designed lab coats for the technicians bearing the NASA logo. Though Tyvek is actually used as a garment material, it would probably not be suitable for space adventure, and Sachs could not resist the idea of combining the Prada brand with an unassuming and utilitarian garment.

There is a great deal of wit in Sachs's Space Program, but he does not criticize the Apollo space missions as such. It would be easy to be cynical about them, given the wide distrust of the U.S. government in recent decades. The art journalist Catherine Taft, reporting on a "space mission demonstration" conducted by Sachs at Gagosian Gallery in Beverly Hills in October 2007, begins a "Diary" entry in *Artforum* by writing, airily, "Any conspiracy theorist will tell you that the 1969 *Apollo 11* lunar landing was a cold war hoax staged in a Hollywood studio, but thus far only Tom Sachs has the wherewithal to show how this might be possible." It has somewhat less paranoically been supposed that the entire Apollo space program was a screen behind which the United States was able to advance its military capability to the disadvantage of the Soviet Union, a supposition that acknowledges that the spaceships actually took off and landed. But Sachs seems greatly to admire the program, and espe-

cially *Apollo 11*, which, in his view, represents the highpoint of American industry, gone badly downhill since. His interest in "military stuff," he explains in the interview with Germano Celant, is that it "represents the finest craftsmanship. It has the most rigorous standards, and money isn't really an object."

The code of craftsmanship has a high value in Sachs's scheme both of life and of art. His own work certainly exemplifies craftsmanly virtues, but they are virtues that go especially with the concept of bricolage. "Ultimately everything I make is a vehicle to support my bricolage," he writes, and it is important, as already noted, that his art not disguise the fact that it was put together by an artist or an artist's assistant, working in a studio, rather than by a team of skilled workers in a factory, manufacturing an object that conforms to precise specifications. Donald Judd's sheet-metal boxes, for example, were made in a machine shop, Judd admitting that he lacked the tools and the skills to achieve the sharp edges and precise corners that conform to a kind of machine-shop aesthetic. Jeff Koons's sculptures are executed by skilled craftspersons, working in traditional ways. Bricolage has no place in the machine shop, and though it may have a place in the workshop of trained craftspersons, it will be disguised in the final product. Sachs cherishes the virtues of invention and improvisation that are part of the bricoleur's code, the making do with whatever is at hand. NASA could not afford to take the kinds of chances that in part define the bricoleur; too much is at stake. In the case of *Apollo 11*, the eyes of the whole world were on the lunar module, and perhaps the future of democracy hung on the outcome of a successful landing. But for all the esteem carried by the concept of art, the value of an artwork is connected to its meaning rather than to any practical use it may have. The meaning of the original lunar module was bound up with the politics of the time, and possibly with the fact that it really was, in Neil Armstrong's famous words, "One great leap for mankind"; the meaning of Sachs's Lunar Module relates to a particular moment in the evolution of the art world and to the fact that it was made by an artist to resemble, within limits, the spaceship that changed history forty-odd years earlier. The limits are defined by the limits of bricolage. Its handmade-ness underscores the difference and, as Sachs says, "results in an intangible quality that [I] describe as magic for loss of a better word. This value, although intangible in practical terms, has huge spiritual value and is what separates my practice from industrial or hobbyist modelmakers."

Not all art, of course, is bricolage, and conversely, not all bricolage is art. Bricolage is really a certain kind of thinking—thinking with one's hands by making use of whatever material happens to be available. Because of the connection between mind, eye, and hand, it has a

certain philosophical weight. In his anthropological masterpiece *Primitive Thought*, Claude Lévi-Strauss identified it with the form of thought believed to characterize "primitive" humanity. Martin Heidegger indirectly speaks of it as one of the ultimate modes of being in the world—of *In-der-Welt-sein*. It is being thrown into the world and seeing it less as an aggregation of objects than as a system of instruments or tools—stones, stick, vines, and the like—which Heidegger speaks of as the "at hand," or *Zuhandene*. For Sachs, an urban artist, the city is full of *Zuhandene*, useful things salvageable for art. It would be a violation of his code to conceal their provenance from the street and the dumpster.

Some of these recycled urban materials find their way into *Dionysus*. For example, the Modularized Equipment Stowage Assembly (MESA), which holds all the tools the astronauts might require when performing tasks on the Moon, is clearly made of used lumber, some of it still painted with the diagonal red stripes of Con Edison barriers. The sides of *Dionysus* are clearly made of plywood and neatly resined together with fiberglass tape. The original—the "real"—lunar module could not conceivably have been made of these utterly fragile materials, which would have been unable to withstand the severe "shake, rattle, and roll" of the liftoff, as Michael Collins, the pilot of *Apollo 11*'s Command Module described it, or to have held its shape at later stages of the epochal flight. The planar surfaces of *Dionysus*, with their taped edges, have the look of a Cubist sculpture, which perhaps expresses the "fragility of it all" that Sachs hoped to convey. The *Eagle* that returned from space may have *looked* fragile, but it was not built to *convey* such a look; *that* belongs to *Dionysus* as a work of art.

Dionysus is full of wry touches, like the recessed bookshelf over the bed that holds such titles as *Ulysses*, *Sex and Destiny*, and the *Woman's Almanac*. One imagines that the *Eagle* had no place for amenities like recreational reading material, and it is difficult to imagine that its crew would have brought aboard the *Woman's Almanac*, as if there were time and space for leisure activity. There is also a bar in *Dionysus*, in the Ascent Stage interior, with a row of bottles, suggesting the module's kinship with the lunar projectile imagined by Jules Verne in his 1869 novel *Round the Moon*, in which its three intrepid but hedonistic voyagers take a "few glasses of good French wine" with their meals and stimulate thought, in a later chapter, by drinking a bottle of 1863 Chambertin. Sachs archly incorporates a Vodka Delivery System (VDS) and a Tequila Delivery System (TDS)—options the American taxpayer would certainly have found offensive, but which here serve as attributes of Dionysus as the god of intoxication. And Sachs has stocked his Lunar Module with rows of cans on which he has somewhat crudely lettered "BEANS." (Verne's gourmet space travelers banquet on "slices of beefsteak . . . as

tender and succulent as if they had just come from the butchers of the Paris Café Anglais," followed by "preserved vegetables 'fresher than the natural ones.'")

Space Program encompasses a great deal more than the marvelous simulacrum *Dionysus*. It is, loosely speaking, an installation that allows the "space mission demonstrations"—performances that mimic *Apollo 11*'s trip to the Moon and back. In addition to *Dionysus*, there is a Scissor Lift (SL), a sort of elevator that raises the astronauts to the hatch through which they enter the Lunar Module; Mission Control Center (MCC, naturally), with banks of monitors, connected by cables to cameras, showing various aspects of the Lunar Module and of the Extravehicular Activity (EVA) in which the astronauts engage on the Moon; a coatrack, made of a fragment of a Con Edison barrier, holding the aforementioned Prada garments; and much, much more, all installed in the gallery space. There is, of course, a Flight Plan (FP), with a list of acronyms, composed tongue in cheek, though in emulation of *Apollo 11*'s flight plan, composed in military lunarese. Sachs even furnishes his astronauts—enacted in these performances by gallery assistants—with portable Flight Plans fastened to their wrists.

The Flight Plan makes amusing reading. It lays out the sequence of tasks the astronauts perform during the demonstrations. On the checklist is "Al Green cassette check" and "candle check," neither of which would very likely have been performed by the *Apollo 11* astronauts. Before the tape is played and the candles lit, the female astronauts—*that* accounts for the *Woman's Almanac!*—take off their helmets and "move to dining area," where the plan calls for the Commander (CDR) to apply lipstick. The various stages of the flight—preparation, liftoff, flight, landing, return, splashdown, carrier rescue, helicopter rescue, and carrier return, the last accompanied by the playing of "Stars and Stripes Forever"—are viewed on one or another monitor by the audience, who are enjoined to silence or applause by LED signs, very much as if this were a television show.

The dining interlude, with its amenities, is entirely in the spirit of Verne's Moon voyage, and in some respect in the spirit of Dionysus rather than Apollo. Again, when the astronauts descend the ladder to reach the Moon's surface, the CDR does so with a shotgun in hand. The crew of the *Eagle* did not carry guns, though it was generally known by 1969 that the Moon's atmosphere would not support life. But fictional narratives of Moon travel, like H.G. Wells's *The First Men in the Moon* and certainly Georges Méliès's 1902 film *Voyage dans la lune*, populate our satellite with hostile Selenites who intend no good to Moon travelers, and Verne's characters speculate about the Moon's inhabitants and their

presumably advanced civilization. In any case, guns play a major role in Sachs's vision of contemporary culture, and he could not resist incorporating one or more handmade guns, if only as further exemplification of his gifts as a bricoleur.

The two tasks anyone familiar with the *Apollo 11* mission will remember its astronauts performing are planting the American flag and gathering a sufficient sample of lunar rocks to validate its credibility as a scientific expedition. Both of these are scripted in Space Program's Flight Plan, and Sachs has supplied the Mission Control Center with a convincing-looking Moon Rock Analyzer (MA). Sachs could easily have made some rocks and distributed them over the gallery floor—oops! the lunar surface, which was covered with "a surprising number of rocks of all sizes," according to Neil Armstrong. But Sachs's mise-en scène does not aspire to something like a diorama of the first men on the Moon as would be installed in a museum of natural history. Sachs's astronauts take what the Flight Plan refers to as a "floor sample," which is lifted by Lunar Equipment Conveyor into the *Dionysus*; there is no call to bear away boxfuls of California concrete flooring of equivalent mass to the samples collected on the *Apollo 11* mission.

Like everything else by Sachs, Space Program is a highly imaginative work at the same time as it is heavily researched, so that the artist can, to whatever effect, add and subtract features of going to the Moon, which he celebrates as "*the* art project of the twentieth century." That, of course, is the kind of compliment one pays to an enterprise that takes great planning, achieves great beauty, and transforms our view of the world in large ways. But the *Apollo 11* mission does not—not really—belong to the history of art. Space Program, on the other hand, does. It is intended to convey knowledge, not add to our knowledge of the world. Of course, there has long been a question of how much knowledge the Apollo program added, and whether it justified the immense cost. When I was a graduate student in philosophy, there was a question of whether it was meaningful to ask if there were mountains on the far side of the Moon, which, since it is always facing away from us, could not at the time be observed. The first circumlunar flight answered that question decisively. The Moon rocks tell us that the Moon is vastly older than Earth, and that it contains none of the minerals that would testify to there having been water on the Moon. Verne's scientists were certain that there were massive amounts of water on the Moon, and the sea names bestowed on craters visible by telescope suggest that they were thought to be, or once to have been, bodies of water. The hero of Wells's *First Men in the Moon*, Cavor, discovers lots of gold and brings some of it back to Earth. By the time of the Apollo missions, science already knew enough about lunar mineralogy to realize that it was not going to be like the

search for El Dorado, that legendary city of gold; on the other hand, it certainly drew on humankind's dream of adventure and our hope for heroes who throw themselves into the unknown. Moreover, as time passes, the Cold War will more and more be seen as one of the great conflicts of history, like the Trojan War or the war in the *Mahabharata*, in which two mighty forces opposed one another with their opposed visions of ideal societies. So there is some basis for thinking of the Apollo missions within the framework of art.

Space Program may not be a celebration of that history any more than Velázquez's *Surrender of Breda* is part of the history of Spain's expansion into the Low Countries. It is instead part of the artistic revolution that began in the 1960s and changed the face of art for all time, and one of the truly monumental works of the twenty-first century. Beyond that, it has brought the value of craft back into the practice of avant-garde art through the ethic of bricolage, emblematized, over and over again, by the arrays of hand tools Sachs incorporates into his art pieces. The works display Sachs's gift for craft, so much so that even when the work violates craft, as in the gloves worn by the astronauts, one knows that it is deliberate; they are there to draw attention to the fact that there is a difference between the handmade and the machine-made, between plywood and titanium. And beyond even that, the work is full of surprises, visual jokes, and winks of complicity that are there to assure Sachs's viewers that he and they are on the same page, and that for all that he is a cultural critic, a moralist, even a judge, the work is designed to give pleasure of a high intellectual order.

When I had gotten deep enough into this essay to feel that I knew where I was going with it, I emailed Sachs to ask what he was working on. He wrote back that he had many projects connected with upcoming shows, but that he was also still very much involved in Space Program: "The Space Program continues in full force." He mentioned that many of the details in the work were never finished: "Such is the nature of improvised construction technique." That left me wondering how much of the evidence of bricolage was meant, and how much was due to haste. The most interesting part of his message, however, concerned the "Moon rocks" taken from the gallery floor:

> *Josh White (the project photographer) and I are meeting on January 10th to catalog the Moon rocks. Our report will include: elemental analysis (by an independent laboratory), photography, measurement, naming, display cabinetry and presentation of all documentation surrounding the collection of rocks, gallery floor excavation repair/restoration. This geologic post mortem is the core justification for making the Space Program civilian vs.*

*military. It's science over politics. If we spent, say,
$1,000,000, divided by 12 lbs. of Moon rock and associated
regolith, the return lunar sample cost is $5,208.33/oz. So
you know we are going to take this stuff seriously.*

There is an irresistible ludic spirit in Space Program, but also a spirit of seriousness. Both belong to the work. I thought, when I read Sachs's email, of a famous moment at the end of Plato's *Symposium,* where Socrates argues that comedy and tragedy are in a sense the same, that anyone capable of writing the one must be able to write the other. In the same way, I thought, it must be possible to be serious and ludic at the same time—that Sachs's Space Program embodies both.

Endnotes:

1. Germano Celant, "Tom Sachs" (interview), *Interview*, September 2007, pp. 122–23.

2. Carl Swanson, "The Prada Armada," *New York Magazine*, April 16, 2006.

3. Sachs, quoted by David Rimanelli, "My Pop," *Artforum* 43, no. 2 (October 2004), p. 269.

INTRODUCTION TO ART IN SPACE

In his exuberant fabrication of objects and scenarios, Tom Sachs asks barbed questions of modern creativity. He refashions the world out of simple stuff—foamcore, hot glue, and standard materials, either scavenged or readily attained from do-it-yourself catalogues—using his prodigious technical skill to expand on the make-do ethics of bricolage. But beneath his compulsive tinkerer's mentality and ribald wit is a conceptual delicacy that addresses serious and profound issues—namely, the commodification of abstract concepts such as originality, shock, newness, and mystery. His elaborate constructions provoke reflection on utopian follies, dystopian realities, the haves and the have-nots, profligate consumption and even more profligate waste.

Sachs has expanded his scope of creativity from crude yet ingenious perversions of weaponry and luxury accoutrements to reimagined living systems on an increasingly ambitious scale. For more than a decade, he has pondered the homespun technical ingenuity and romance with the unknown that brought America the Apollo program. These reflections have culminated in the realization of his own life-size Space Program. Pirating the milestone moment in the collective memory when man took his first walk on the Moon, Sachs has reconstructed the key components of the Apollo mission, building them to scale, but in his own way.

In addition to the huge, intricately built Lunar Excursion Module (LEM), replete with such classic Sachsian features as a fully stocked booze cabinet and a soundtrack for survival on an alien planet, Sachs has created a fully functioning Mission Control Center (MCC), the site of live demonstrations by Sachs and his team. On a grid of monitors, the liturgy of space exploration unfolds, involving countless rituals and procedures, from instrument and inventory checks to Moon walking, sample collecting, and the final splashdown. Thus the art gallery becomes a reliquary of both the material traces and the special effects of the artist's encounters with the terrible sublime.

Recollecting this historic event from the domain of public imagination and re-forming it as a custom-made experience, Sachs renders it entirely in and of our time, charged by a vigorous artistic idiom that is ambivalent to the core.

Louise Neri

ART IN SPACE

BUZZ ALDRIN, TOM SACHS, AND LOUISE NERI IN CONVERSATION

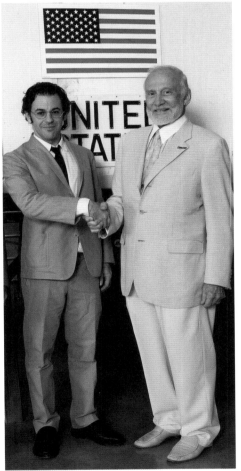

TOM SACHS AND BUZZ ALDRIN IN FRONT OF
THE LUNAR EXCURSION MODULE (LEM), GAGOSIAN
GALLERY, BEVERLY HILLS, CALIFORNIA, SEPTEMBER 2007.

Louise Neri: Buzz, the *Apollo 11* space mission has been hailed as one of the greatest technical feats of the twentieth century. Tom, you have been quoted as saying that going to the Moon was *the* art project of the twentieth century. Can you address these perceptions from where you each stand respectively, in the fields of science and art?

Tom Sachs: In science, there is always a need or reason for achieving greatness: the Hoover Dam, Great Wall of China, penicillin, splitting atoms, etc. The technical benefit of going to the Moon had no immediate importance; besides Teflon, the technologies that were developed exclusively for the Apollo missions have few common applications. But for the United States of America, it was an important political victory over Russia. As well, it captivated the world's imagination. Therefore this spectacular achievement has a conceptual value as an event in history. Its lack of practical result places it in the realm of the useless and spiritual—just like art.

Buzz Aldrin: I'm anticipating a tremendous technical achievement of the twenty-first century, something that could rival the Manhattan Project. I'm not sure how I would stack up the Manhattan Project against the Apollo project. I would say that the Manhattan Project probably had a greater impact on the world because of the long-lasting effects of introducing nuclear weapons.

LN: And atomic power.

BA: The competition in the Cold War didn't result in a nuclear exchange, but it did generate the movement that both sides then used to avoid having a conflict. It stimulated a competition that I was certainly aware of when *Sputnik* went up. I was in Europe flying supersonic fighters; patrolling the border was part of our mission. And then our mission changed to nuclear weapon delivery, in preparation for potential conflict with the Soviet Union. Then things changed around again, and suddenly we were in a race to the Moon with the Soviet Union. What I feel had a profound impact—and not everyone would agree with this—is that the Soviet Union achieved a surprising level of technical prowess at a time when they also had rather remarkably threatening military capability.

They had a space program—they were making progress and showing the rest of the world how confident they were. We challenged ourselves with just a suborbital flight. Twenty days later, our president said, "We're going to go to the Moon before the end of the decade." And we did it.

LN: In an interview, you showed the badge that was attached to your space suit—an eagle dropping an olive branch on the Moon. In other words, your mission was a harbinger of peace.

BA: Certainly there was a difference between how we implemented the technical challenge to ourselves in a very challenging arena of space capabilities. President Eisenhower made the decision that this was not going to be a military effort but a civilian one, expanding on the National Advisory Committee for Aeronautics, which then became NASA.

TS: In the Russian program, the rockets were painted army green, whereas NASA's were civilian/scientific white, their technology packaged and presented as a civilian or peace effort. The Russian program had more military elements, at least in its aesthetic. Yet the technologies were competitive. Green rockets versus white rockets, both with the capability of delivering missiles or men to the Moon.

BA: It was clear that President Eisenhower felt that we needed to have a civilian program, and he established it as one that was open, not classified. On our initial flights—the *Redstone* suborbital flight and then the *Atlas* flight, which put *Mercury*, a one-man capsule, into space—the progressive rockets, which had been developed as intermediate-range missiles, were used to launch the spacecrafts. The *Titan II* was an intercontinental missile that put the *Gemini* spacecraft into orbit. The Russian rocket developed for part of their lunar program was comparable to our *Saturn V* rocket. And, ironically, our rocket was developed by the same German engineers who had developed the missiles that rained down on our British allies in World War II.

TS: War has always been the ultimate motivator. Great technology has come out of mortal combat.

BA: Let's talk about the actual touchdown landings and where they led . . .

LN: Buzz, the first words that you uttered when you stepped onto the Moon were "magnificent desolation." Years later, in a television interview, you explained the seemingly endless process of preparation required before going to the Moon, and that you then got there and stepped into this vast emptiness. Independently, Tom has talked about his Space Program in terms of the elaborate preparation, the rehearsal,

the incredible level of technical detail required, and the endless trial and error, all building up to the moment of performance. Could you both address this coincidence between the reality and the art?

BA: It was about the culmination of a maturing of a species that could invent the wheel, dig down in the earth, create fire, and then begin to melt some of the things that were found down there and make them into metals, eventually forming those metals into wires and transistors, then blowing things up in rockets. Pretty soon, we were able to go from the Earth to the Moon. What a magnificent mark of achievement, to be able to get there and land. That's the magnificence that I was talking about.

LN: And the desolation?

BA: The opposite, sort of. You think that "magnificent" is going to lead to ivory towers and all things that serve humanity, but instead you have a lifeless, totally desolate place where humans had never been before.

TS: And yet, going to the Moon had been the common dream for centuries. We've always been able to see it with the naked eye. And although we may have killed one of our heroes by going there—going to the Moon and finding it lifeless is akin to meeting a hero and discovering that he is mortal—it was still interesting. We learned about how to get there, we learned about where we came from, where the planet Earth came from.

Buzz, you were known as "Dr. Rendezvous" because you wrote some of the protocols and developed the essential aspect of "microgravity rendezvous," which is very complex. When we met in Los Angeles, you outlined in a very simple, articulate way this complex concept and how it works.

BA: We can tell a computer to calculate how to go from here to something that's traveling 17,000 miles an hour—we're smart enough to tell it what it has to go through to figure that out. But the human isn't going to understand the computer at all—he is going to want to go through it step by step. What I did was to *humanize* the complex process of going from the surface of the Earth to rendezvous with something in space. It was a big rocket, and you have to get fairly close. You begin to do things step by step, and you gradually get closer. Pretty soon, you're on a direct course and you know you're going to reach where you need to go. And then you slow down when you get there.

TS: You mean it's humanizing to take this abstract, hard math concept and bring it down to a reality where people can interact?

BA: Right, right, right.

TS: A jazz musician, a martial artist, an astronaut—they do thousands of hours of preparation for just a few minutes. When you guys were on the Moon, it was two and a half hours, roughly, for which you had done . . .

BA: 4,500 hours, something like that.

TS: 4,500 hours of preparation for that activity, to familiarize yourselves with the tools and flight plan. When you got to the Moon, you had just a few minutes to scramble and do everything. Although it was choreographed, it was still improvised, because it was live. So the experience of all that was mostly about the training, rather than the few seconds of action.

BA: Let me offer the following as a counterpoint: The person here on Earth who's looking at the Moon landing focuses their attention on humanizing our presence there—they focus on the walking on the Moon, rather than on the landing itself. It turns out that walking around is very easy to do, but it's also very symbolic. The complexity is in getting to the point where you can do that, step by step—getting into an orbit, then modifying that orbit so that you come down, and then starting the thrust and moving toward where you want to go. Landing is the complex achievement.

TS: Right.

BA: But who makes the first step? This is the sort of thing that people focus on. We have an artistic rendering by Paul Kelly of this event, which became a stamp. Making an artwork of a Moon landing is nowhere near as humanistic as putting a footstep on the Moon. A footstep on the Moon is very easy to do [laughs].

TS: When my astronaut took her first step on the Moon, or the gallery floor, we had rehearsed it so many times that we were sure that it was going to be disappointing. But when it finally happened, we all went crazy! We weren't surprised because we were so prepared, but it was nevertheless a huge thrill and relief.

LN: Buzz, someone asked you how it was determined who got to be first on the Moon, and whether you flipped a coin. You replied that if you had flipped a coin, it wouldn't have come down again [laughs].

TS: If you could break down the process into two jobs, one would be what you love, believe in, and do, and the other would be bringing that to the world. Perhaps you could say that those steps on the Moon were very important in communicating everything and humanizing the act, but it's

really the work behind it—the landing, the rendezvous, the *Saturn V* rocket itself—that was the incredible achievement. And that stuff was relatively hidden compared to those famous steps.

Buzz, in your preparations, you did a simulation. You were all in a simulator, like a large sandbox, pulling up the lunar conveyor, testing out the space suits. All that stuff, all the choreography, planning your very few moments on the Moon—all of that was akin to rehearsal, in theatrical terms. Yet, it was also scientific and tangible.

BA: It seemed really silly with all those cameras out there, trying to make something of playing in the sandbox as a kind of rehearsal. We didn't rehearse putting up the flag. We did that for the very first time on the Moon.

TS: So, was the flag a last-minute addition?

BA: No. It was very contentious as to which flag, whose flag, and how many there would be. Was it going to be the United Nations flag? We figured they didn't contribute very much money . . .

TS: They didn't pay for the advertising space, so you weren't going to give it to them [laughs].

BA: We would have opened up Pandora's box if we'd started putting the flags of all different nations up there! We did get messages from seventy-two leaders around the world. We etched those messages on a silicon disk and deposited it on the Moon.

TS: How did you feel having the American flag up there?

BA: Of course, I was pleased. It was symbolic of explorations, like climbing Mount Everest and planting the New Zealand flag or the Explorers Club flag.

LN: What about your flag, Tom? What did it symbolize for you?

TS: It was definitely a claiming of territory.

LN: Along with every person and part of the gallery structure itself . . .

BA: Before we went to the Moon, the question of territorial sovereignty was spelled out by the Outer Space Treaty of 1967. It is suggested that President Johnson wasn't sure if we were going to get there first, so he wanted to do something that would prevent the Moon from being claimed.

LN: Maybe the treaty means that the Moon landing really was a work of art, because it was extraterritorial.

TS: When you go to the Smithsonian, there are all kinds of objects that parallel Duchamp's *Air de Paris*: a vial of Moon atmosphere; a double of the *Viking* lander, the flight alternate for the first Mars lander. On the landing leg of this is a memorial to Thomas Mutch, which is an art piece in itself: a plaque that represents the *Viking* on Mars that will be taken off when we eventually get to Mars. But let's not have any illusions about the real point of the space program; it's not really about process, it's about gain as a result of process. So whoever has the guns, wins.

LN: Let's return to the whole question of ingenuity. Historically, the Russians have been known as a nation of backyard tinkerers. Buzz, you also have an anecdote about being in the landing module and finding a switch lying on the floor that you realized was the switch from a circuit breaker, without which you wouldn't have been able to take off again. Didn't you use a felt-tipped pen to jam the switch in the right position?

BA: The switch was a circuit breaker, which has two positions—in contact, and out. We left a lot of them in the second position. If they're out, they're exposed and can be broken off. Now, if you break one off, it doesn't mean you can't push it in, but it presents something of a dilemma: Once you push it in, will you be able to pull it out again? Will it stay in when you push it in? And as an electric circuit is being closed, it might have a spark, so you might not want to push it in with something metal. So you use what you can. But you *don't* improvise. If you find something wrong, you tell the boss about it back home and you let them worry about it for a while, and they come up with an answer.

TS: When things go wrong for us, it allows our ingenuity to shine. By "wrong," I mean having to solve a problem with very little time or resources. Bricolage, like the British artist Richard Wentworth says, is about making do and getting by. Bricolage in the studio is very different from what you would do to survive in a hostile environment. In the studio, you have the time, resources, and materials to solve almost any problem. There is a triangular paradigm in construction: good, cheap, fast—you must choose two. If it's cheap and fast, it's going to be crappy; if it's good and fast, it's going to be very expensive; if it's good and cheap, it's going to take a long time. The NASA stuff was very expensive, very good, and fast; our Space Program is expensive, slow, and crappy . . . but that's why it's magic.

BA: In our program, there was a lot of stored ingenuity, and it wasn't

all up in the spacecraft. So much of it was on the ground. Flying from place to place was no longer the biggest challenge—the people on the ground came up with schedules, locations of alternate fields . . . and less relied on the command authority inside the spacecraft.

LN: Did you have the same experience, Tom?

TS: Well, on our team we have a code, a methodology, a way of building, and then because of the speed, the person building—whether it's me or someone else—has to take an improvisational approach to get it done. Our astronauts actually built the Lunar Module with their own hands, just as the people in Mission Control built the Mission Control Center themselves.
 I love the story about Alexei Leonov doing the first space walk and trying to get back in the capsule. His space suit was inflated and he couldn't get back in. Rather than waiting for permission from ground control, he acted with the creativity of an individual and adjusted the air pressure to deflate his space suit without asking. He felt he didn't have time to radio in; he made the decision and got back in safely, and then was reprimanded officially, I believe, for doing this improvised action.

BA: Well, he's done a few more unsupervised actions since then [laughs].

TS: But for us, the idea is to go by what we know, and to do as little improvising as possible outside our implicit agreement as a team. That's why we say that creativity is the enemy; by creativity, I really mean individual caprice.

BA: Once something is set in motion, that is absolutely true. But in the early stages, if you try and set something on a path and say that's the only way to do it, you outlaw other inputs that might come up with a better solution.

TS: That's a possibility, yeah.

BA: And I'm very proud of the fact that when I look at something, I consider whether it is the best way to do it or whether there is possibly a better way. That is what really came up in my work. I looked at all the systems in the spacecraft and all the information and considered how to join things together—I came up with different strategies of going from the Earth to the Moon. Some of them made some sense, some of them didn't.

TS: JFK said, "We choose to go to the Moon not because it is easy, but because it is hard."

In my studio, by building functional elements, by making systems that really work, we create new problems that require even more work to solve. This compounded work process, with things built according to our strict code of love and haste, defines the look of what we do. So for us, going to the Moon is a physical armature for continuing to practice what we do.

LN: Could you both discuss the relationship between art and exploration?

BA: There are rather perfect models of spacecrafts in the Smithsonian, and young children visit and learn from them. They can't play in them. As soon as you begin to get something that young people can understand, crawl into, look around inside in different ways, it begins to depart from reality because the real thing is too expensive and too much of a memorial to allow kids to mess around in it. But if you can begin to humanize that spacecraft the way Tom has done, humanized in varying ways that are somewhat of a surprise because they're not thought of as being part of the real spacecraft . . .

LN: You mean the orthodoxy?

BA: . . . to open up a cabinet in a spacecraft and find a can of beer is not an ordinary way of looking at something.

TS: But these things serve the needs of *our* Space Program because we're sculptors and we make things. In our spacecraft, we have woodworking tools, beer, and music, because those are part of the way we live. So in our attempt to represent every significant aspect of a lunar landing, we were less concerned with historical accuracy than with the idea of an original spacecraft's need to reflect the requirements of the people involved. From this process, we were able to learn a great deal about the whole experience.

To get back to what you were saying earlier about our procedure and our methodology, of course we studied what you guys did. You're the model that we approached with a sense of play.

LN: The model and the reality.

TS: Well, I would argue that ours is just as real, although it's maybe more theatrical and more representational.

BA: I'd really like to sit down and give you a suggestion for my version of the next generation . . .

TS: Well, we're doing another mission, so maybe . . .

BA: You want to emphasize success, and what you can do with success. So, once you have confidence in your ability to land, you don't have to pay the penalty of carrying the extra fuel and the extra engine. Instead, you can carry something that you can leave on the surface.

TS: [Laughs.]

BA: And it would make a very nice mock-up, because it would make people aware that this was the "mature" landing, a step beyond, not just a copy of Apollo.

TS: Well, we are interested in representing the next thing; we are interested in doing more. We did the "go to the Moon, get the contingency sample, and get the hell out of there" thing. Now we're all interested in going to the next place.

When we had dinner a while ago in Los Angeles, you said to me that dinosaurs didn't have rockets, and that we need rockets to preserve our species, because eventually the planet's going to run out, or an asteroid is going to hit us, and this is our big insurance policy. It's cynical because it means that we are not respecting or preserving our natural resources here and now. The need to conserve energy on our planet is the same as the need to conserve energy in space, and developing technologies, regardless of their impact in avoiding our dependency on oil, is equally essential . . .

BA: Whatever the reason is, we may need to be able to go somewhere else. And I've used the phrase over and over again: sooner or later, a mature species does everything it can to guarantee the survival of the species. Not for the comfort of the people as much as for preserving the past—keeping humanity alive to protect evolutionary history.

LN: In Tom's Space Program, the gallery becomes a reliquary for artistic artifacts inspired by the mission, and a reliquary for the history of the mission itself. As you say, for people who never experienced any of the real material of the Apollo space program, Tom's program speaks to and extends itself to a new community of people. Buzz, you also have a personal project of creating some kind of archive on the Moon. Can you discuss?

BA: Libraries are very useful. Many of those strong words printed on paper have been digitally recorded. Now, maybe you could store that physically by protecting it inside a box and putting it somewhere it'll last, independent of chaos on the surface of the Earth—you could put something like that on the Moon. In my science-fiction story, people left Alpha

Centuri and traveled to different places. While they explored and survived, the people back home decided it was a good idea to give the travelers the very latest information—the travelers had left the planet due to its primitive diseases but they needed the information. So it's sort of a backhanded way of storing information needed for a people to survive.

TS: That's an interesting story, and it's believable because the Moon is a kind of archival environment. Those footprints that you left in 1969 are still there and will be there for a million years. Think about the Library of Alexandria and now Google's Digital Library of Alexandria, and how ephemeral the nature of digital information is, as opposed to analog. Every one of us has lost information when our computers have crashed . . .

LN: So you're affirming the existence of physical culture.

TS: Isaac Newton was the last guy on Earth who knew everything there was to know, because afterwards knowledge became very specialized. Analog technology is something that almost anyone can fix when it breaks. You can see it, feel it, touch it. The ephemeral quality of digital media makes it more mysterious—mystical and vague. I think it's important to make things physical and keep them real and concrete, because digital storage technology is so tiny it becomes ephemeral and sometimes just disappears.

BA: With your art, you re-create things that have a degree of variation from true fidelity.

TS: My sculptures are not just studies of "real" things; they *are* real things. Building a spaceship out of plywood creates some special problems that force unique solutions. It's in those solutions that the work has value to me. Many amateurs have built homemade lunar modules. But our LEM stands on its own four legs without a central column; the only other ones that do that are on the Moon. This "mission requirement" forced us to use custom steelwork and improvise assembly procedures that resulted in an exposed structure.

When you go to Canal Street and buy five-dollar Gucci sunglasses, it's not that they are fake; they are unauthorized. And with that comes some advantages that can't be overlooked.

LN: Can you discuss the difference between bricolage in art and bricolage in life?

TS: Bricolage in life is a quick, resourceful, disposable fix. In art, it can be both the process and the signification of lasting value. Art

is much more pretentious: bricolage becomes an expression of rehearsed improvised gestures, whose roots were derived from necessity, to become key words in my language of sculpture. Maybe another connection is military training. A combat pilot is trained in simulations for all kinds of life-threatening situations, but when there is a real threat, the pilot must decide what procedure or instinct is applied. What I believe is that Buzz and I both have a great deal of esoteric knowledge about how to make a sculpture or fly a spaceship. The other part of our job is bringing that to the world, helping people connect so as to share in our experiences or where we go in our imaginations. In some ways, that's a hard part—not the hardest part, but an equally difficult thing to accomplish.

BA: Comics exist because people enjoy them. What is comedy? It's taking something that's recognized, putting an absurd twist on it, then treating it as if it's normal [laughs]. That makes people react accordingly— that's what makes a joke. And now we're taking reality, rendering it artistically, and then treating it as the real thing. I mean, the *Mona Lisa* is not real, not alive or anything, nor is it a holographic view. It's an interpretation that has a degree of beauty all to itself. How you take something and make it operate in a situation—whether it's a beer can that makes the lunar lander a little absurd, or the drill you put in the cabinet that doesn't belong in there in the real thing—it attracts human curiosity and somewhere in there people ask themselves what's real and what's not real. And sometimes it matters and sometimes it doesn't.

LUNAR EXCURSION MODULE (LEM) SYSTEMS MANUAL
Mark Van de Walle

Engineering projects, unlike art, aren't supposed to have aesthetic qualities or be judged on aesthetic merits. They either work and can be built on time and on budget, or not. Actually, though, this isn't true. Engineers do have a sense of aesthetics, and they judge the things they build according to a scale defined by two opposing concepts: at one end of the scale, there's "elegant"; at the other, there's the "kludge." An elegant solution solves a problem in the minimum number of steps, with the fewest parts possible, and sometimes it even solves two or more problems simultaneously. Once you've seen the solution, it's difficult to imagine how else it might have been done. Elegant engineering is essentialist, practically eidetic. Antoine de Saint-Exupéry, an aviation engineer as well as a novelist, came up with perhaps the best definition of elegance: "A designer knows that he has achieved perfection not when there is nothing to add, but when there is nothing left to take away."[1]

Perhaps unsurprisingly, there's no similarly concise definition for "kludge." The simplest way to think of it is as a clumsy solution to a problem, made out of parts and ideas lifted from other projects—but this doesn't quite get to the heart of it. According to Jackson Granholm, in his pioneering 1962 article in the early computer magazine *Datamation*, it is important to understand that creating a kludge "is not work for amateurs. . . . The correct design approach is to use . . . [a] standard, well-known electric typewriter, but to *alter the character set*. Of course, one chooses an internal machine character set different from that of any other manufacturer (after all, theirs are no good either) and this internal character set must, at all costs, be different from the one on the console keyput."[2] This approach forces one to scavenge for parts and use them for purposes they were never intended for, or to create one's own—preferably both primitive and fiendishly complex, fragile yet clunky, and demanding the utmost in creativity.

Generally, designed or engineered objects lean toward either elegance or kludge. However, the Lunar Excursion Module (LEM) is one of the few that manages to exist at both extremes at the same time. On the one hand, it's the pinnacle of elegant engineering. Two separate programs, one known as Scrape and the other, even more rigorous, known as the Super

Weight Improvement Program, were carried out by teams of Grumman engineers to ensure that nothing in the LEM was extraneous. Everything that could be made to perform double duty, made smaller, or simply taken out, was. Everything that was left was critical, its presence determined solely by the design principle that no single failure should cause a mission abort. There were no rounded corners or sleek skins covering anything, because they would only add weight. That's why the LEM isn't bullet-shaped and doesn't have fins or a needle nose, the way people had imagined space-ships would since the turn of the twentieth century. Instead, the craft that fulfilled man's oldest dream looks like a collection of boxes and tanks, strung together with exposed plumbing and electrical wiring. Mylar and aluminum foil wrapping were substituted for exterior walls and heat shielding. Interior walls were thinned down to the point that a screw-driver, dropped in full Earth gravity, would tear through the floor. Seats, unnecessary in low gravity, were removed in the lander portion; Velcro and nylon straps were substituted. The LEM, in other words, is an object reduced to its absolute essentials.

At the same time, it's among the kludgiest kludges ever. Granholm wrote that in order to reach its "full flowering," a kludge requires a specialized environment, one of "complete, massive, iron-bound, depart-mentalization."[3] The way the LEM was built was a kind of hothouse for kludge efflorescence. Five different companies were used to make the rocket, and each of them had its own subcontractors, who in turn had their own vendors to make the millions of parts they needed. Physically, the LEM was a nightmare to fabricate. There were endless delays while companies attempted to hand-machine increasingly strange and intricate shapes from thinner and thinner materials. Other parts were literally bolted on at the last moment: the plume deflectors, which kept the Reaction Control System (RCS) from torching holes in the foil exterior of the Ascent Stage (AS), were installed while the rocket was on the launchpad. The Apollo Guidance Computer (AGC) only had two contractors, but the MIT engineers who developed it were able to convince NASA to keep a user interface they'd developed as a kind of joke when they wanted to show visitors to their lab what the AGC actually did. The manual for the system was 1,840 pages long and so complicated that no one truly under-stood it completely. At one point during the LEM's approach to the Moon, it looked like the mission would be scratched when a computer error nobody recognized—now known as The Famous Error 1201—shut down the AGC repeatedly. In order to avoid a complete meltdown, the head of Mission Control had to find the man in charge of the AGC, who in turn had to find the one man who knew enough about everything that could possibly go wrong with the system to be able to tell them what Error 1201 meant. And when they found him, he was so nervous that the only thing he could do was grin shakily and give them a thumbs-up. Everybody interpreted this as a

signal to turn the AGC off and then back on again and to ignore the error message—which, fortunately, was close enough to the right thing to do that the astronauts were able to proceed with the Moon landing.

The point is that the LEM is a seemingly endless collection of nearly infinitely complex systems and subsystems. It is beyond the capacity of any one person to comprehend completely, and it may very well represent the decisive moment at which engineering projects became so complicated that it was impossible for one person to know everything about them, and computers, and thus the digital age, became a matter of necessity. At the same time, it is the pinnacle of engineering elegance and simplicity; it has to be, since otherwise there would have been no way for it to carry enough fuel to get to the Moon and back again. The LEM is a paradoxical object, the elegant kludge.

This, then, is the problem that confronted Tom Sachs's Space Program. Making a LEM isn't simply a matter of re-creating an object that was so insanely hard to produce the first time, even with practically unlimited financial and intellectual capital, that it's still a watchword for "incredibly difficult to do or understand" (hence the saying "it's not rocket science," referring to things that may be difficult but are nonetheless still comprehensible or achievable by ordinary humans—as opposed to rocket scientists); it's a matter of re-creating a nearly impossible thing, one that unites two opposing aesthetic categories. Fortunately, the juncture at which the apparently clunky and the sophisticated converge is Sachs's area of expertise. He's a specialist at Frankensteining the two together; the results have lots of visible seams and seemingly sloppy suturing, but they still manage to shamble along fine.

Because he's worked in this way, at that juncture, Sachs has been known as a *bricoleur*, a kind of primitive techno-wizard who's able to whip up highly technically advanced assemblages out of whatever happens to be at hand or easily scavenged. On the surface, his Lunar Excursion Module (LEM) looks like precisely that, every seam showing, every screw head and pencil mark evident. But really, Sachs's LEM is more or less the exact opposite of bricolage: every piece on it is either specially made, overdesigned, overdetermined, or all of the above. For instance, the boom box that plays the rocket noise during liftoff is not just any boom box, but is the star of hours and hours of YouTube videos showing nothing but the JVC Victor RC-M90 playing various songs. The turntable used to play *Dark Side of the Moon* is the same one Alex uses to play his beloved Beethoven in *A Clockwork Orange* and is in the design collection of the Museum of Modern Art. The lab coats worn by the Grumman crew were manufactured by Prada, and the shoe system for the astronauts' space

suits were specially made by Nike to the standards established by the Department of Energy's Nuclear Regulatory Commission. Even something as apparently prosaic as the fiberglass tape holding together the seams of the plywood that forms the body of the LEM had to be specially fabricated so that it wouldn't unravel and explode into a cloud of its constituent glass fibers at some inopportune time but would still look suitably sloppy nonetheless. Piece by piece, in other words, everything in the LEM has, in fact, been carefully selected for elegance—whether of design or concept or both.

At the same time, though, while the pieces are individually elegant, the way they work in context, or together, is pure kludge aesthetics. This is why, while it would be easy to run MCC digitally, it's obviously preferable to have an analog video-switching board, which is such a pain to use that the whole elaborate camera choreography necessary to document the mission has to be handwritten on the board, where it can then be easily misinterpreted in the heat of the moment. The rescue helicopter (painstakingly pieced together out of two different sets scavenged from eBay) would require elaborate resetting in the incredibly likely event of a crash. And while the seats have been left out of the LEM, an elaborate suck-blow vacuum system, repurposed from an earlier project by Sachs, has been installed and retooled so that it runs throughout the interior of the craft. In theory, it's for the relief of irresistible urges, but since the astronauts are both female, it's sort of useless for that, not unlike the Urine Collection Transfer Assembly (UCTA) provided for urination in the space suits.

Given that the entire staff of Sachs's Space Program was only fourteen people, this kind of thing could not have been easy to achieve (remember, a real kludge grows best with lots of departments). But by hewing fairly rigorously to Granholm's design principles, Sachs was able to attain a highly authentic level of simultaneous elegance and kludge. Or, as Directive 19 of the "Glue Gun Manifesto," written on the wall of Sachs's studio, puts it, "We want it to be 'fucked up.' That is good."

Endnotes:

1. Jackson W. Granholm, "How to Design a Kludge," *Datamation*, February 1962, pp. 30—31.

2. Ibid.

3. Ibid.

Lunar Module

The primary function of the Lunar Excursion Module (LEM) is twofold: to send two astronauts to the Moon, and to return them safely to Earth. This mission is simple to state, but profound in its execution and implications. It represents nothing less than the fulfillment of one of mankind's long-cherished dreams, the stuff of myth since the first man thought to look up in wonder at the Moon.

The LEM is the most complex object ever built, an interlocking system of systems. In order to begin to get a sense of how these work together, it is useful to start with the two largest components of the craft and work inward from there. The largest parts of the LEM—the systems that actually touch down on the lunar surface—are the Descent Stage (DS) and the Ascent Stage (AS). The two are connected together on Earth and make the trip to the Moon as a unit. However, the parts are built to separate once Translunar Injection (TLI) has been achieved. After the astronauts have completed a package of scientific experiments and geological sample gathering, as well as various commemorative activities, on the Moon, the AS fires its 3,500-pound thrust engine, separating it from the DS, which remains on the Moon. At that point, the AS enters into lunar orbit and carries the astronauts to rendezvous with the Command Service Module (CSM) for the return trip to Earth.

The DS is made up of a landing radar antenna, descent engine, and quadripedal landing assembly. A cargo hold—the Modular Equipment Stowage Assembly (MESA)—is built into the side for the storage of tools used in gathering geological samples and to hold and prevent contamination of the samples on the return trip. A door in the side of the DS provides access to the fuel and oxygen storage areas, as well as the LEM's suck-blow system, waste disposal, and special-effects models for the filmed documentation of the mission.

The AS is more complex, with radar and communications antennae, as well as four sets of guidance and navigation rockets (the Reaction Control System, or RCS), on the exterior. Hatches in the roof and on the side of the module provide ingress and egress. Inside, the cabin holds: instrumentation and communications equipment; suck-blow stations, which are throughout the cabin to provide for the astronauts' needs; crew consumables such as canned beans; a small library of literary works; and soul music from the 1950s, 1960s, and 1970s. Additionally, an Alcohol Tobacco Firearms (ATF) station holds Marlboro cigarettes, firearms, and fluids such as water, whiskey, and vodka.

In order to ensure the crew's safe journey to and from the lunar surface, all systems need to be sufficiently redundant so that no single part's failure will result in a mission abort. However, because of weight considerations, all objects that are not essential to the mission's success must be eliminated: the AS's crew cabin, for instance, has no seats, as low gravity makes them unnecessary, even for the one-and-a-half-hour mission. All remaining items are stripped down to the simplest, most efficient form possible for their intended use. As a result, the LEM is the purest elaboration of the dictum "form follows function" ever built; it is the highest expression of engineering elegance. Perhaps unsurprisingly, it is the only non-human component in the history of the Apollo/Saturn program never to suffer a mission-critical failure.

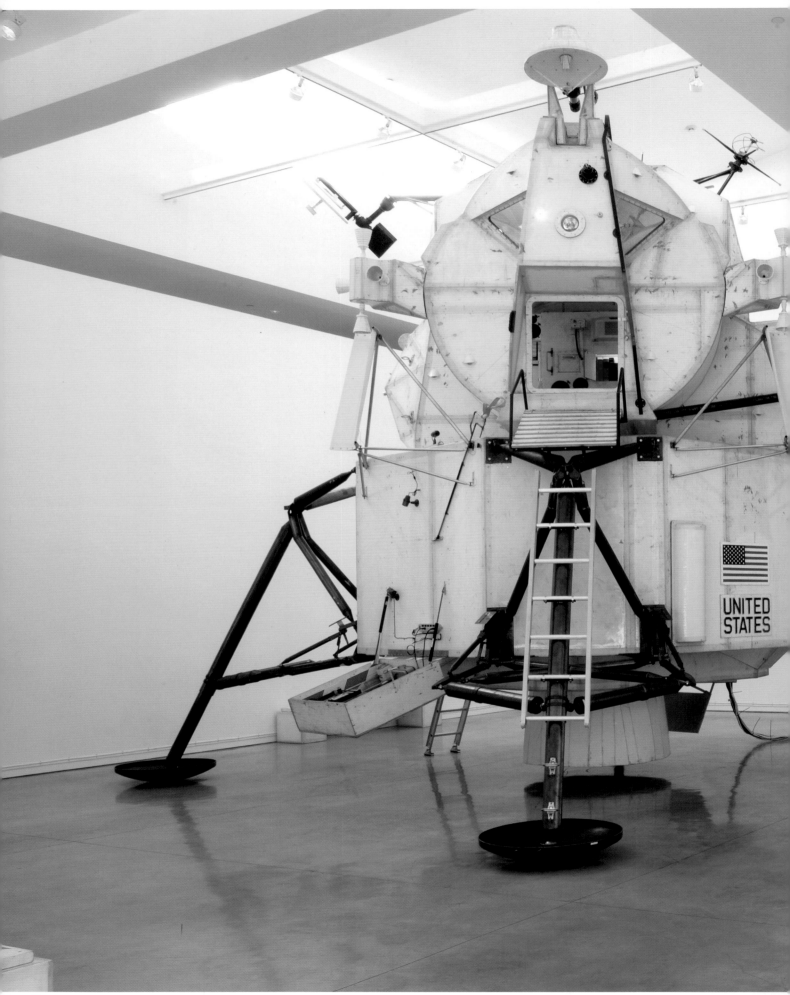

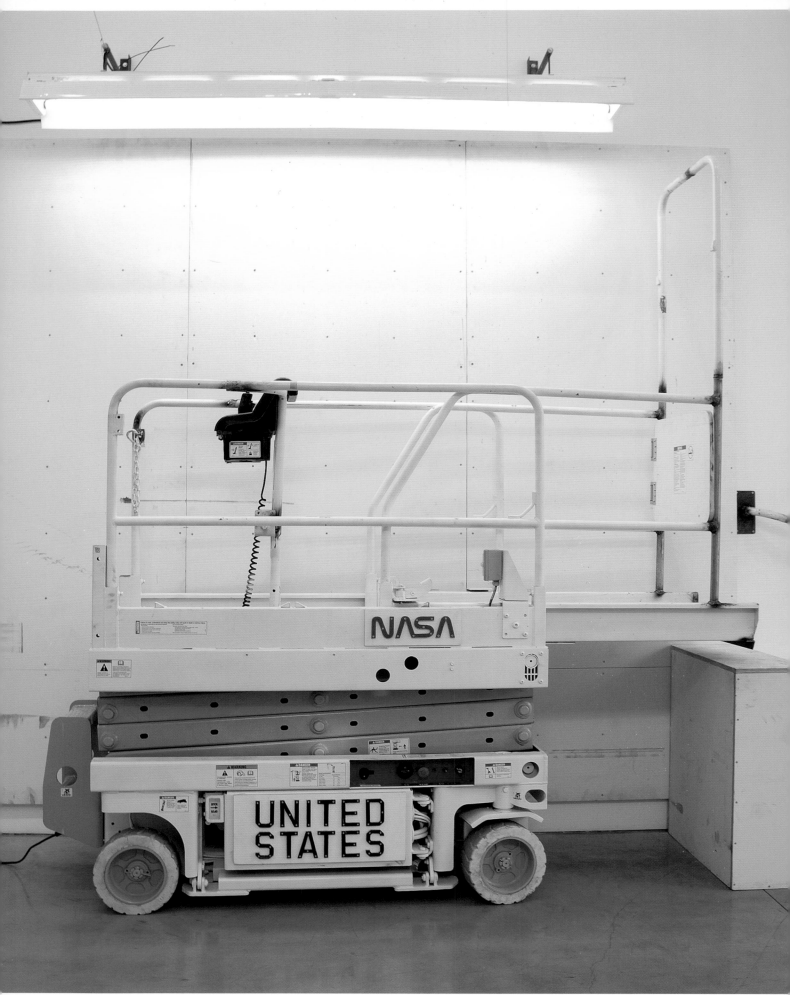

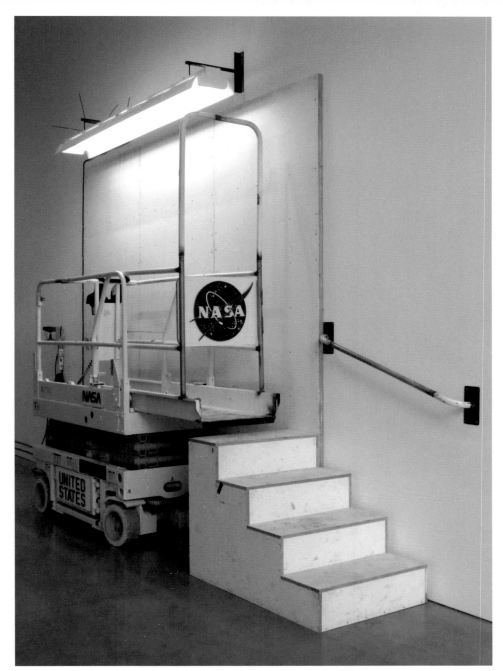

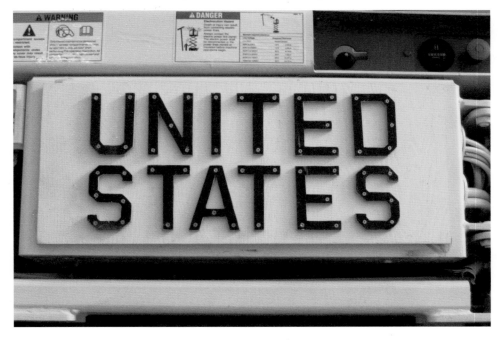

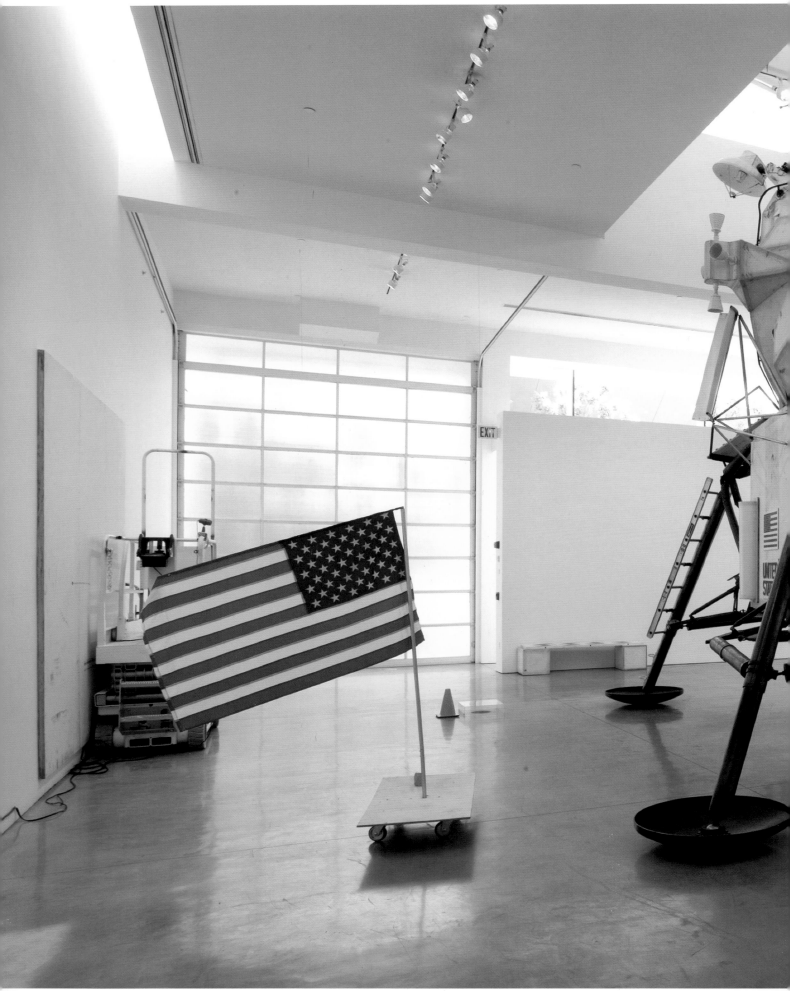

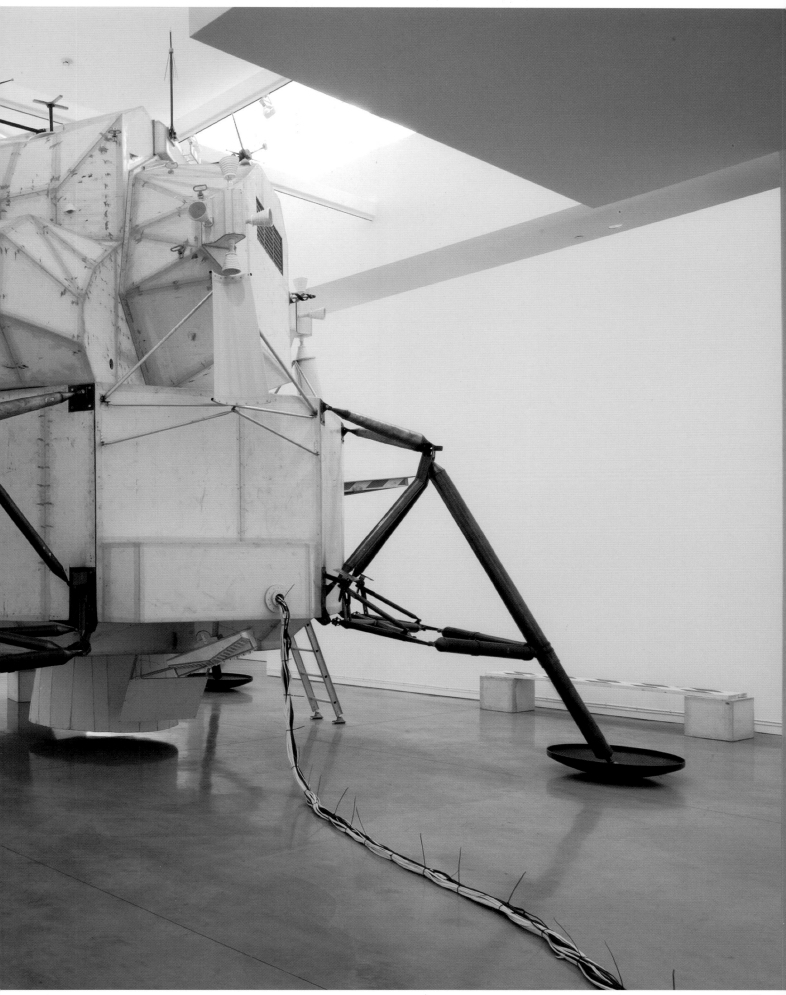

REACTION CONTROL SYSTEM (RCS), QUAD THRUSTER, AND PLUME DEFLECTOR

The LEM is equipped with four Reaction Control System (RCS) units, each with four thrusters pointing in different directions—up, down, angle right, and angle left. By means of these relatively small rockets, the attitude and velocity of the Ascent Stage (AS) is controlled after liftoff from the lunar surface for docking with the Command Service Module (CSM). Following a 7 minute 14 second burn of the main LEM ascent engine, the AS achieves insertion into lunar orbit. At that point, the RCS is used to perform four maneuvers, putting the AS in the proper altitude and attitude for docking with the CSM.

During the *Apollo 9* mission, it was noted that the blast from the RCS heated the thin skin of the LEM to a potentially dangerous temperature. In order to protect the AS from the heat of the rocket's burn, each downward-pointing thruster is equipped with a plume deflector (four in all). These were first installed while the LEM was atop the *Saturn V* stack, on the launchpad. Each plume deflector consists of a blast shield, stretched between an upper and a lower beam, joined by a support rib in the center. In an earlier version, two catenaries supported the edges of the deflector, but they are not present in the current iteration. A network of support struts both attach the deflector to the skin of the AS and keep it at the proper angle for diverting the rocket's blast.

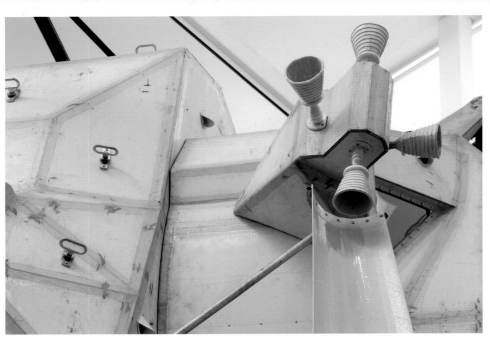

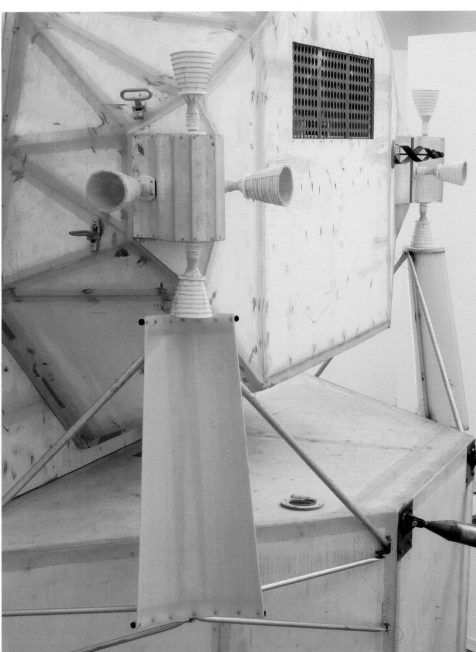

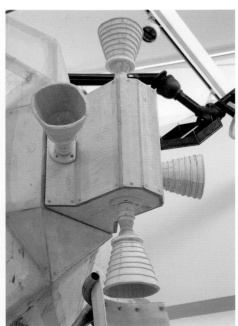

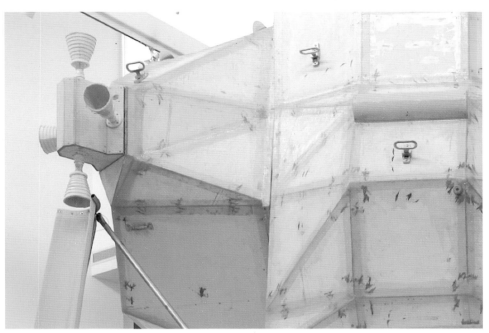

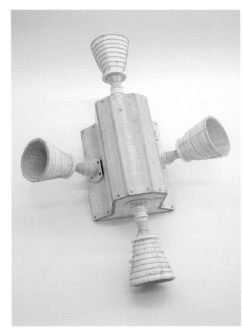

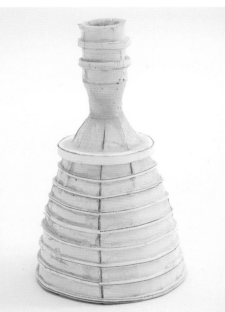

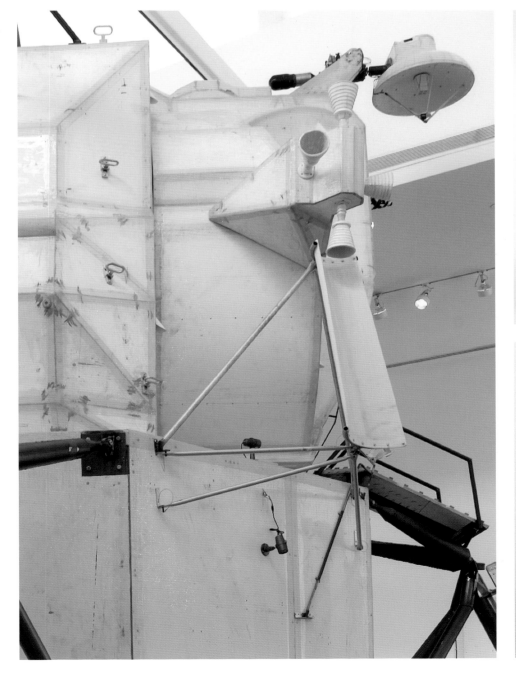

COMMUNICATIONS SUBSYSTEMS (CS)

Assorted antennae, including the Rendezvous Radar Antenna (RRA), which is used to acquire and track the Command Service Module (CSM) prior to docking, and two omni-directional VHF antennae, used for communication between the astronauts and the LEM during Extravehicular Activities (EVA), are attached to the exterior of the LEM. The docking target assembly (a white spotted assembly mounted next to one of the VHF antennae) provides a visual of a three-dimensional axis as an aid during docking maneuvers. The S-band antenna is part of a system that combines all communications—audio, visual, medical, and systems telemetry—between deep space and Earth into a single feed, the Unified S-Band System. This feed is picked up by three stations, located in California, Spain, and Australia, before being routed on to the NASA communications center in Greenbelt, Maryland.

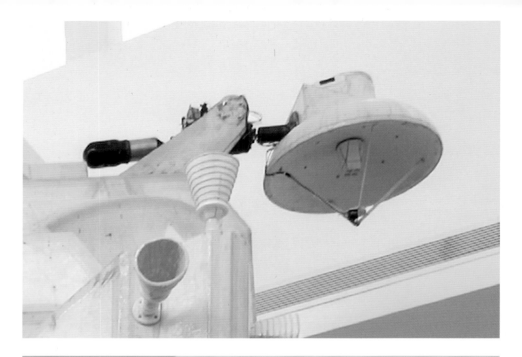

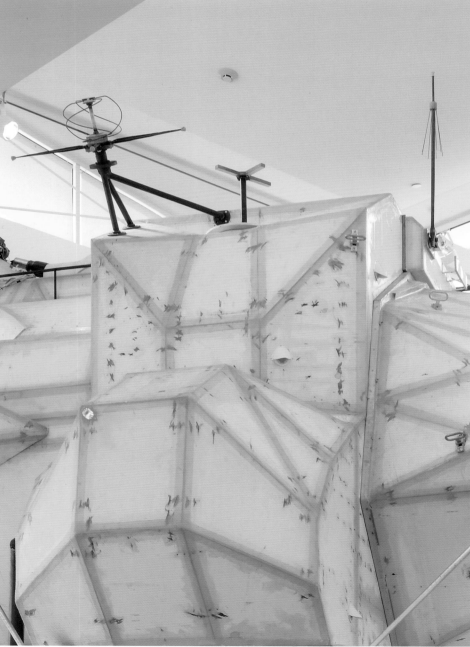

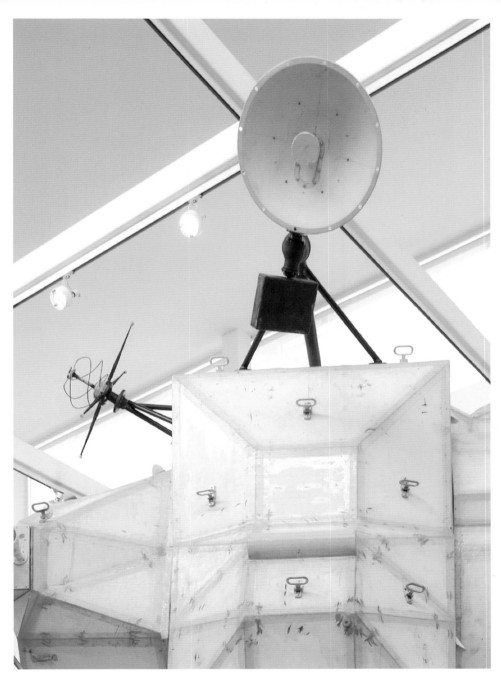

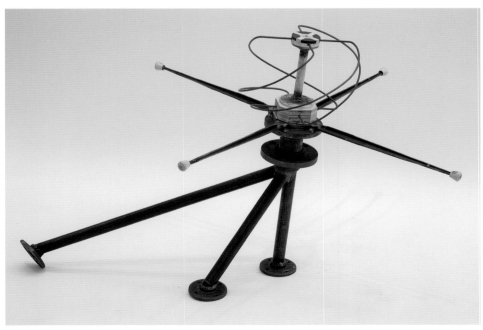

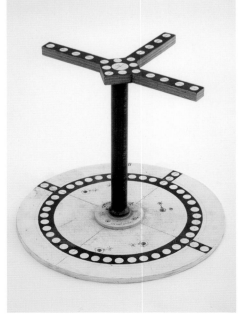

MODULAR EQUIPMENT STOWAGE ASSEMBLY (MESA)

The Modular Equipment Stowage Assembly (MESA) is a cargo hold that stores tools for use during Extravehicular Activities (EVA). Tools include a flag, Moon rock gathering kit, case to hold samples (in order to prevent contamination), turkey baster, lobby broom, dustpan, rock hammer, shovel, brush, Dixon Chart Recorder, Samsonite train case, cold chisel, charger, battery, and hammer drill.

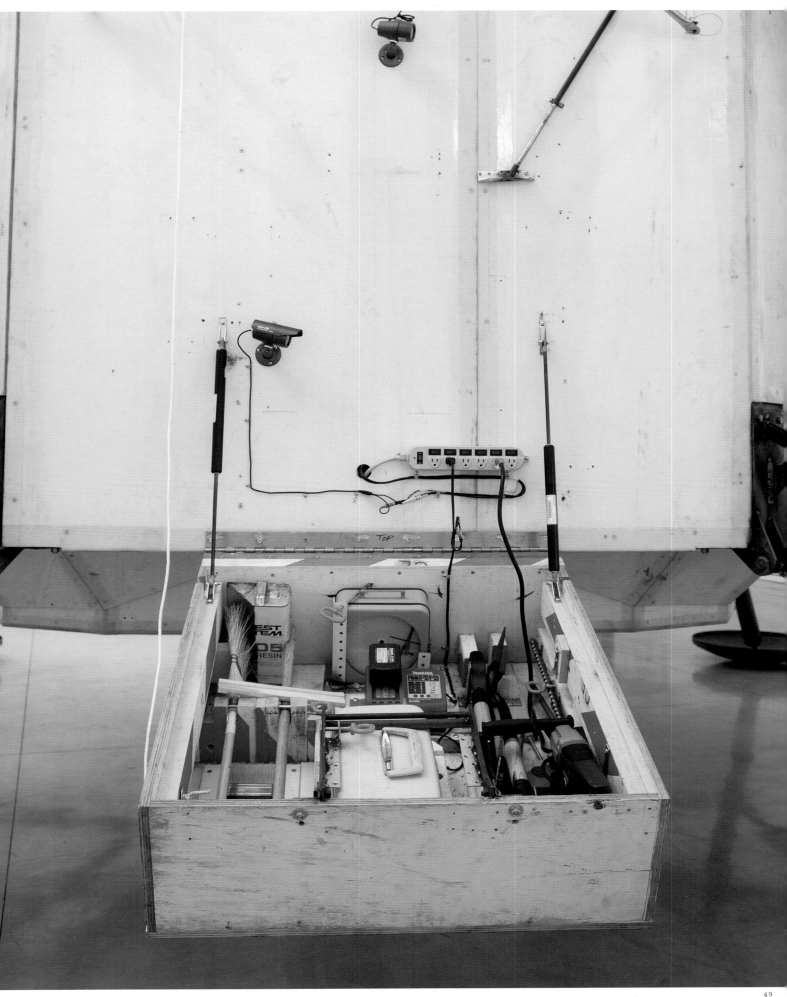

EGRESS HATCH

The Egress Hatch is used for transferring astronauts and equipment to the lunar surface.

LEM SKIN (INTERIOR AND EXTERIOR)

All seams where the panel shingles are joined have been sealed with 14-ounce fiberglass biaxial adhesive that has been laid down in a diagonal pattern for maximum strength. Adhesive was custom cut to 5 inches because of width requirements for the project. The biaxial adhesive was then cemented into place using West Systems 105 Epoxy Resin with #207 Hardener. Otherwise, apart from NASA mission and national insignia, no unnecessary surface finishes or decoration have been used.

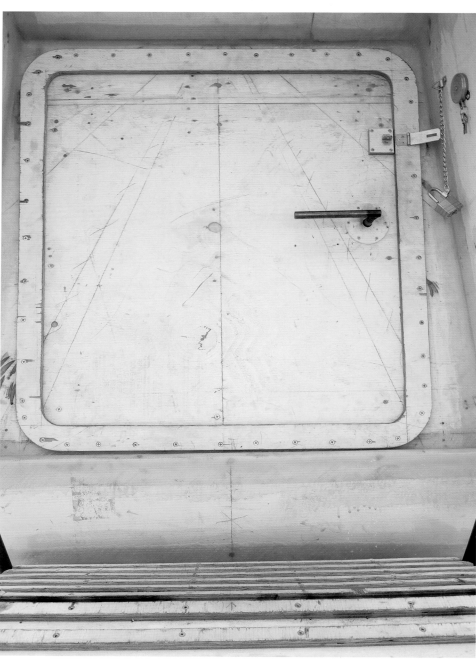

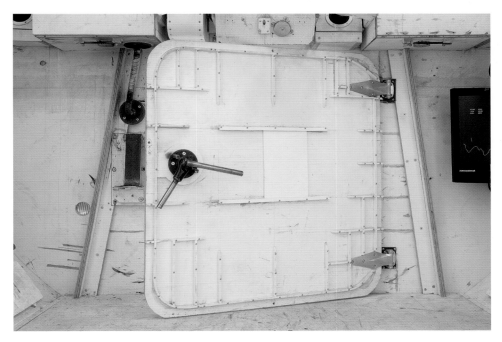

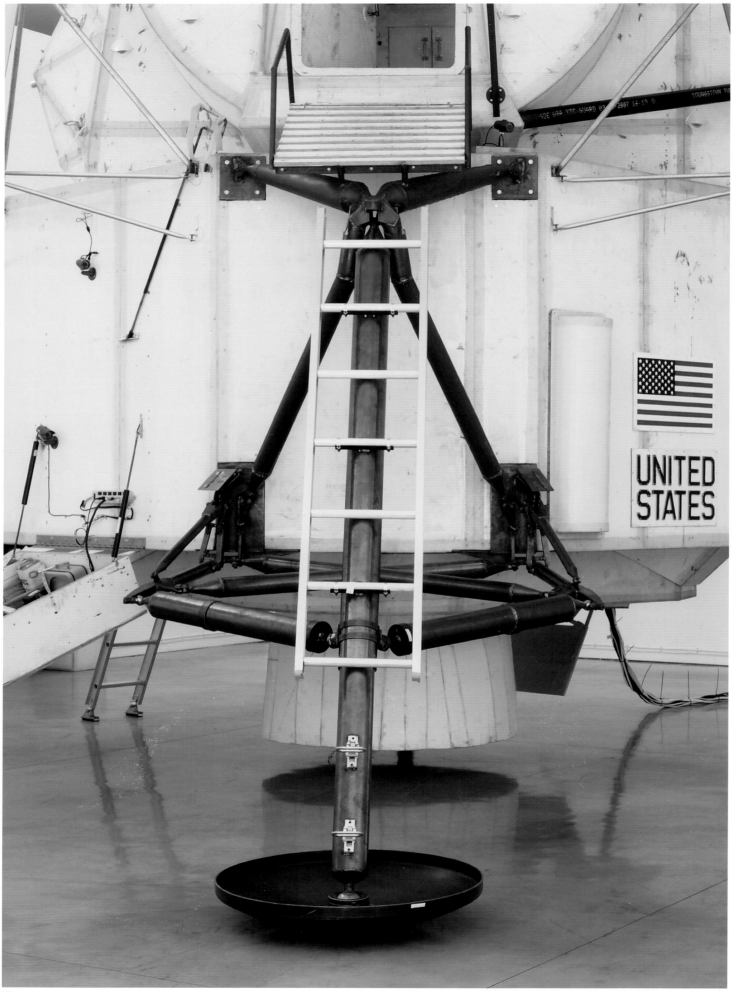

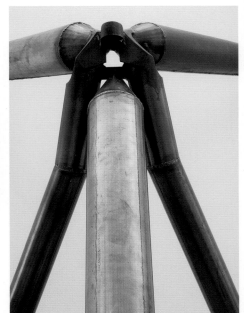

LANDING GEAR

The earliest NASA proposal was for a five-legged LEM with nonfolding landing gear. However, that evolved to the current four-legged folding model. Other early concepts called for hydraulic shocks capable of "popping" the LEM, and constructing the landing gear out of preexisting parts, including a Chevy drive shaft and Monroe shocks. Both of these were ultimately abandoned in favor of the current quadripedal welded-steel assembly. Steel, as opposed to aluminum, was chosen due to a combination of engineering and aesthetic considerations. Steel is more forgiving to work with and shows the traces of construction in a way that aluminum does not permit. The one remnant of the earlier designs is the landing pads, which were constructed from steel propane tank caps, each approximately 36 inches in diameter to prevent sinking into the soft dust on the lunar surface.

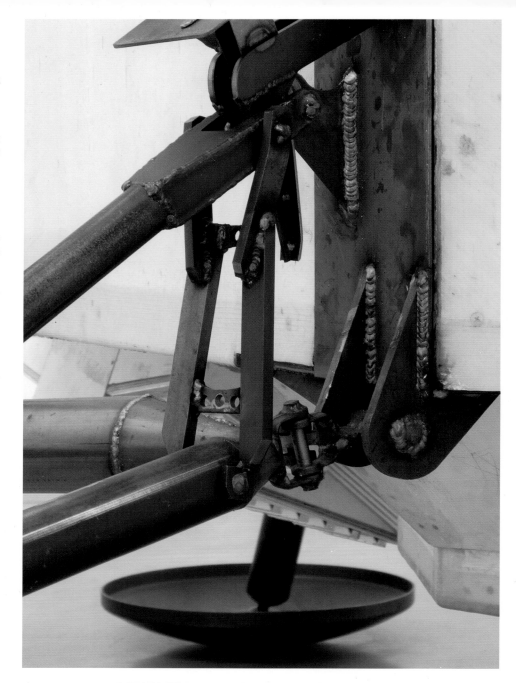

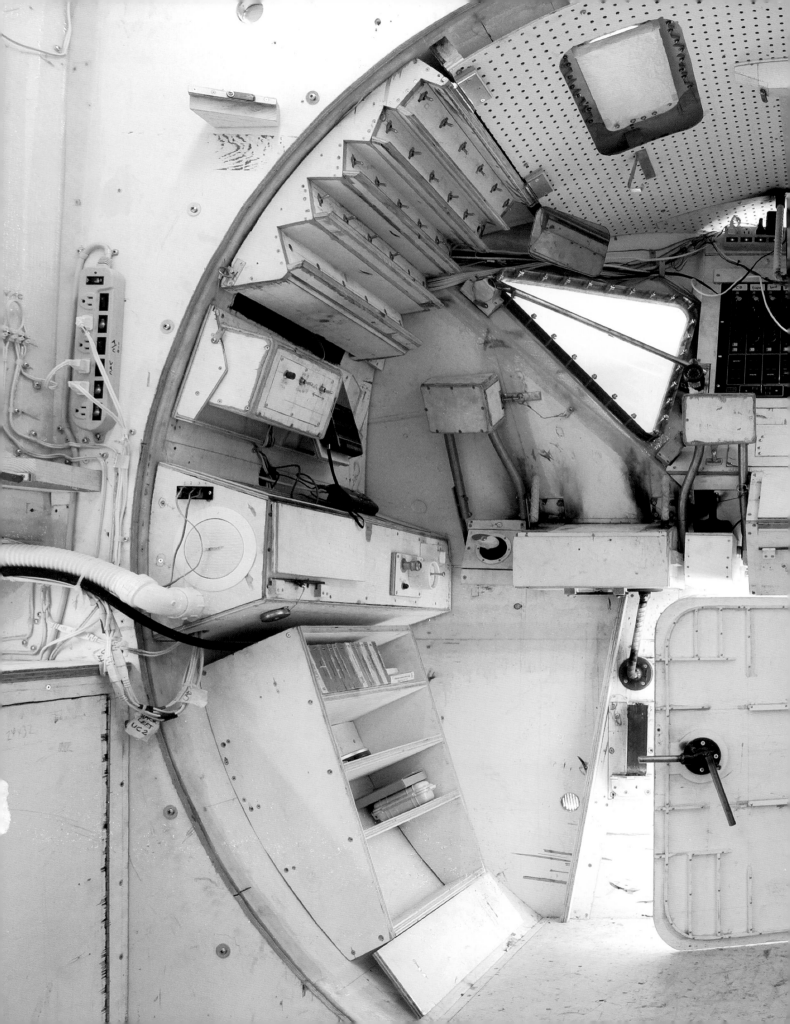

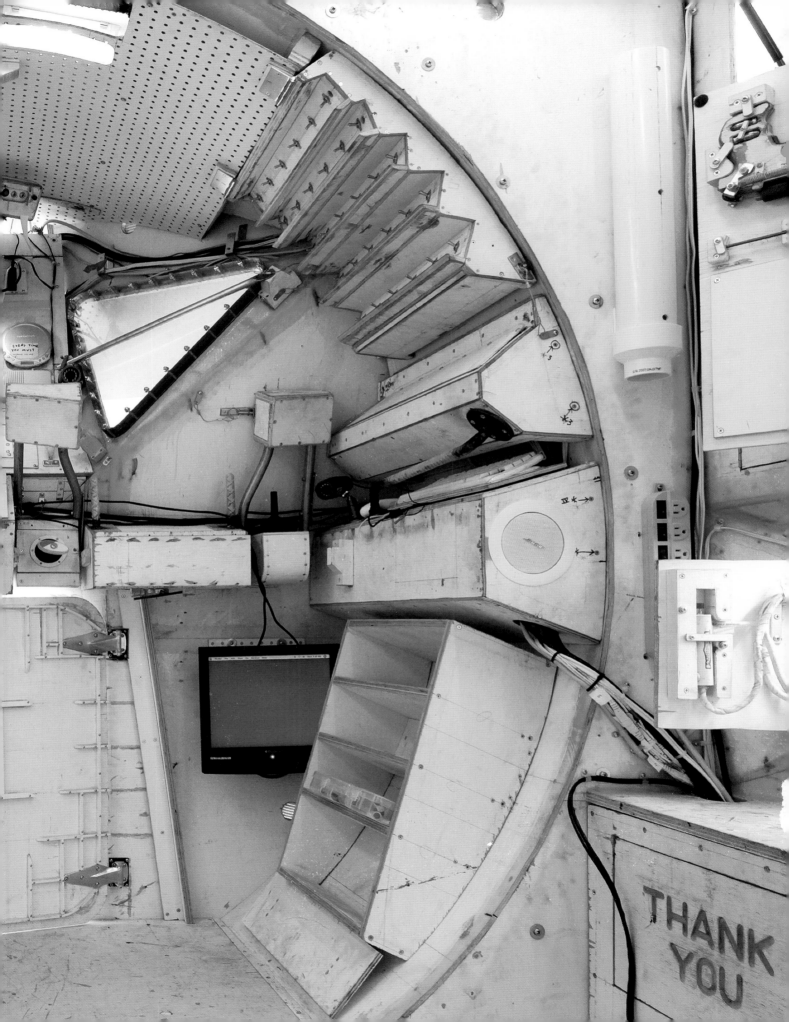

FORWARD BULKHEAD ASSEMBLY (FBA)

The Forward Bulkhead Assembly (FBA) is the observation and flight control center of the LEM. It has two triangular windows that allow for observation of the lunar surface during landing and Translunar Injection (TLI). A third, rectangular window is set into the curved ceiling, allowing direct observation of the CSM during docking. A television monitor, mounted in a yellow-painted protective steel rebar cage, provides another view, along the exterior of the LEM, from a camera mounted at the front of the craft. The Atari "Lunar Lander" ROM and MacMame Emulator rest in the centrally located computer (Mac mini) console connected to two Atari joysticks. This emulated software system allows the astronauts to control the altitude and thrust movement of the LEM specifically for landing. This software also supports a landing abort feature.

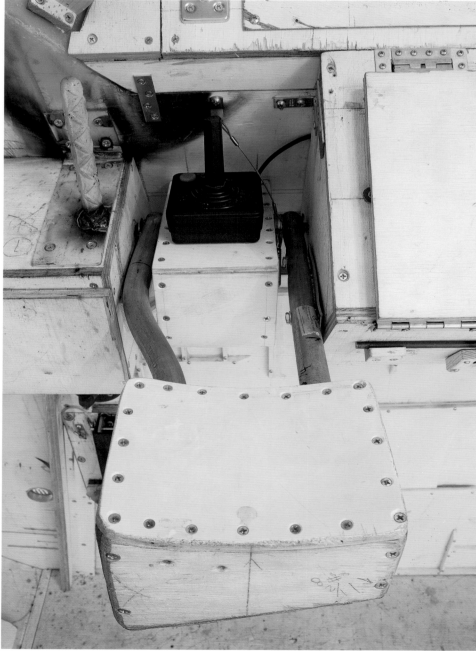

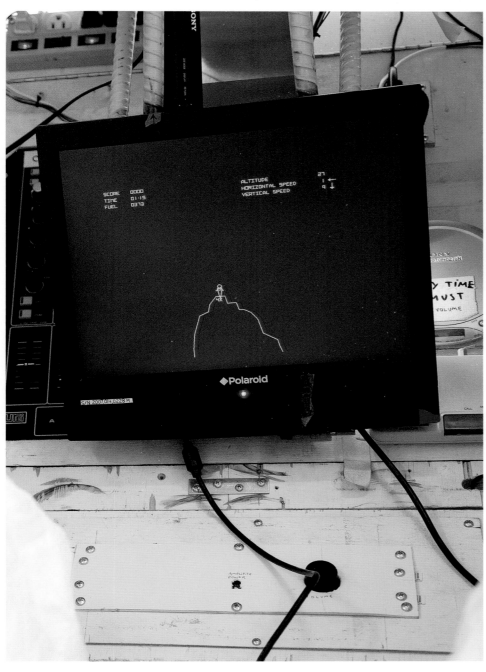

INSTRUMENT PANEL

The instrument panel is the viewing center of the LEM. It contains a controller that allows astronauts to switch from the exterior TV camera to the Rendezvous Radar Antenna (RRA). A second monitor also provides a real-time readout of the LEM's altitude, attitude, and horizontal and vertical speed. If necessary, the Lunar Module Pilot (LMP) can take over from the onboard navigation computer and manually fly the craft from this position. This became necessary during the *Apollo 11* mission, when an error caused the computer to select a landing site in the midst of a boulder-strewn crater. It is also necessary during the final stages of docking procedures.

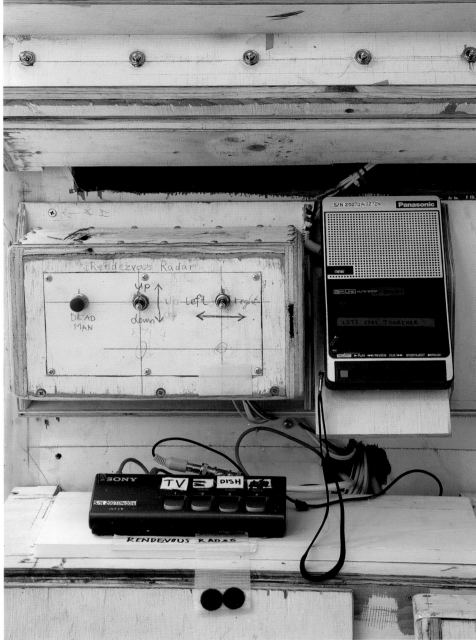

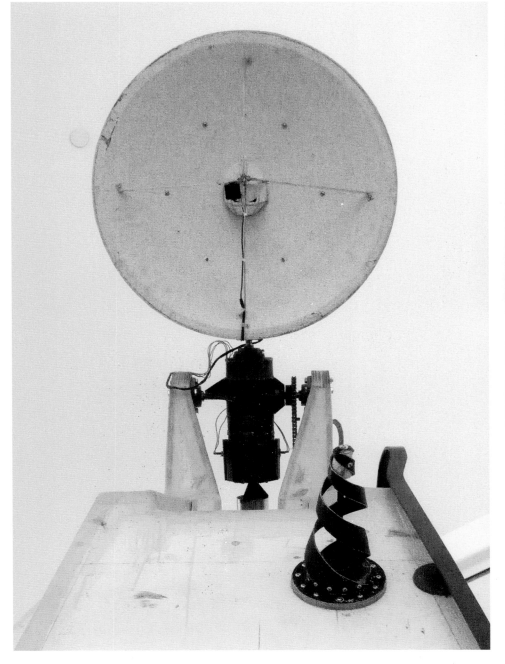

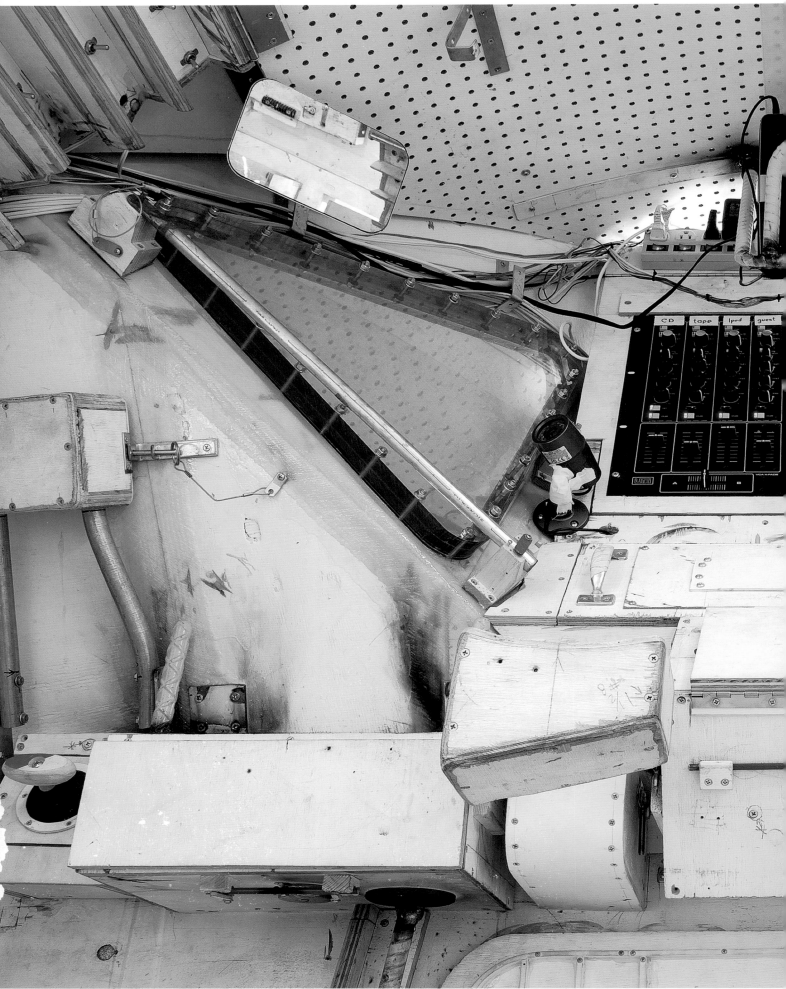

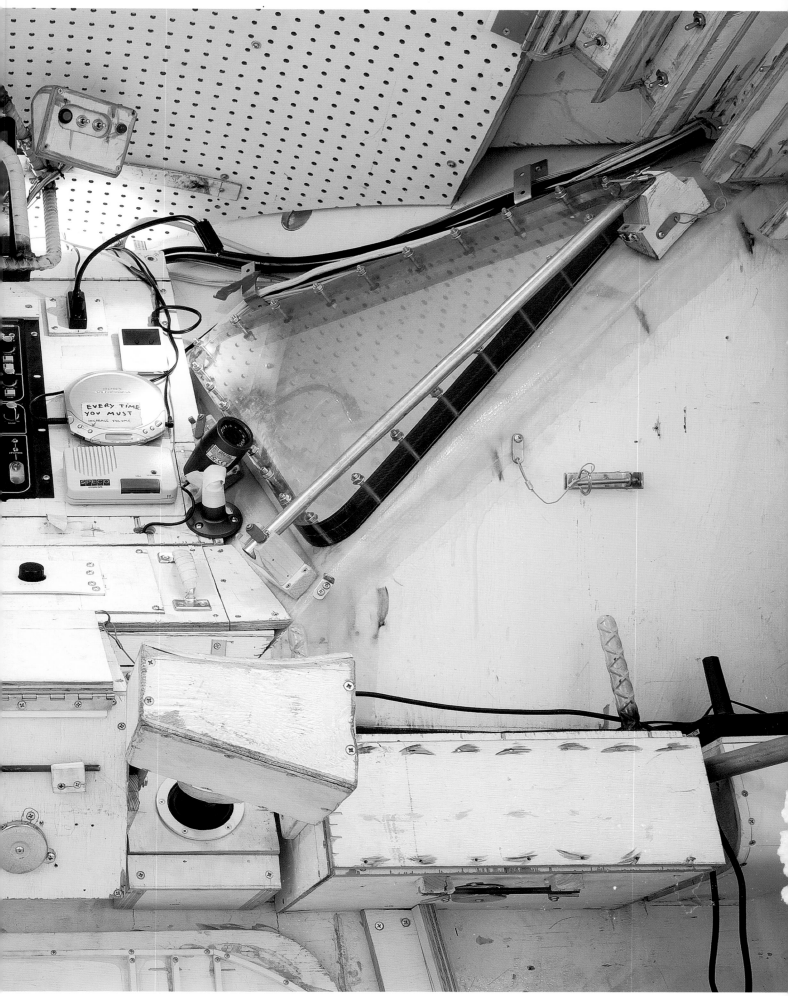

SOUND SYSTEM

Astronauts activate the sound system during Flight Plan activities and communications with Mission Control. Included in the system are a Panasonic Slim Line cassette recorder, with a cassette tape of Al Green's "Let's Stay Together," a UREI Soundcraft 1603 DJ mixer, a portable Sony Discman, left and right MFX speakers with Crash Bar, and an iPod (20 GB, White).

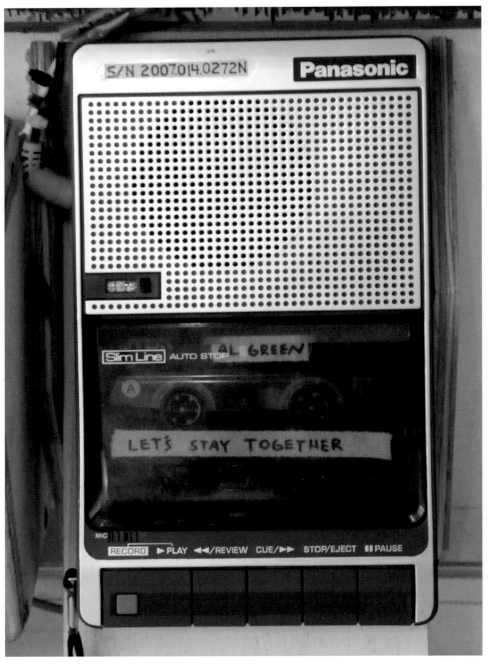

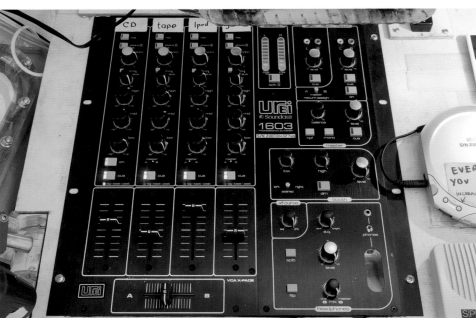

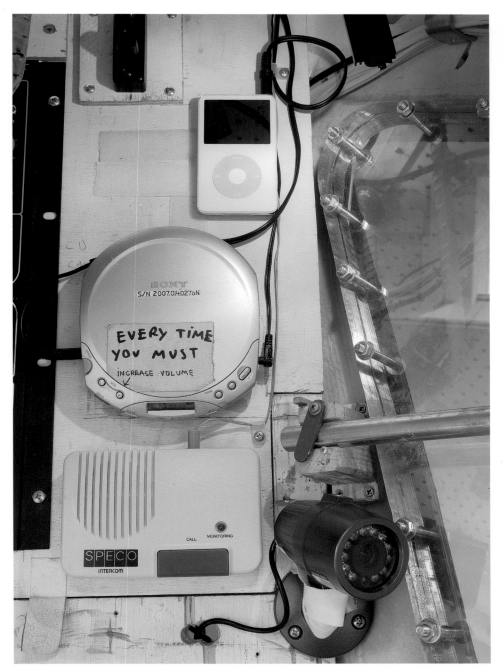

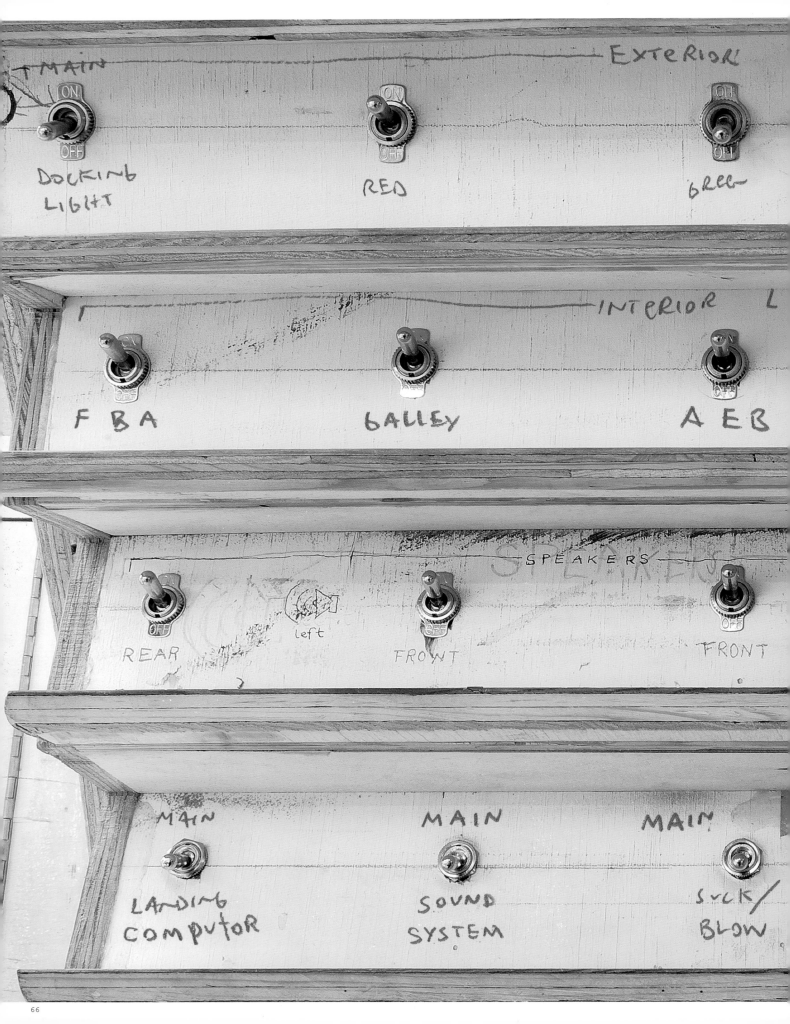

MAIN ON ON EXTERIOR OFF

DOCKING RED GREE
LIGHT

INTERIOR L

F B A GALLEY A E B

SPEAKERS

OFF left FRONT OFF FRONT

REAR

MAIN MAIN MAIN

LANDING SOUND SUCK/
COMPUTOR SYSTEM BLOW

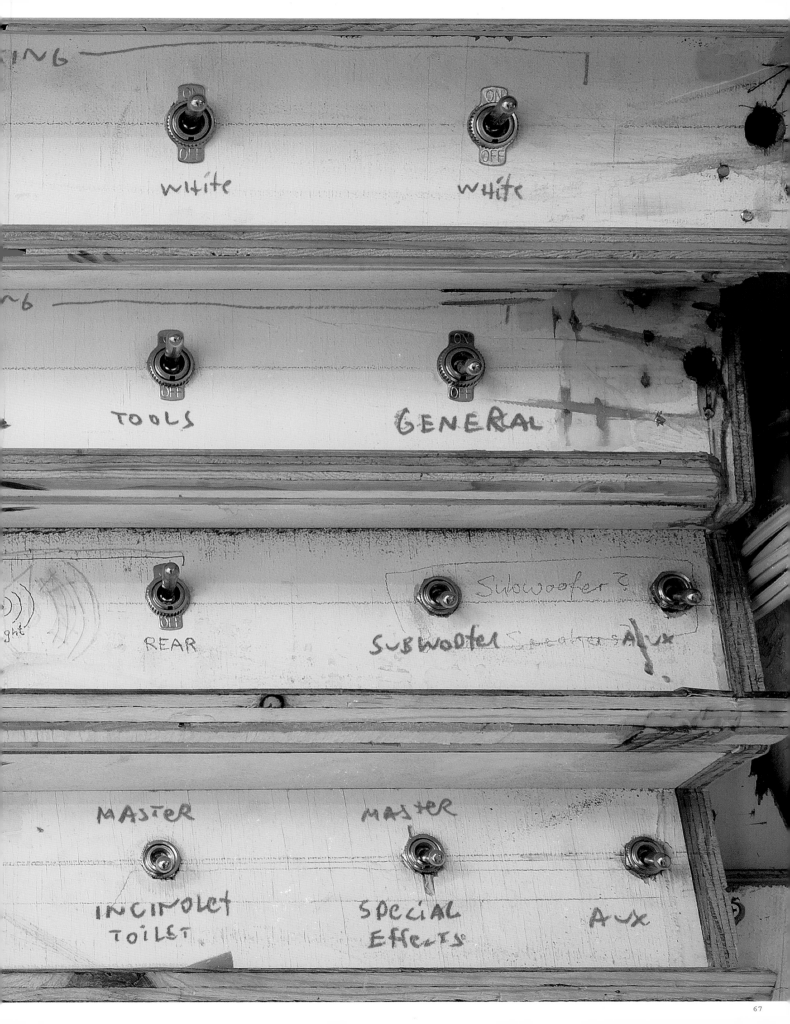

STOWAGE (STW)

In order to provide for the comfort and safety of the astronauts, the LEM is equipped with first-aid and hygiene supplies. All of the following designs were developed in response to comments from the crewmen on previous missions, including eyewash, bandages, a dental kit, and Kleenex.

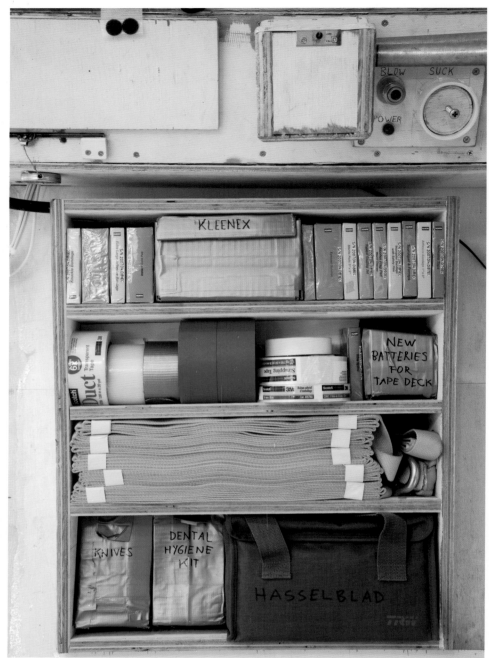

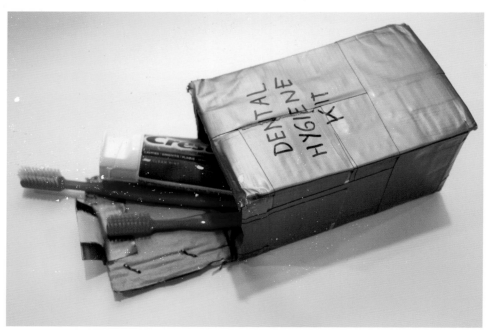

NORTH

Cool Jel
Topical Cooling Jel

* Cools and soothes minor burns, sun burns, scalds and abrasions
* Moisturizes
* Forms a protective barrier

Six—Packets, 1/8 oz (3.5 g) ANSI Z308.1-2003

W113198
EXP 05/11

02-11-55

NEW BATTERIES FOR DECK TAPE

Eyewash Solution

NORTH

Eyewash Solution
Sterile Buffered Eyewash

One Bottle, 1 fl. oz (30 mL) Purpose
 Eyewash

Drug Facts
Active Ingredient
Purified water 98.5%

Uses
For flushing the eye to remove loose foreign material or potassium, or chlorinated water

Warnings
For external use only

02-06-99

1.41 in x 2160 in (60 yd) 36 mm x 55 m
Strapping Tape
Scotch

Scotch™ 3M Ruban adhésif
 d'emballage
24 mm x 55 m Cat. 8957NA

Sterile Pads 3" x 3"

NORTH

Sterile
Pads

Four—Pads
3" x 3" (7.62 cm x 7.62 cm)
ANSI Z308.1-2003

W121290

02-04-30

AFT EQUIPMENT ASSEMBLY (AEA)

In order to help ensure the astronauts' mental well-being, a bed and library are onboard. Titles include classics such as *Ulysses*, *Sex and Destiny*, and *Remembrance of Things Past*, as well as the *Woman's Almanac*.

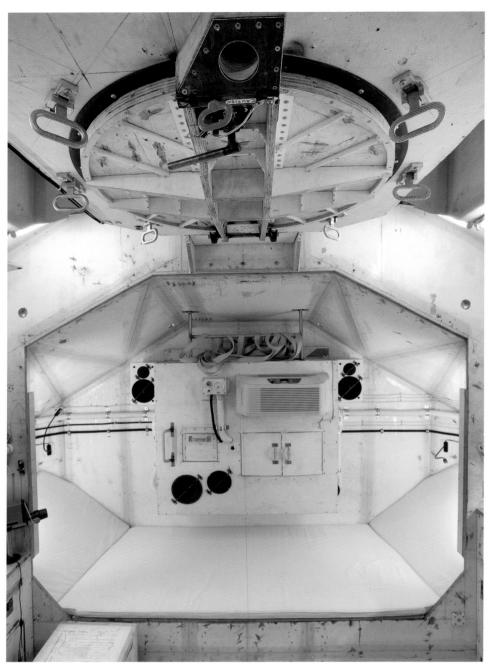

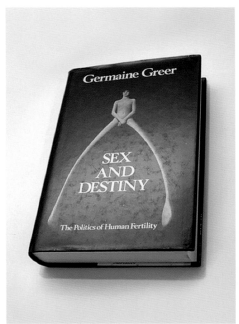

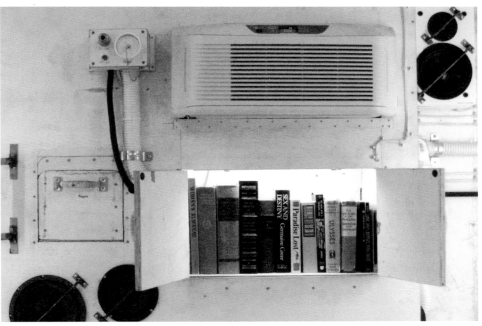

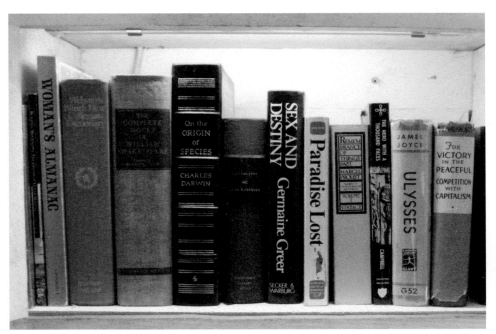

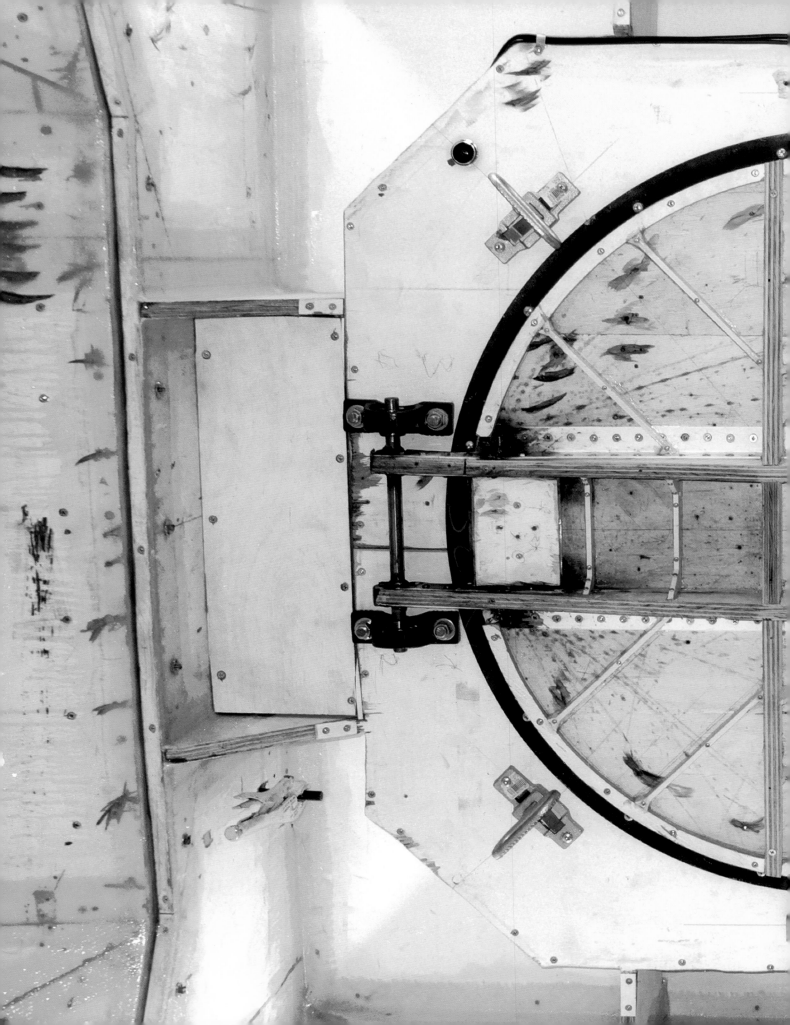

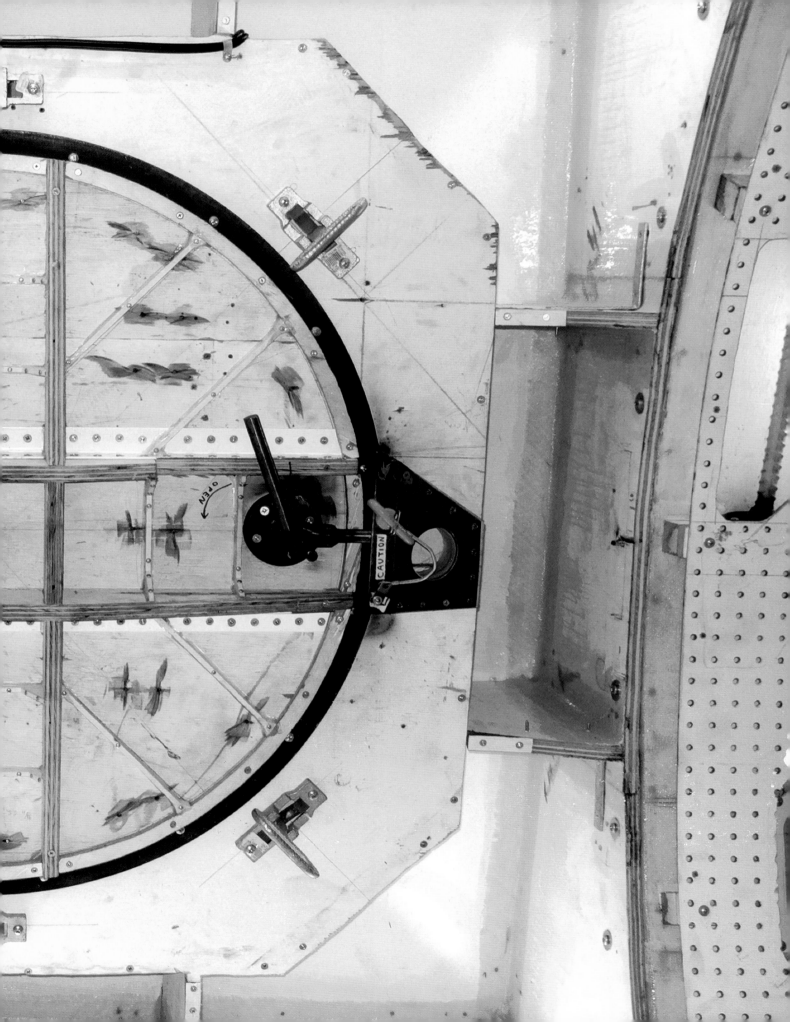

DOCKING HATCH

The Docking Hatch provides a pressurized link and passage between the Command Service Module (CSM) and the Ascent Stage (AS), used by the astronauts after docking and during translunar orbit. The earliest NASA specs for the LEM called for two hatches, an upper and a forward hatch, with both being usable as docking ports. After several iterations, this design was abandoned in favor of a square forward hatch and a single circular docking hatch at the top of the aft cargo hold.

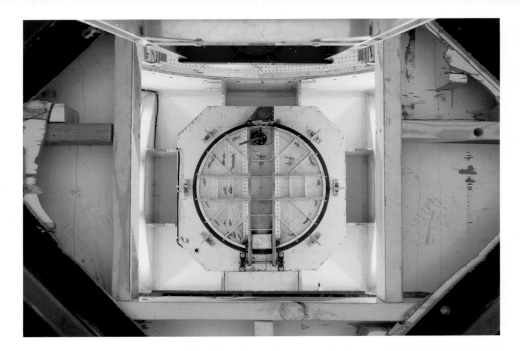

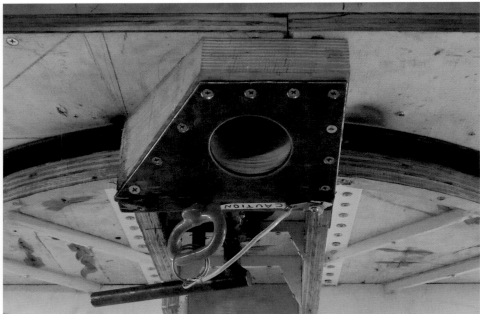

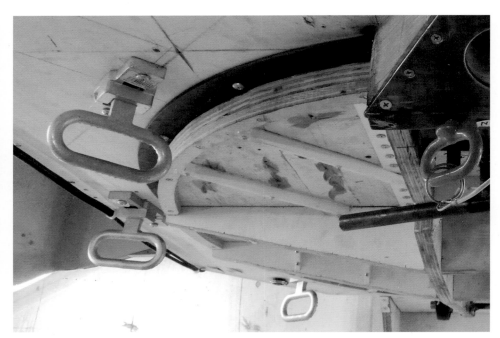

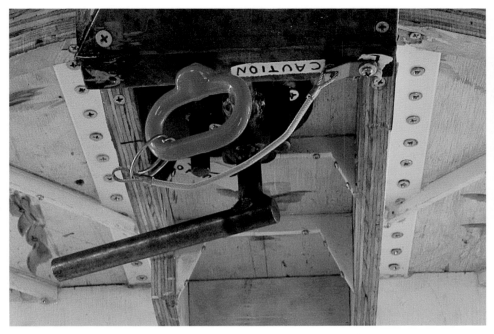

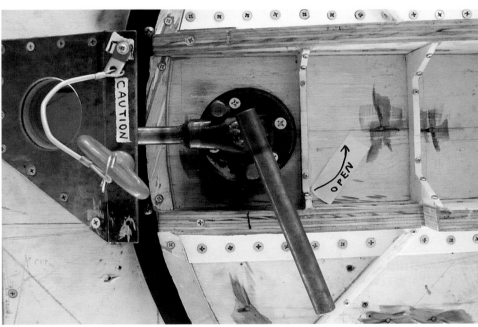

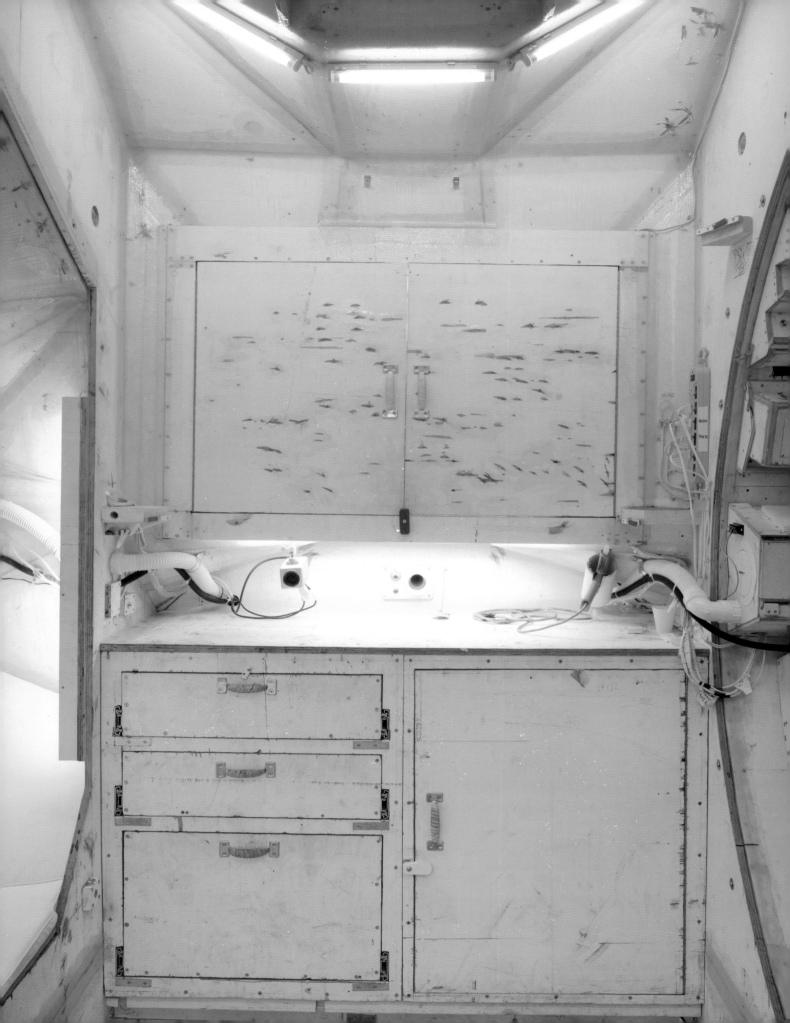

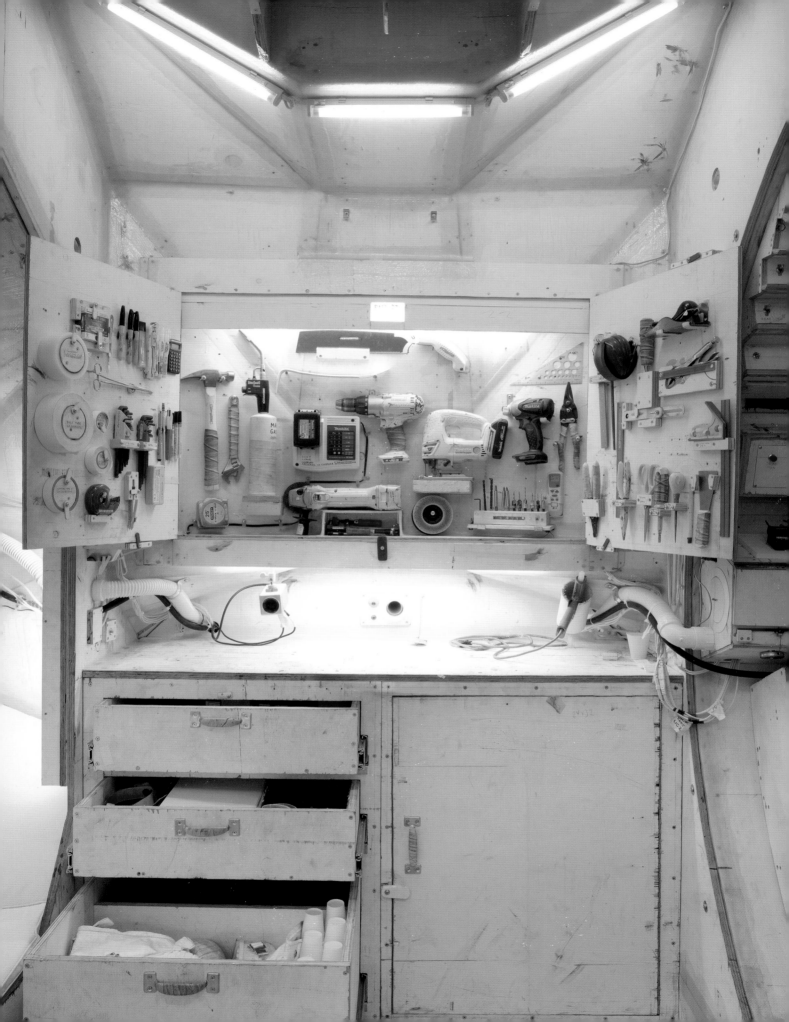

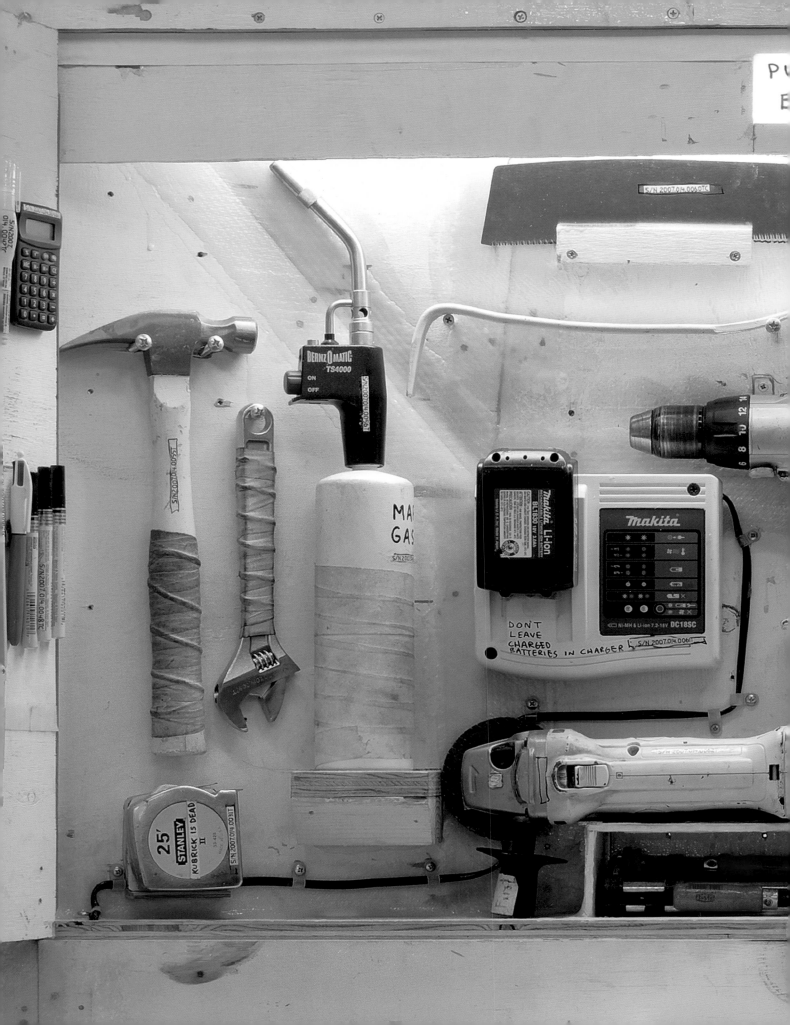

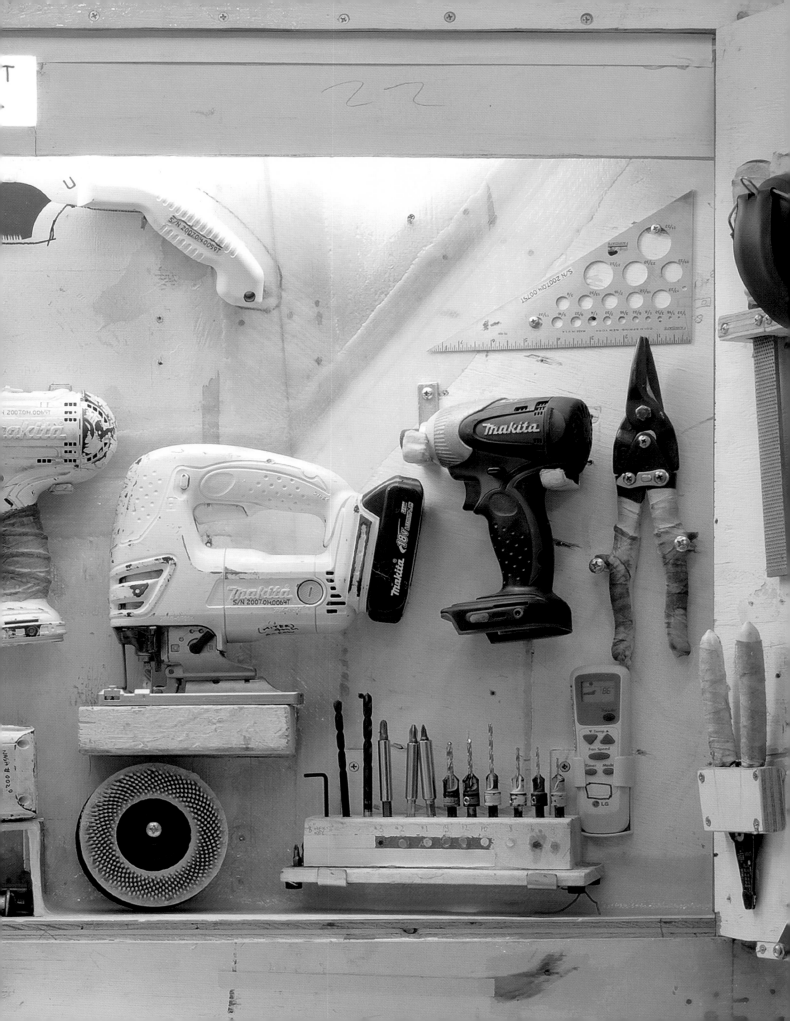

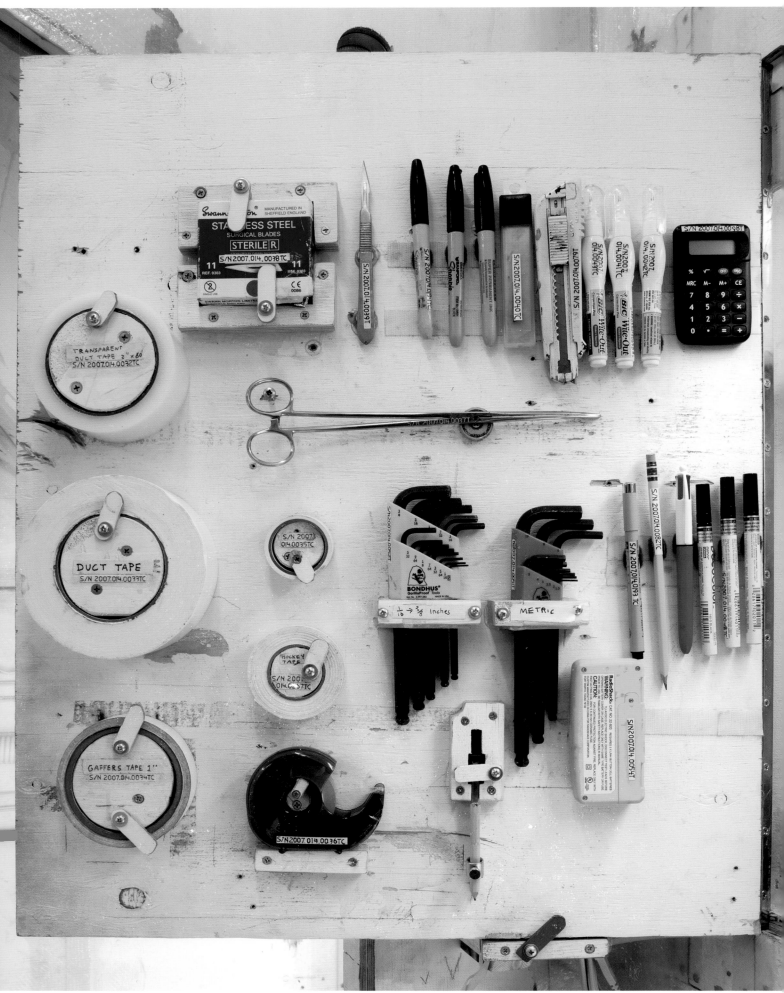

S/N 2007.014.0052T

BONDHUS®
GorillaProof Tools
Pat. No. 3,997,053 MADE IN USA

1/16 → 3/8 Inches

GAFFERS TAPE 1''
S/N 2007.014.0034TC

S/N 2007.014.0082TC

S/N 2007.014.0193 TC

S/N 2007.014.0048TC

S/N2007.014.0036TC

Swann-Morton® MANUFACTURED IN
SHEFFIELD ENGLAND

STAINLESS STEEL
SURGICAL BLADES

STERILE R

11 S/N 2007.014.0038TC 11

REF. 0303 REF. 0303

SINGLE USE CE 0086

SWANN MORTON LIMITED
SHEFFIELD ENGLAND

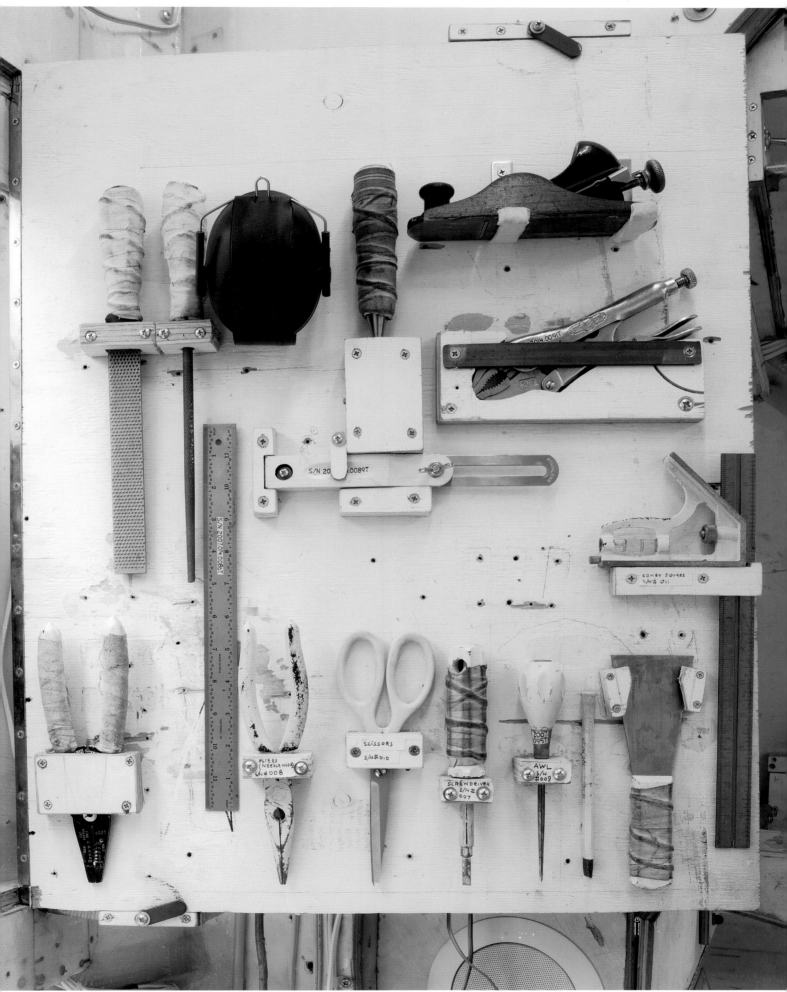

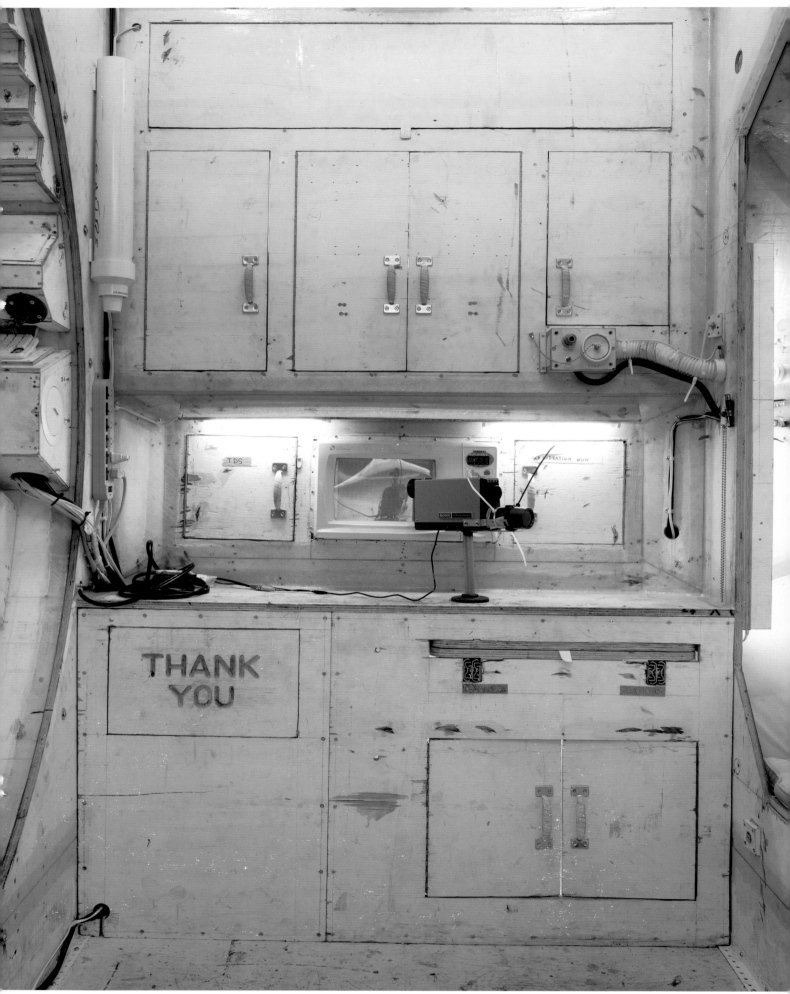

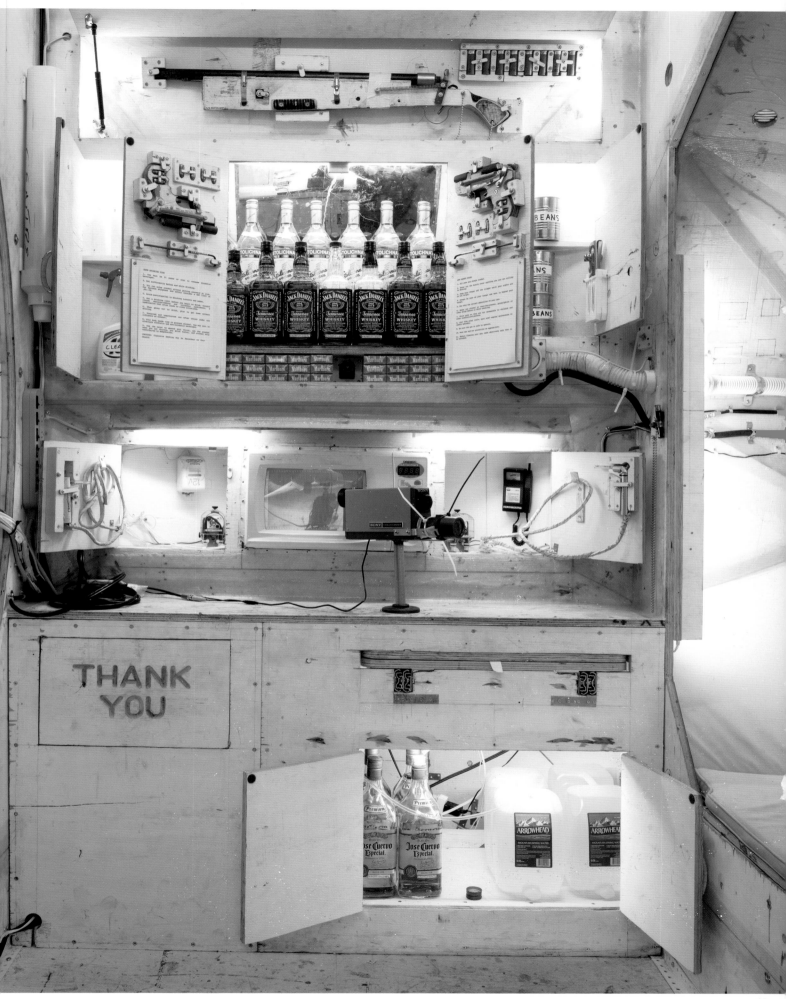

ALCOHOL TOBACCO FIREARMS (ATF) CABINET

The physical well-being of the astronauts is as important as any other aspect of the lunar landing mission. To that end, the astronauts have been provided with an Alcohol Tobacco Firearms (ATF) cabinet stocked with various consumables—beans, vodka, whiskey, water, Marlboro cigarettes, etc. For security on the mission, the astronauts have been provided with two handguns and a shotgun. The guns have been used on several earlier missions, but have here been provided with six individually numbered rounds each. The shotgun, which is above the cabinet, comes with fifteen rounds of Full Metal Jacket ammo.

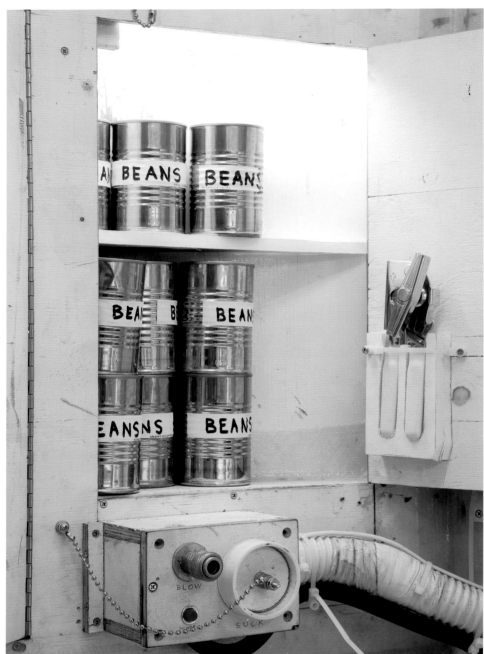

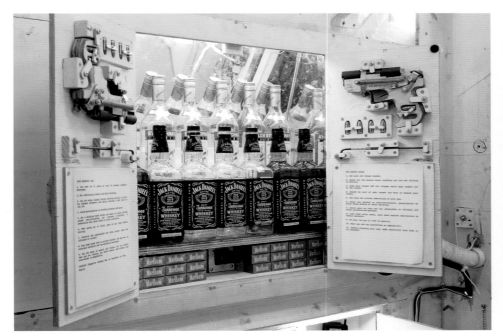

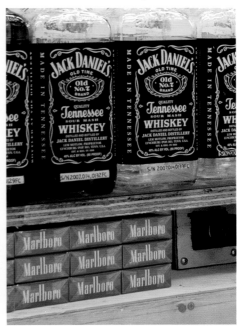

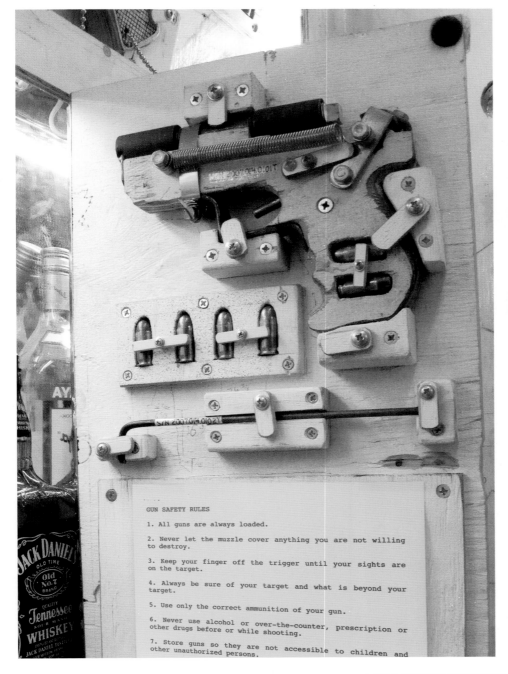

GUN SAFETY RULES

1. All guns are always loaded.

2. Never let the muzzle cover anything you are not willing to destroy.

3. Keep your finger off the trigger until your sights are on the target.

4. Always be sure of your target and what is beyond your target.

5. Use only the correct ammunition of your gun.

6. Never use alcohol or over-the-counter, prescription or other drugs before or while shooting.

7. Store guns so they are not accessible to children and other unauthorized persons.

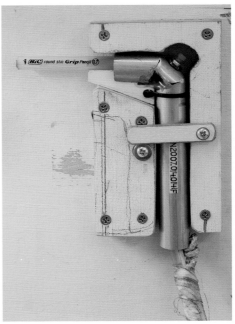

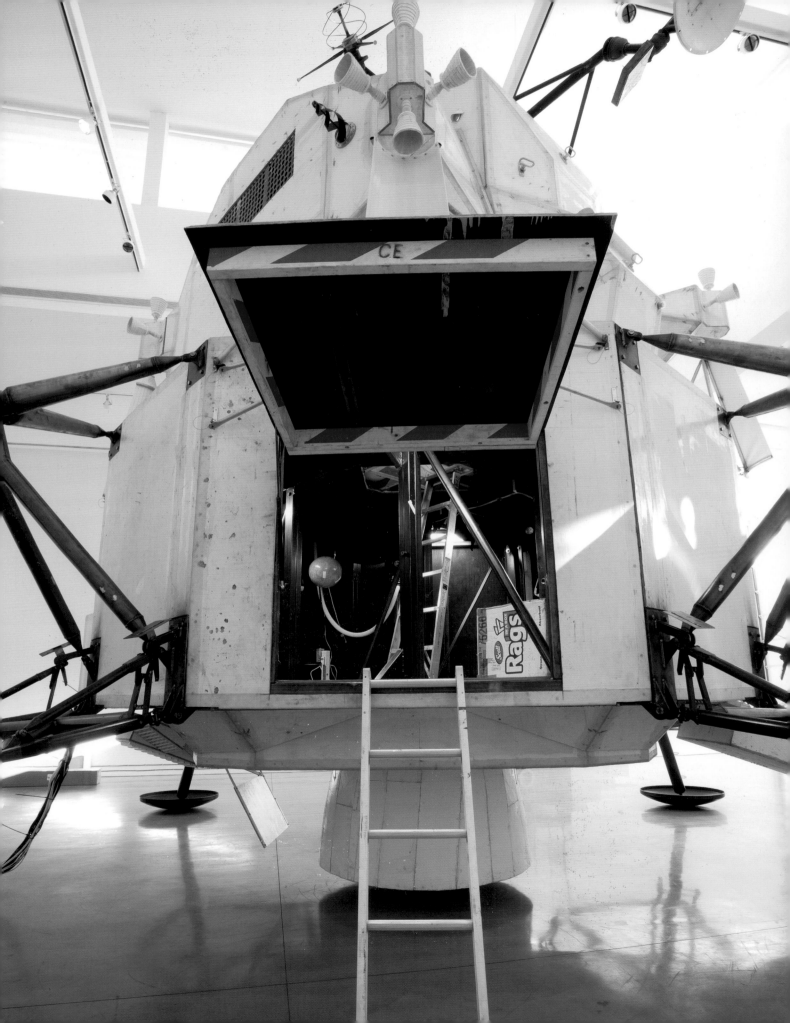

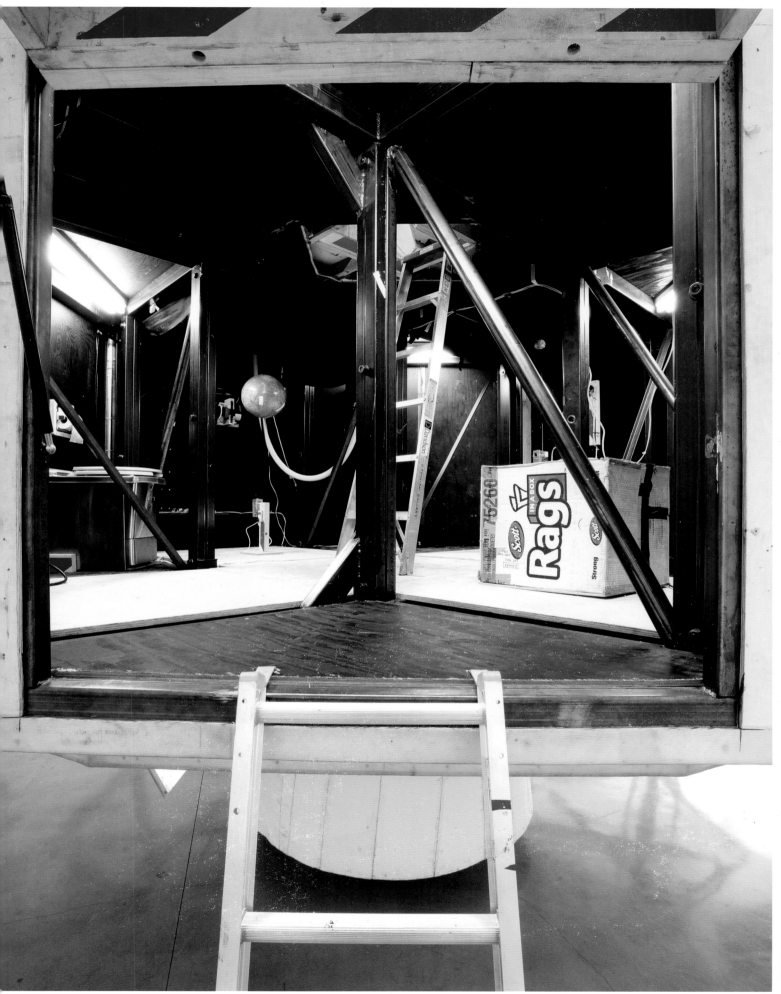

DESCENT STAGE (DS)

The Descent Stage (DS) contains an incinerating toilet, a pump and a vacuum for the suck-blow system, and special effects, including Earth, Moon, and Darkness/Stars. Both Earth and Moon approach and recede as the mission progresses. Three cameras transmit live images back to Mission Control Center (MCC), documenting the Earth orbit, Translunar Injection (TLI), lunar orbit, Transearth Injection (TEI) and reentry. Another camera provides a view of the incinerating toilet.

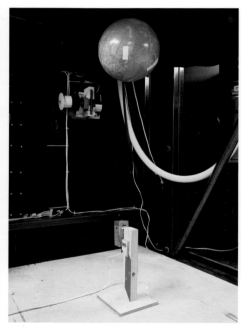

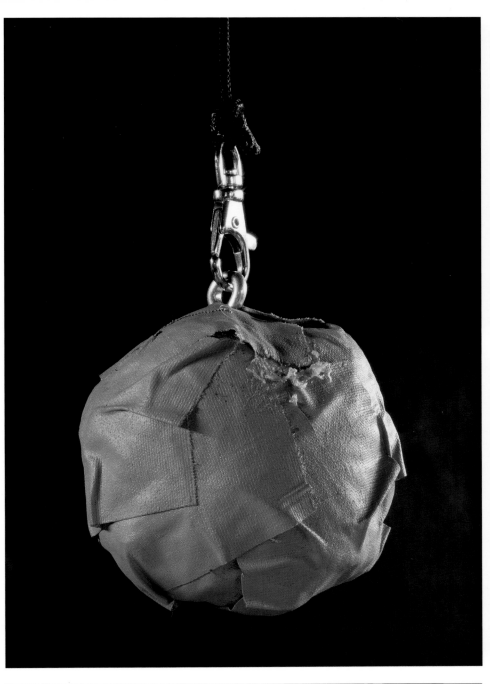

WASTE MANAGEMENT SYSTEM (WMS)

One of the most difficult tasks confronting engineers on the Apollo project was the Waste Management System (WMS) for the zero-gravity environment. For some years, it was even said that the primary obstacle to women participating in the program was plumbing. Early solutions included plastic bags with adhesive around the mouth to hold them in place during use. These were then sealed and placed in receptacles on the Ascent Stage (AS). Other solutions explored toilet systems with fans to generate suction sufficient to detach the bolus from the anus. For this mission, an incineration system is used for solid waste disposal.

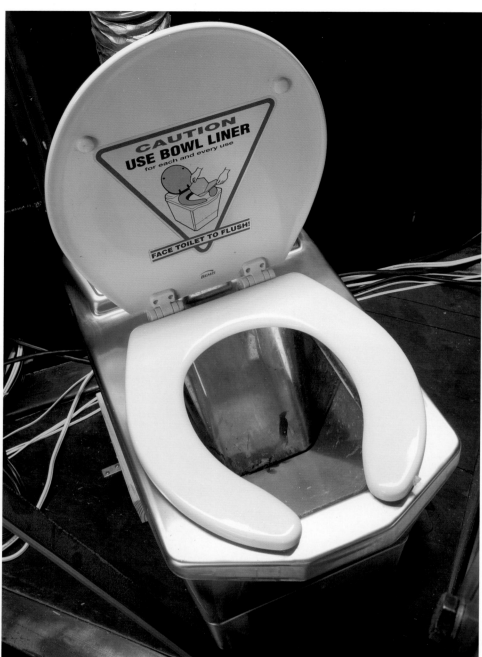

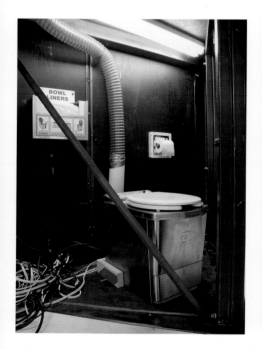

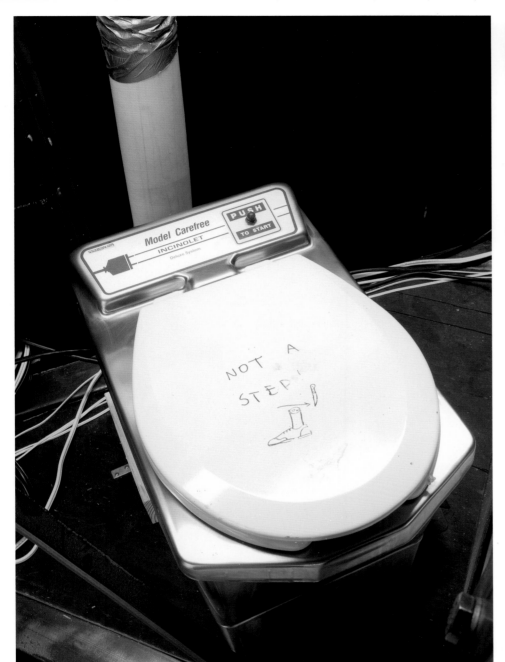

1. PUT BOWL LINER IN BOWL BEFORE EACH & EVERY USE.

2. FLUSH WITH FOOT PEDAL.

3. PUSH BUTTON TO START.

4. EMPTY ASHPAN WEEKLY.

INCINOLET THAT ELECTRIC TOILET

RESEARCH PRODUCTS / Blankenship • U.S.A. (214) 358-4238 • 1-800-527-5551 • CANADA 1-800-263-0379

SUCK-BLOW

There are four different suck-blow outlets distributed throughout the Ascent Stage (AS), all of which are attached to the air compressor and vacuum stored in the Descent Stage (DS). The suck-blow wand assembly is an evolution of a system developed for earlier projects. In its current iteration, the system allows the astronauts to direct air flow or vacuum throughout the entire AS. The system has been provided for maintenance as well as hygiene, both mental and physical.

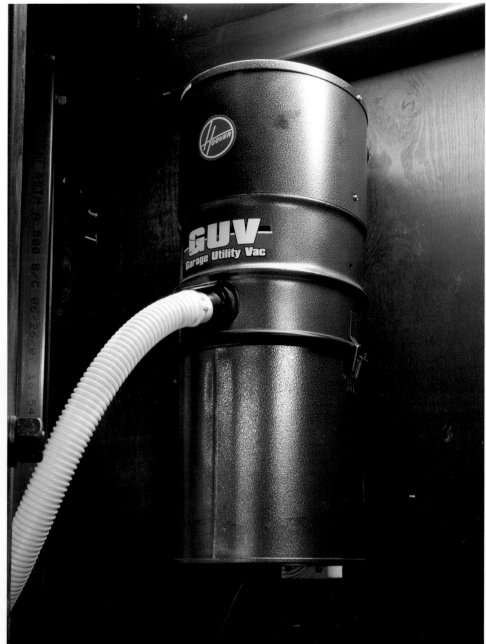

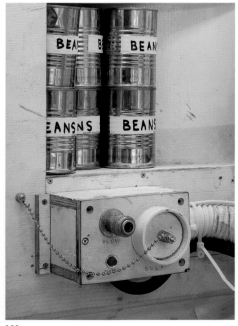

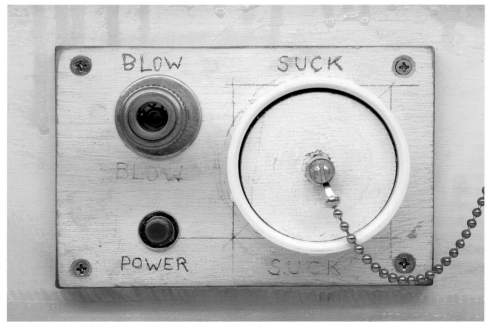

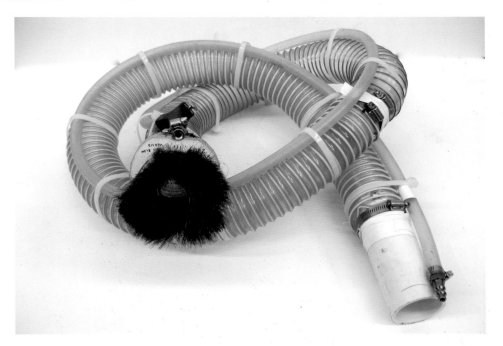

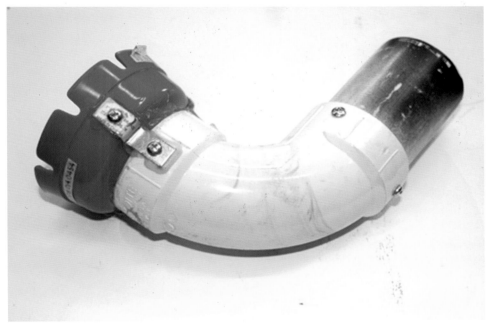

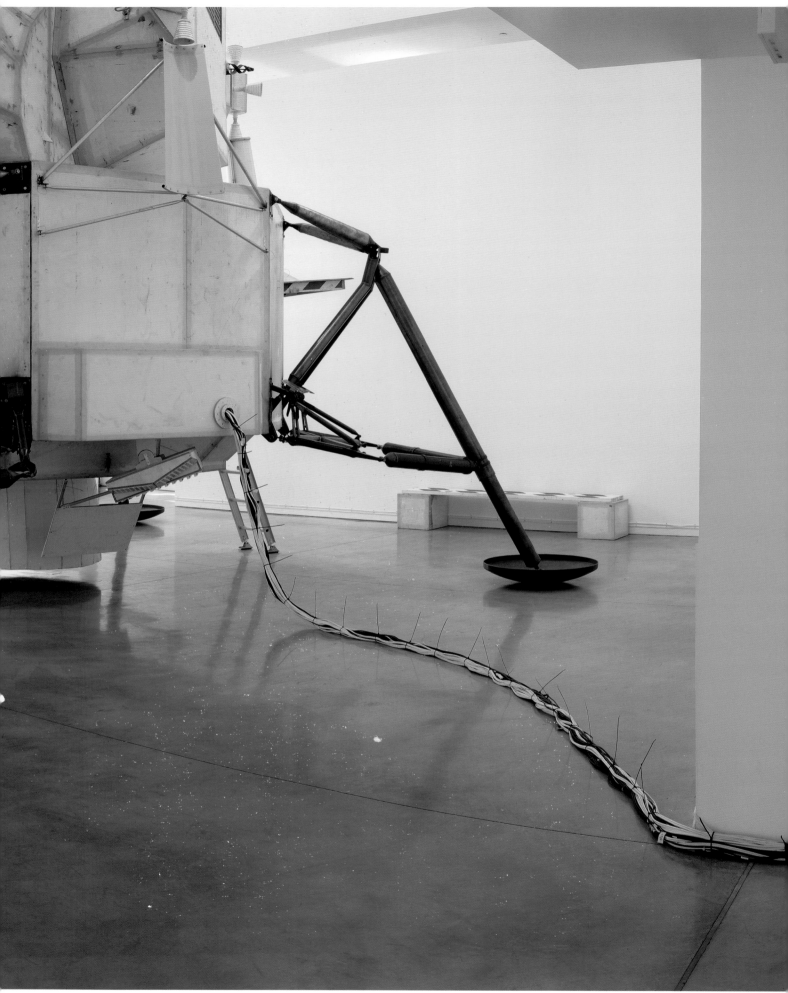

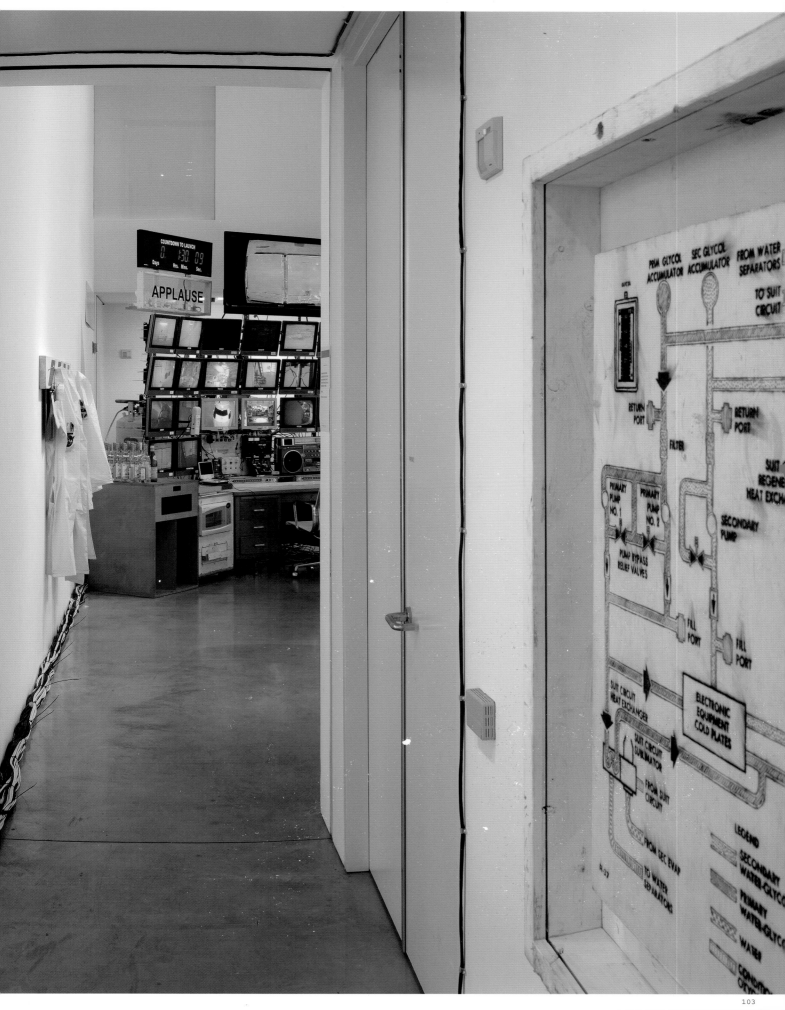

THIS PAGE INTENTIONALLY LEFT BLANK.

Mission Control

Mission Control Center (MCC) is the nerve center and, in many ways, the brain of the lunar mission, a team of experts charged with understanding all the myriad parts of the Lunar Excursion Module (LEM) and making them work together as a unified whole. Although their jobs are not as glamorous or as obviously exciting as the astronauts', they are just as essential to the mission's success. The LEM represents the highest level of technical, scientific, and engineering achievement ever assembled by mankind. It is an immensely complex network of systems, each of which is, in turn, made up of a nested series of equally complex subsystems. Because of the mandate that no single failure can result in mission abort, redundancy is a necessity. Many parts, such as flight controls, computer guidance systems, and flight systems, are doubled, thus increasing the ultimate complexity of the LEM. The Apollo Guidance Computer (AGC), for instance, requires an 1,840-page manual, plus a forty-page memo describing how to issue commands. This is doubled by a similar system, known as the Abort Guidance System (AGS), which requires similarly robust documentation. Because of this unavoidable complexity, the mission, and the LEM itself, is beyond the ability of any one person, or even a single group, to comprehend. As a result, while the astronauts actually make the journey from the Earth to the Moon and execute all operations, they could not do so without a team working in tandem on the ground. MCC is the brain to the astronaut's hands and guts.

Also, while the astronauts are the actors on the scene, ideally the lunar landing is a carefully thought-out series of events that deviate as little as possible from the predetermined script, known as the Flight Plan (FP). MCC provides a decision-making backup and action protocol that helps ensure that the FP is followed as well as directing how it is documented. All of the feeds from the twenty-four cameras arrayed inside and around the LEM run into MCC, one per monitor. All sound effects are controlled here, as well as the special effects. The astronauts may be going to the Moon, but men and women on the ground determine what the first draft of history looks and sounds like.

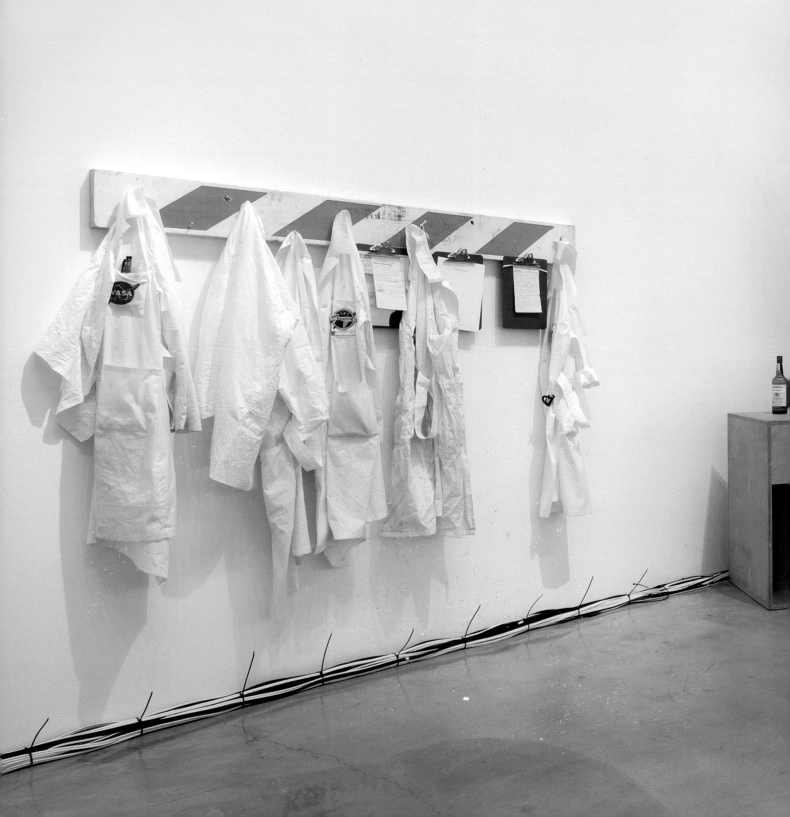

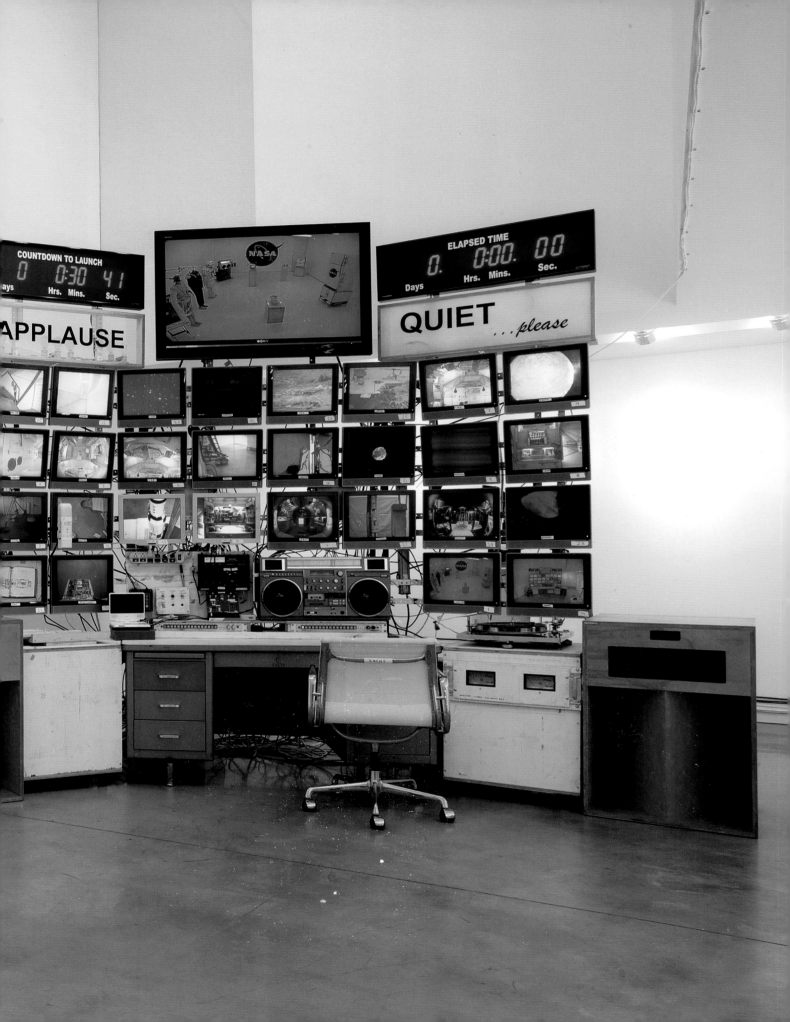

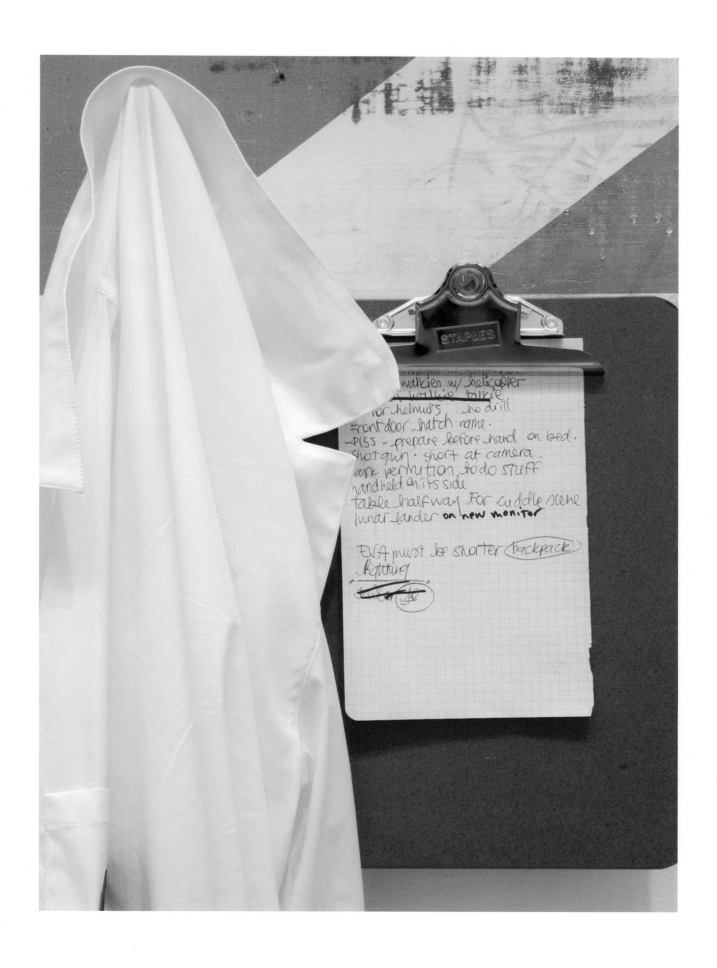

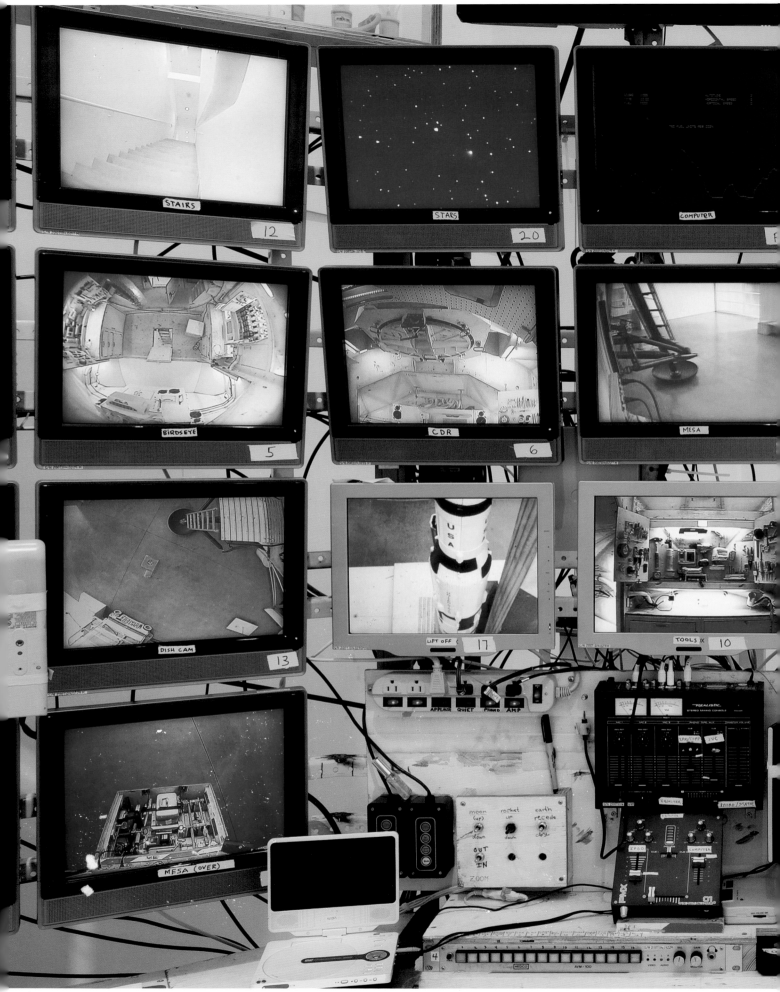

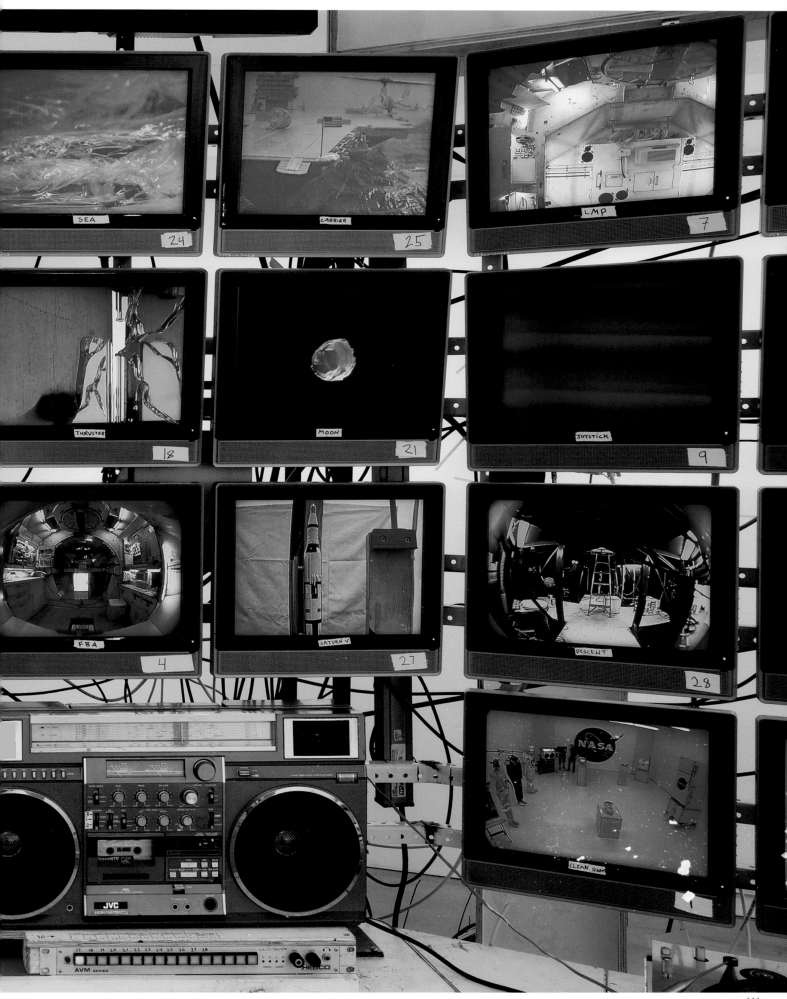

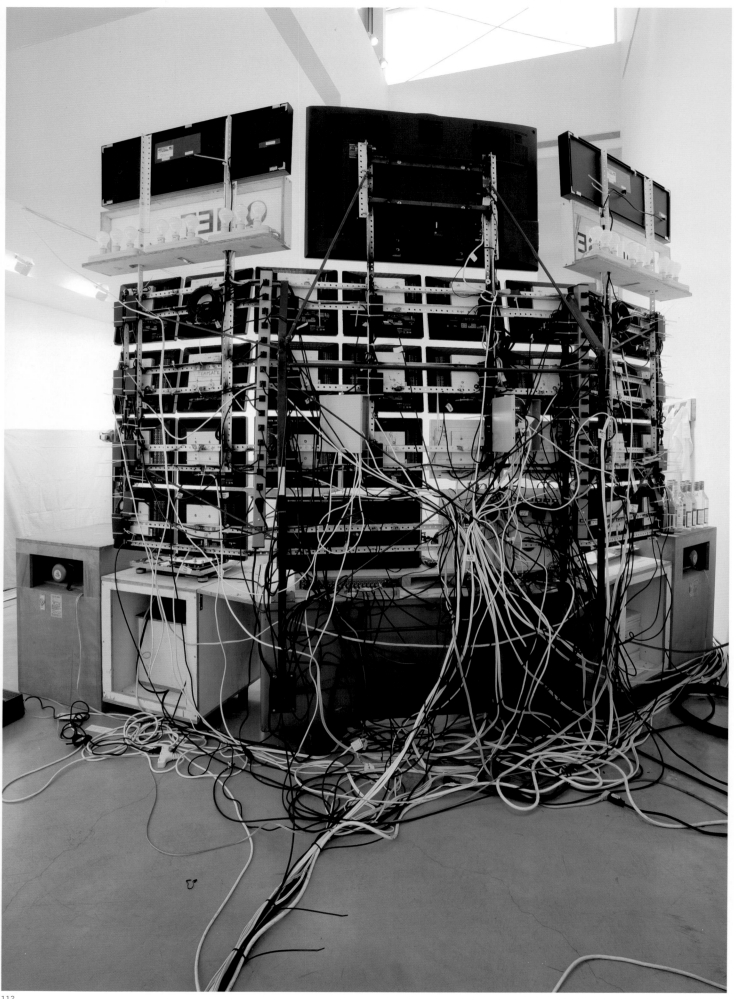

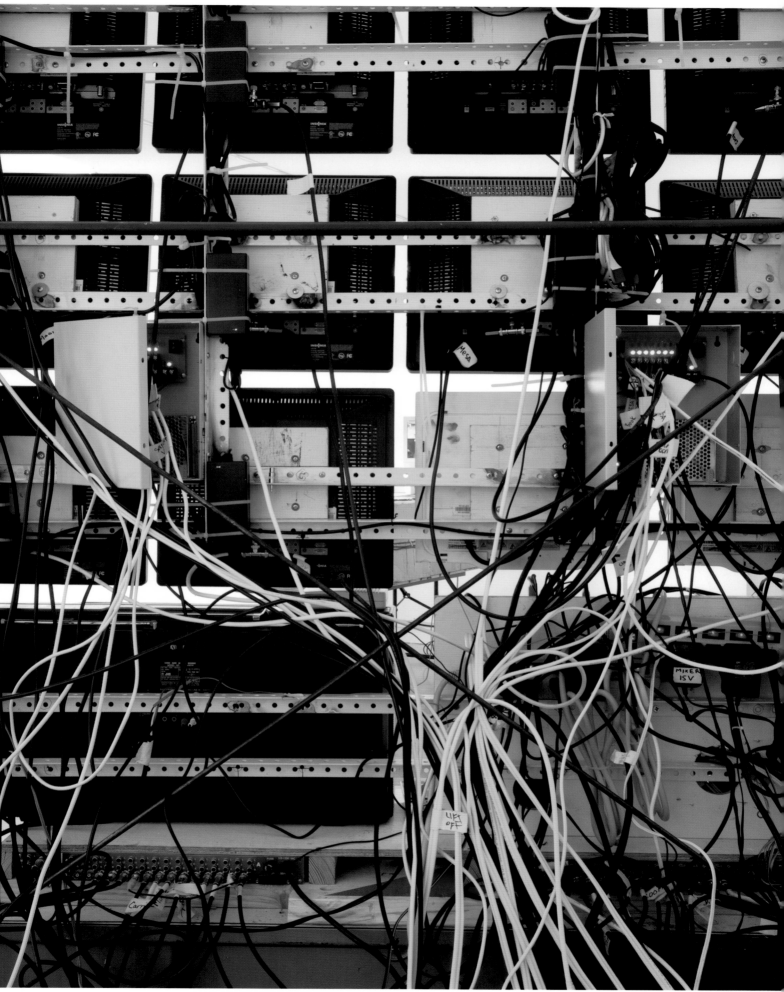

HOT-COLD OVEN

The temperatures in outer space fluctuate
wildly from -212 to +248 degrees Farenheit.
The crew's survival and the mission's success
depends on being able to withstand these
stresses. The Hot-Cold Oven represents these
extreme temperatures. Liquid nitrogen is used
to serve cocktails at temperatures well below
the freezing point of water. The microwave
oven is the engine that supports the Hot Nuts
Delivery System (HNDS).

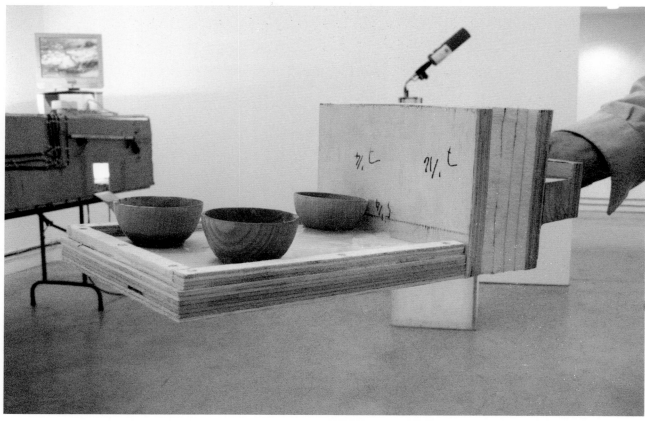

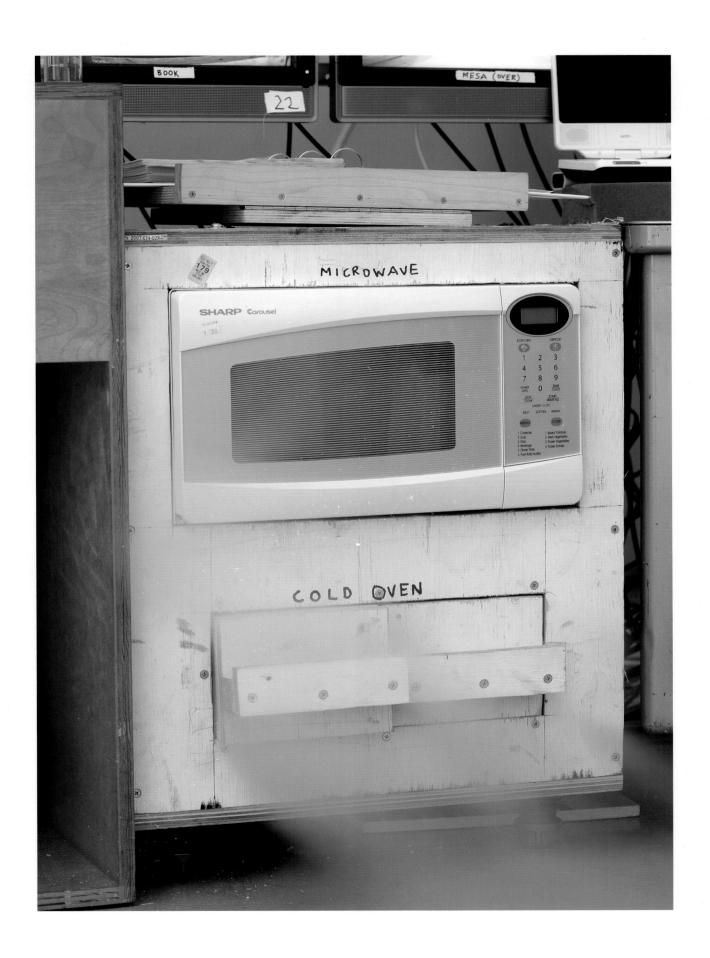

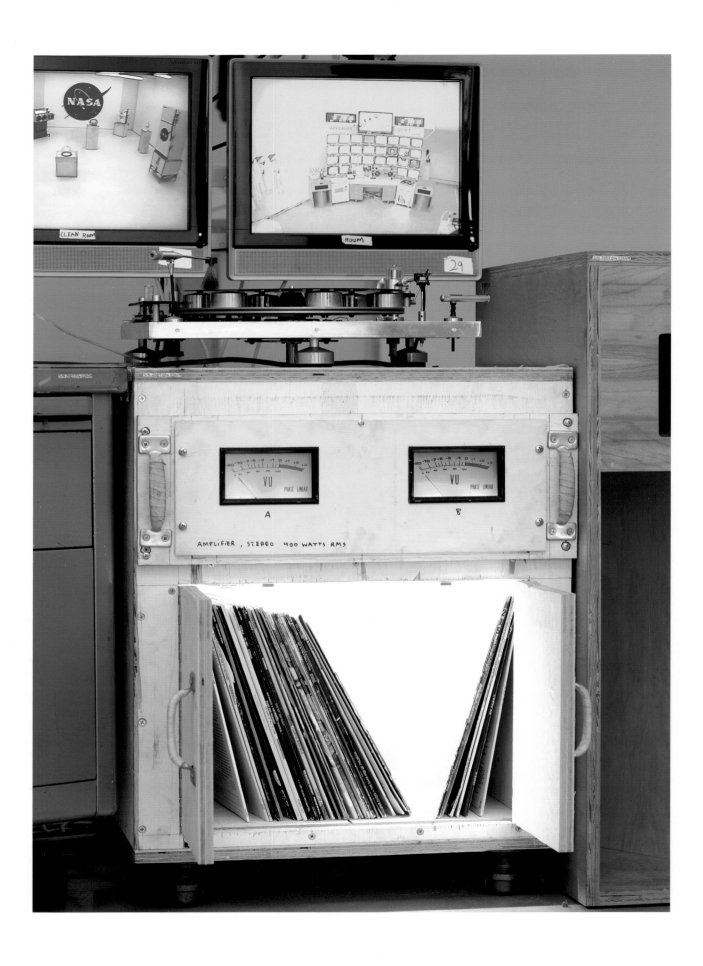

A

AMPLIFIER , STEREO 400 WATTS R.M.S.

CAMERA SYSTEM

Twenty-four cameras placed through-
out the interior and exterior of
the Lunar Excursion Module (LEM)
allow every aspect of the mission,
including the Extravehicular
Activities (EVA), to be monitored
by two engineers at MCC. Each
camera can be toggled on and off,
either individually or as a group.
The left video switcher has
sixteen buttons to switch between
camera views. The following page
shows the right video switcher,
which has thirteen more buttons
connecting to different camera
views.

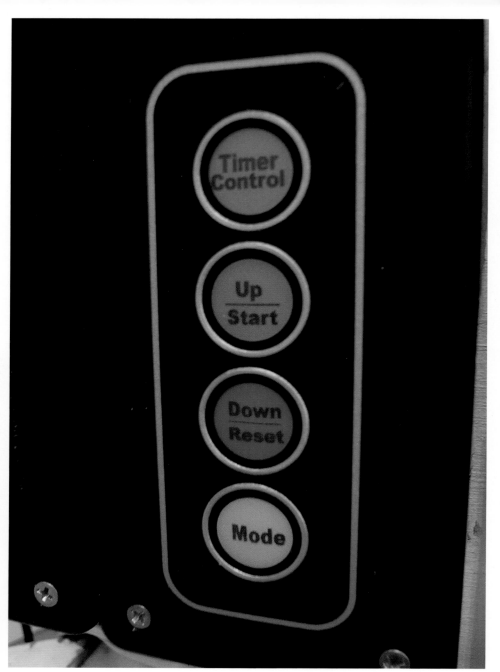

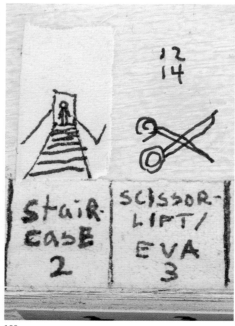

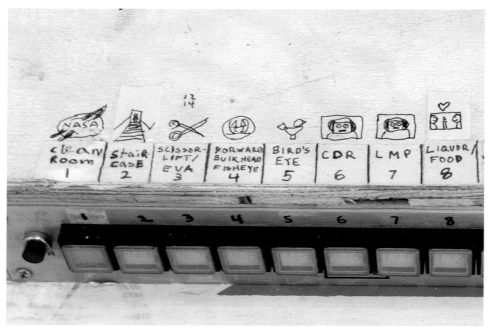

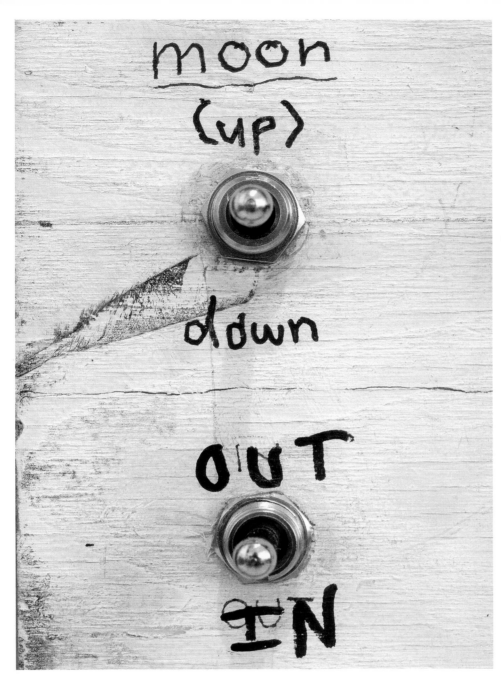

MCC AUDIOVISUAL

One of the most advanced portable sound systems ever made, the JVC (Japanese Victor Company) RC-M90 boom box is a design icon in its own right. It features separate knobs for tuning AM, FM, and shortwave radio stations, a VU meter, five-song index searching, FM mic mixing input, Super ANRS noise reduction, and a full-logic tape control system. The FM knob, the AUX output, and the volume control are the main features used in MCC. The first is utilized to find an empty station, which provides static. The AUX output is then used to feed the static into the main soundboard during takeoff and other engine-firing sequences.

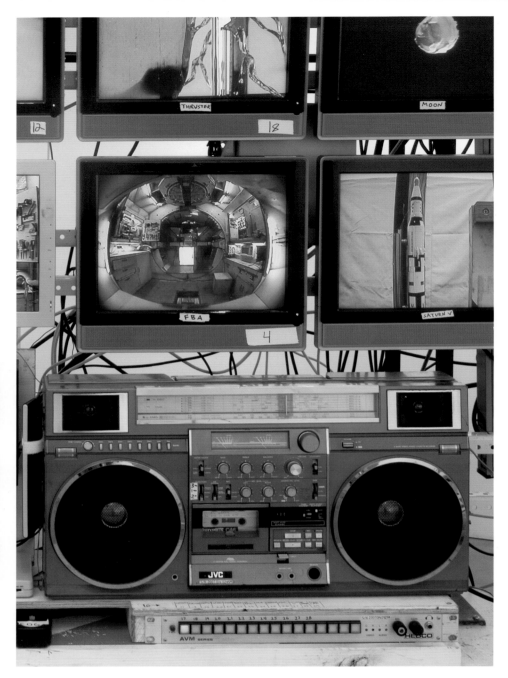

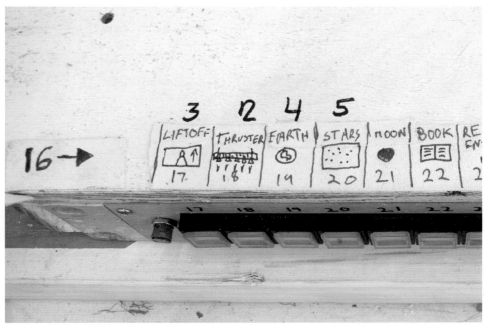

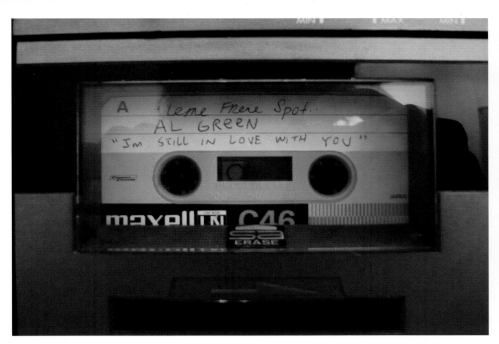

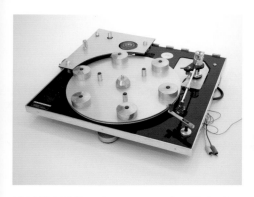

1964 TRANSCRIPTOR HYDRAULIC REFERENCE TURNTABLE WITH VESTIGIAL ARM

Designed by David Gammon, the Transcriptor Hydraulic Reference turntable was built to meet the rigorous criteria associated with studio use and audio testing. It is philosophically the twin of the LEM in that its design includes nothing extraneous to its function.

ALBUM, "STARS AND STRIPES FOREVER," COMPOSED BY JOHN PHILIP SOUSA

The composer's father, a trombonist in the U.S. Marines Marching Band, enrolled him in the Marines when John was only thirteen. The compositions of the March King are the quintessential sound of American military and patriotic music. It is difficult to imagine a more appropriate song to celebrate the first American steps on the Moon than his "Stars and Stripes Forever." Sousa was a favorite of astronaut Frank Borman, who listened to one of his recordings before every mission.

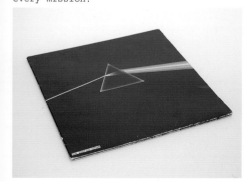

ALBUM, "DARK SIDE OF THE MOON," PINK FLOYD

This Pink Floyd album featured technological breakthroughs in both sound quality and the use of synthesizers in mainstream music. The song used for the mission during Transearth Injection (TEI) is "Breathe," also known, on early vinyl pressings, as "Breathe in the Air."

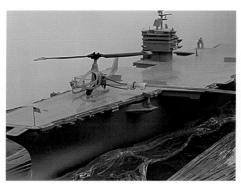

VERTIBIRD RESCUE CHOPPER AND SHIP

The VertiBird is used to lift the Command Module (CM) and astronauts out of the ocean and onto the deck of the *Enterprise* after splashdown. It has a twenty-one-inch arm with pitch control and a spindle that transfers power, which is supplied by four D batteries. The helicopter is controlled by a spring-lift assist and a two-lever throttle. The rescue team has been assembled using parts from two different teams. The orange helicopter is from the Astronaut Rescue set, while the command-and-control base is Police technology. The VertiBird demands considerable skill from operators, as in the event of a crash it must be laboriously reset by hand.

KLIPSCH LA SCALA

The La Scala was first designed in 1963 as a public-address system for Arkansas Republican gubernatorial candidate Winthrop Rockefeller. It has an unfinished birch plywood body and a folded horn woofer, which produces powerful bass using very little power.

HEADCO AZM 100

An all-analog video switcher, the Headco AZM 100 has been hand-modified by MCC—or Grumman ground crew—with mnemonic glyphs to aid with the choreography of cameras and the actions of astronauts on the lunar surface.

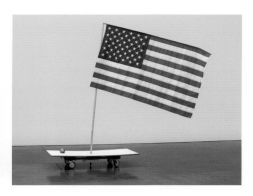

FLAG

The flag flown on the Moon had to overcome several difficulties, in terms of both design and politics. Astronauts have always been considered heroes, and more specifically, American heroes. Still, a U.N. treaty passed in 1967 stipulated that the Moon, like other celestial bodies, could not be claimed by any one nation. It was decided that an American flag should be left on the lunar surface, but that what was said by the astronauts should stress the international character of the mission. In order that the flag could be seen by television cameras, a folding flagpole assembly was designed. It was put on wheels so that it could easily be moved, and featured a crossbar from which the flag hung at the top, simulating a flag flying in a breeze. In the end, this simulated lunar wind proved to be prophetic, as the last thing one of the astronauts reported seeing was the flag being knocked over by the backblast from the Ascent Stage (AS) rockets. It is recommended that subsequent flags be planted further from the LEM to avoid this problem.

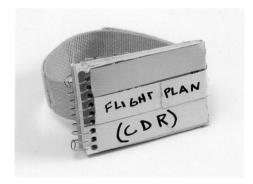

FLIGHT PLAN (FP)

The Flight Plan (FP) wrist manual contains every step of the mission written on a portable and specially reinforced reporter's notebook. It is held in place on the exterior of the Extravehicular Mobility Unit (EMU) with two-inch nylon lifting webbing. Pornographic material (20%) alternates with instructional content (80%) for mental-hygiene purposes.

Flight Plan

The Flight Plan (FP) is the outline and best-case scenario for the entire mission, a complete delineation of responsibility and authority for the mission. Every event leading up to, during, and after the lunar expedition has been timed and scheduled in order to achieve optimal crew health and safety, while at the same time maximizing the scientific value of the mission. Wherever possible, contingency plans have been put in place that take into account chance and provide for alternative courses of action. And while every system, insofar as possible, has built-in redundancies, in many cases the room for error, or deviation from the FP, is measured in minutes or even seconds. However, in many instances, because of engineering or human-safety concerns, it has been impossible to leave significant room for change. For instance, fuel, and thus engine burn-time, has been strictly measured because of weight considerations, so missing the lunar landing site by only a few seconds could easily result in a mission abort due to excess fuel use. In other situations, reviewing the correct response to a given situation would be as bad as an incorrect response, or no response at all, and the loss of seconds in reacting could result in catastrophic failure. Time is always the mission-critical factor. For these and other reasons, it is essential to follow the FP as closely as possible for the successful completion of the mission. The only appropriate reason for a change to the plan during the mission is a change in real-world conditions. In the event that an unforeseen event necessitates a change, any deviation from the plan may be made only after consultation with, and on the authority of, Mission Control Center (MCC). Because of this rigorous pre-mission planning process, it was possible for MCC flight and ground crews to make rapid, coordinated, and preplanned responses for over 80% of the failures, both equipment and otherwise, over the course of the entire Apollo program.

NO.	TIME	EVENT	NOTES
1	T-20'	Astronauts suit up	
2	T-16'	Special effects check	DIALOGUE Communication on walkie-talkies
3	T-10'	*Saturn V* with humidity effect	DIALOGUE MCC: "T-10 minutes to liftoff and counting."
4	T-6'	Astronauts descend staircase	DIALOGUE MCC: "T-6 minutes to liftoff and counting." AUDIO "Mars" (Gustav Holst)
5	T-5'30"	Astronauts remove protective slippers	
6	T-5'	Astronauts mount Scissor Lift	DIALOGUE MCC: "T-5 minutes to liftoff and counting."
7	T-4'	Scissor Lift and platform positioned	DIALOGUE CDR: "Position confirmed."
8	T-3'30"	Astronauts enter Eagle and transfer PLSS	DIALOGUE MCC: "Life support transferred."
9	T-3'	Hatch closed	DIALOGUE CDR: "Area cleared, close hatch."
10	T-2' through T-1'	System check	DIALOGUE Communication between astronauts and CAPCOM (items 10.1–10.13) NOTE Astronauts do a verbal check; if any one of these items is not cleared for "GO," countdown stops until operation is cleared for "GO"
10.1		Communications check	DIALOGUE CDR: "Communications 'GO.'"
10.2		Alternate communications channel and walkie-talkie check	DIALOGUE LMP: "Backup communications 'GO.'"
10.3		Food and consumables inventory	DIALOGUE CDR: "Consumables 'GO.'"
10.4		Atari Lunar Lander Emulator check	DIALOGUE CDR: "Emulator 'GO.'"
10.5		Al Green cassette check	DIALOGUE CDR: "Cassette 'GO.'"
10.6		Candle check	DIALOGUE CDR: "Candle 'GO.'"
10.7		Water gun check	DIALOGUE CDR: "Water gun 'GO.'"
10.8		Climate system check	DIALOGUE CDR: "Climate system 'GO.'"
10.9		Special effects check: Earth	DIALOGUE Grumman Tech: "Earth 'GO.'"
10.10		Special effects check: Moon	DIALOGUE Grumman Tech: "Moon 'GO.'"
10.11		Special effects check: Stars	DIALOGUE Grumman Tech: "Stars 'GO.'"
10.12		Special effects check: Thrust	DIALOGUE Grumman Tech: "Thrust 'GO.'"
10.13		Special effects check: Liftoff	DIALOGUE Grumman Tech: "Liftoff 'GO.'"

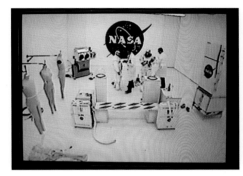
1 Astronauts suit up

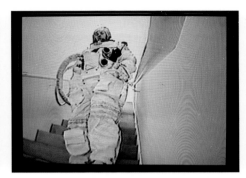
4 Astronauts descend staircase

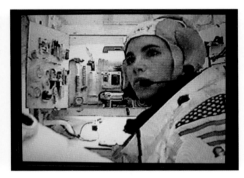
5 Astronauts remove protective slippers

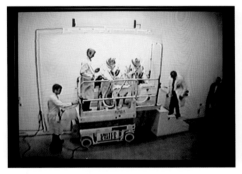
6 Astronauts mount Scissor Lift

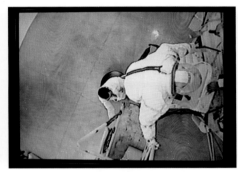
8 Astronauts enter Eagle and transfer PLSS

10.1 Communications check

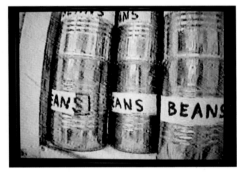
10.3 Food and consumables inventory

10.5 Al Green cassette check

10.8 Climate system check

10.9 Special effects check: Earth

10.10 Special effects check: Moon

10.11 Special effects check: Stars

NO.	TIME	EVENT	NOTES
11	T-30″	All systems go	DIALOGUE MCC: "All systems 'GO.'"
12	T-20″	Countdown begins	DIALOGUE MCC: "20 seconds and counting." NOTE "Quiet on the set" sign illuminated
12.1		Countdown continues	DIALOGUE MCC: "T-15 seconds."
12.2			DIALOGUE MCC: "Guidance is internal."
12.3			DIALOGUE MCC: "12, 11, 10, 9 . . ."
12.4			DIALOGUE MCC: " . . . start ignition sequence . . ."
12.5			DIALOGUE MCC: " . . . 6, 5, 4, 3, 2, 1, 0."
13	T+00″	Engines running	DIALOGUE MCC: "All engines running." AUDIO Static sound begins
14	T+01″	Liftoff	DIALOGUE MCC: "Liftoff, we have liftoff." AUDIO Volume of static increases NOTE Mirror breaks, camera melts
14.1			DIALOGUE MCC: "Liftoff at 5 minutes past the hour." AUDIO Volume of static increases
15	T+05″	Liftoff	DIALOGUE MCC: "Liftoff on *Dionysus*." AUDIO Volume of static increases; loud blastoff NOTE Camera vertically pans model rocket
15.1		Close-up of LMP	AUDIO Loud static NOTE LMP vibrates
15.2		Camera on 1st stage model rocket	NOTE Camera continues to pan model rocket
15.3		Close-up of CDR	DIALOGUE MCC: "Tower cleared, all clear." NOTE CDR vibrates
15.4		Close-up of LMP	NOTE LMP lurches
16	T+10″	Earth recedes	NOTE Earth effect
17	T+20″	Darkness and stars	NOTE Darkness and stars effect
18	T+40″	LMP removes helmet	
19	T+40″	CDR removes helmet	
20	T+1'30″	Astronauts move to dining area	DIALOGUE Improvised by CDR and LMP NOTE Dim lighting; fish-eye camera lens
21	T+2'	Candle lighting	AUDIO Al Green cassette plays NOTE Soft-focus camera zooms in

10.13 Special effects check: Liftoff

13 Engines running

14 Liftoff

15 Liftoff: camera vertically pans
model rocket

15 Liftoff: camera vertically pans
model rocket

15 Liftoff: camera vertically pans
model rocket

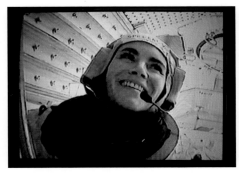

15.3 Close-up of CDR

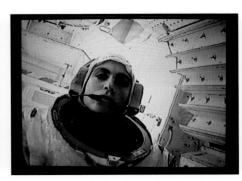

15.4 Close-up of LMP

16 Earth recedes

17 Darkness and stars

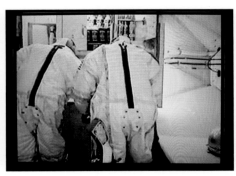

20 Astronauts move to dining area

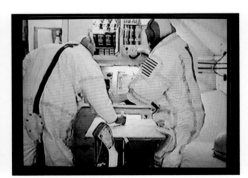

21 Candle lighting

NO.	TIME	EVENT	NOTES
22	T+2'10"	LMP romance view	NOTE CDR applies lipstick
23	T+2'15"	CDR romance view	
24	T+2'20"	Overhead camera (meal option)	NOTE Dim lights; camera on detail of table
25	T+3'30"	Moon approaches	DIALOGUE MCC: "Excuse me, ladies, let's not forget that we have a job to do here." AUDIO Lunar proximity alarm NOTE Moon effect
26	T+3'35"	Astronauts leave table	
27	T+3'40"	CDR returns to controls	
28	T+3'40"	LMP returns to controls	
29	T+3'45"	Atari Lunar Lander Emulator (set up)	AUDIO Atari game (ROM)
30	T+4'10"	Close-up of joystick and control panel	
31	T+4'30"	LMP executes landing sequence	AUDIO Atari game (ROM)
32	T+5'	Lunar lander touches down	NOTE "Applause" sign illuminates
33	T+10'	Astronauts secure PLSS and helmets	AUDIO "Socialist" (Public Image Limited) NOTE MCC deploys HNDS and VDS
34	T+12'	Hatch opened	
35	T+12'30"	MESA deployed	DIALOGUE CDR: "I'm on the front porch."
36	T+13'	CDR descends ladder halfway	
37	T+13'05"	Cut to commercial	NOTE Prerecorded on DVD
38	T+18'	CDR descends ladder to surface	DIALOGUE MCC: "Addison, you ready for that step?"
39	T+18'05"	CDR steps onto surface	NOTE "Applause" sign illuminates
40	T+19'	CDR deploys shotgun and secures lunar surface	DIALOGUE CDR: "Area secure. LMP, please descend ladder."
41	T+20'	LMP descends ladder	
42	T+22'	Flag raised	DIALOGUE MC: "We have visual confirmation."
43	T+23'	Hole drilled; floor sample	
44	T+26'	Carrier conveyor deployed, samples conveyed to LEM	
45	T+28'	Ingress	

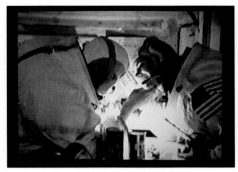

22-23 LMP and CDR romance view

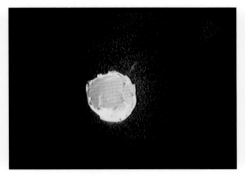

25 Moon approaches

29 Atari Lunar Lander Emulator

34 Hatch opened

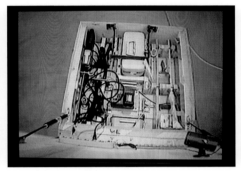

35 MESA deployed

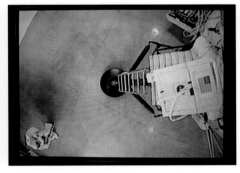

36 CDR descends ladder halfway

37 Cut to commercial

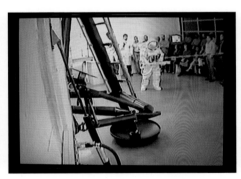

40 CDR deploys shotgun and secures lunar surface

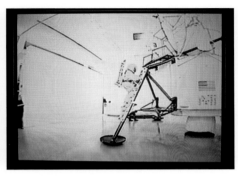

41 LMP descends ladder

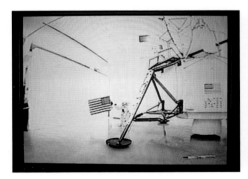

42 Flag raised

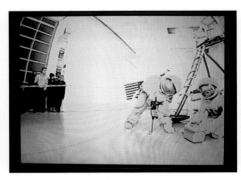

43 Hole drilled; floor sample

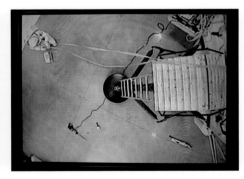

44 Carrier conveyor deployed, samples conveyed to LEM

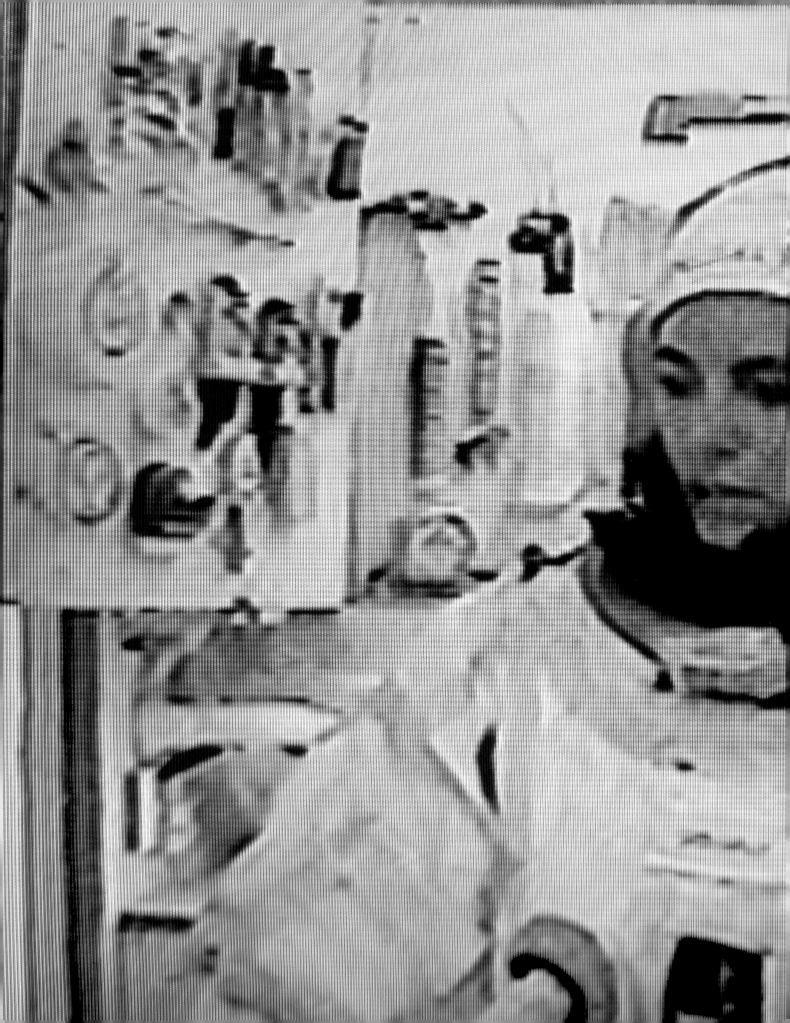

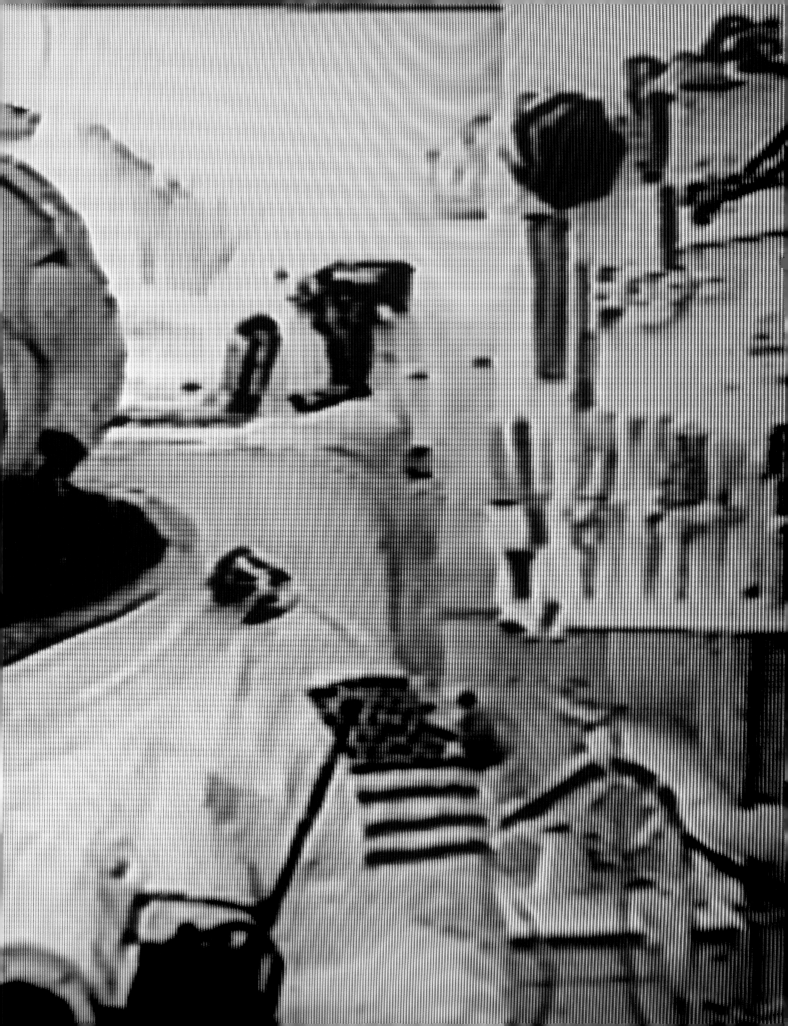

NO.	TIME	EVENT	NOTES
46	T+30'	Hatch locked	
47	T+30'30"	LMP in position	
48	T+30'30"	CDR in position	
49	T+30'35"	Lunar lander lifts off; transearth injection	AUDIO Static sound begins; "Blue Danube" (Johann Strauss) NOTE Moon effect; series of drawings illustrates rendezvous
50	T+34'	Astronauts remove helmets	
51	T+34'30"	CDR and LMP move into spoon position	
52	T+34'45"	Cone of silence	AUDIO "Breathe" (Pink Floyd)
53	T+35'55"	Darkness and stars	NOTE "Applause" sign illuminates
54	T+36'	Two days later	NOTE Camera on drawing
55	T+36'30"	CDR in position for splashdown	NOTE Lipstick on CDR's collar
56	T+36'30"	LMP in position for splashdown	
57	T+37'	Final systems check for reentry	DIALOGUE MCC: "Cleared for reentry"
58	T+37'05"	Earth fills frame	NOTE Earth effect
59	T+37'15"	Fiery reentry	NOTE Reentry effect
60	T+37'20"	Close-up of LMP	NOTE LMP sweating
61	T+37'25"	Close-up of CDR	NOTE CDR sweating
62	T+37'30"	Fiery reentry	NOTE Reentry effect
63	T+37'35"	Splashdown	NOTE Splashdown effect
64	T+37'40"	Carrier rescue alert	NOTE Carrier effect
65	T+37'40"	VertiBird pickup	NOTE Splashdown effect
66	T+38'	Carrier landing	NOTE Carrier effect
67	T+38'02"	Zoom in	AUDIO "Stars and Stripes Forever" (John Philip Sousa); applause NOTE "Applause" sign illuminates
68	T+38'20"	CDR and LMP descend	
69	T+38'25"	Reset monitor to carrier	NOTE Carrier effect

48 CDR in position

49 Lunar lander lifts off; transearth injection

50 Astronauts remove helmets

51 CDR and LMP move into spoon position

53 Darkness and stars

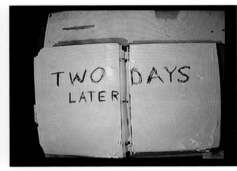

54 Two days later

58 Earth fills frame

59 Fiery reentry

61 Close-up of CDR

63 Splashdown

65 VertiBird pickup

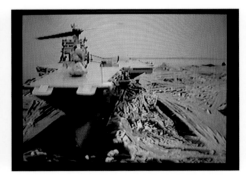

66 Carrier landing

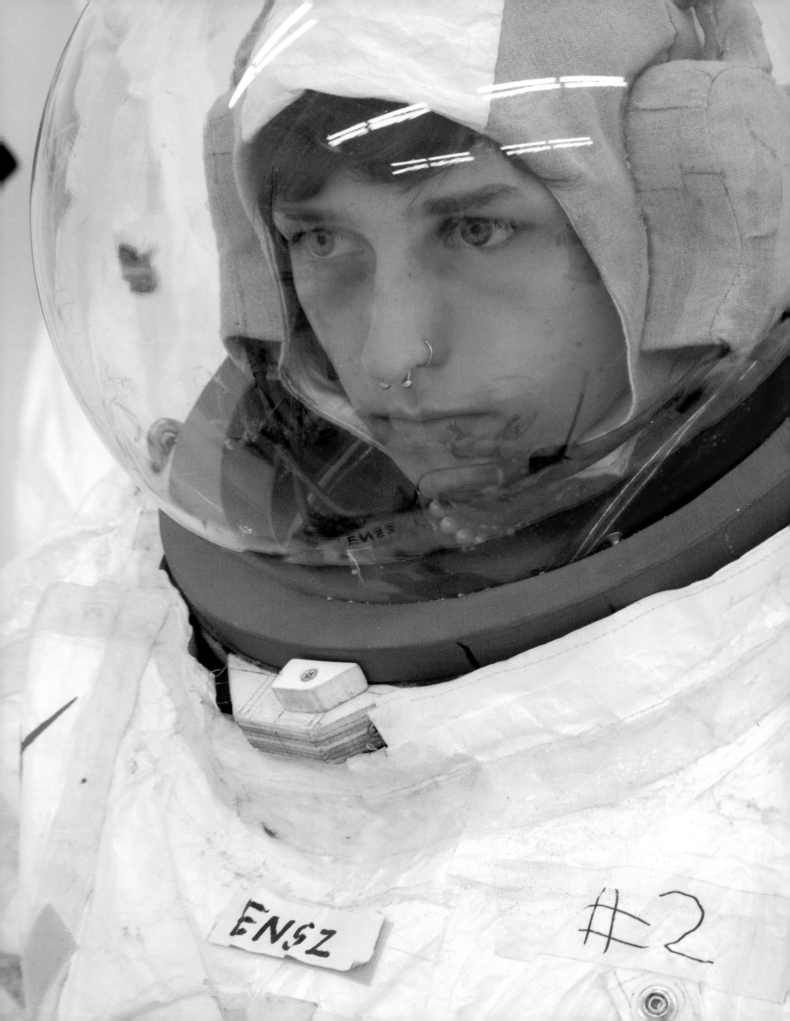

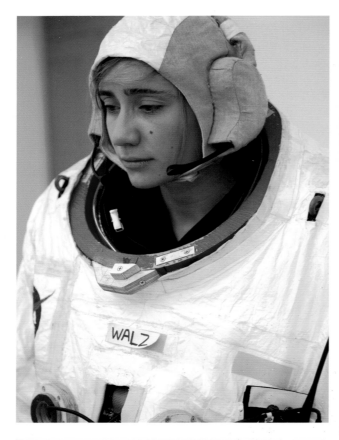
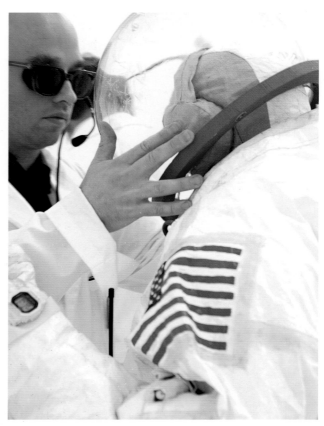

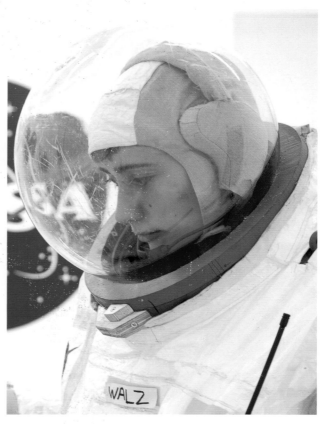

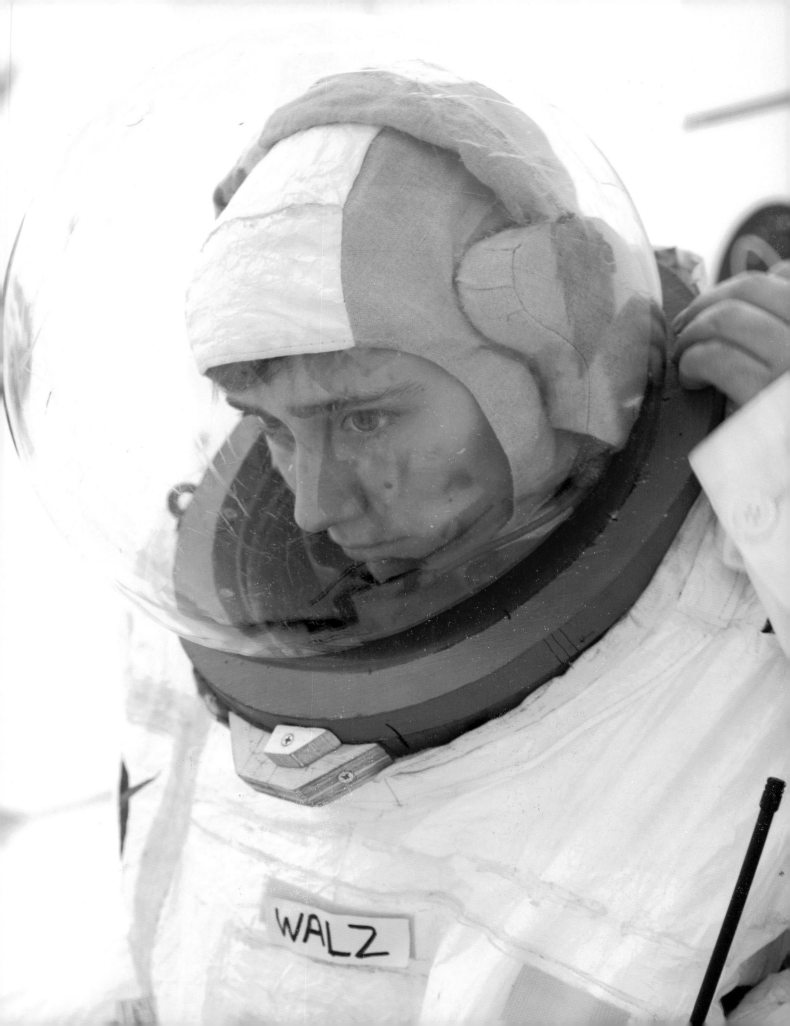

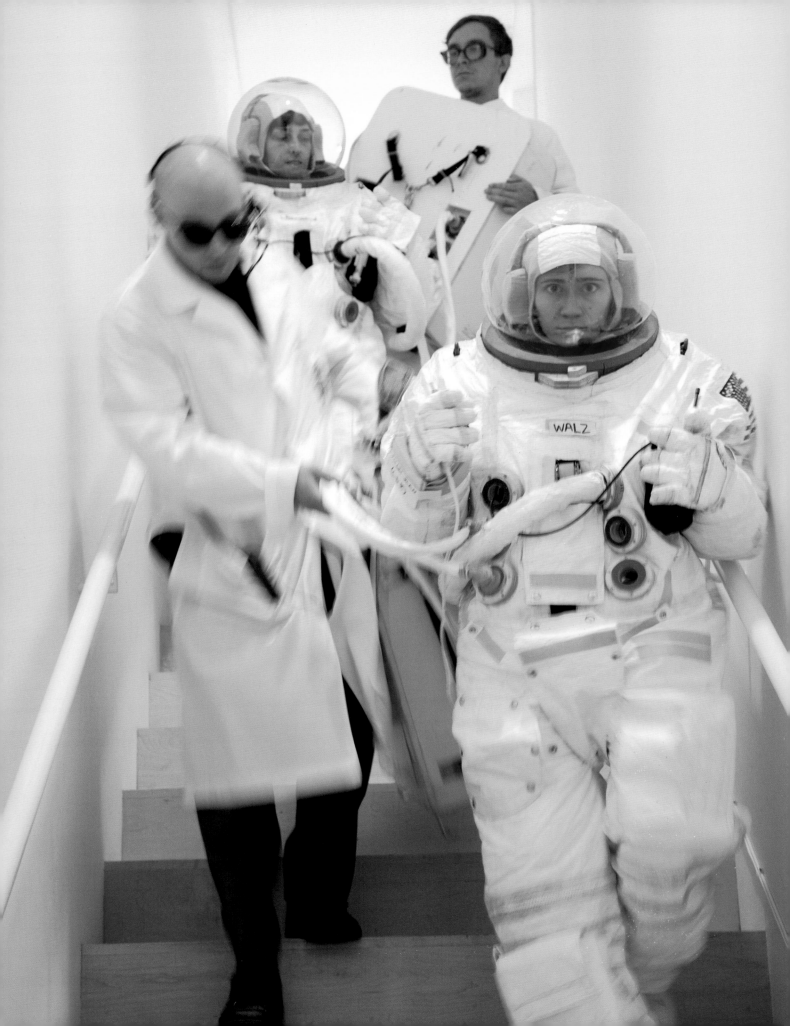

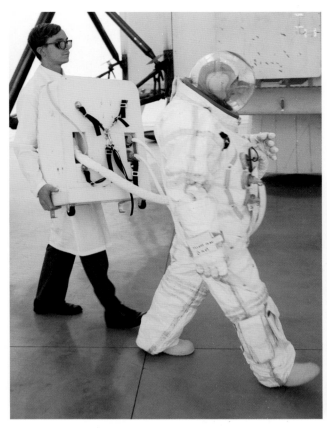

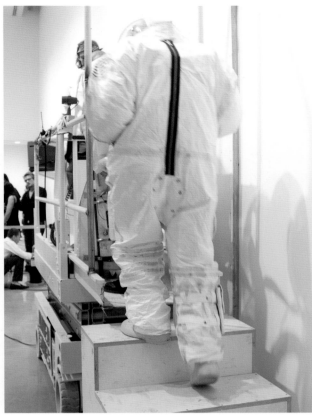

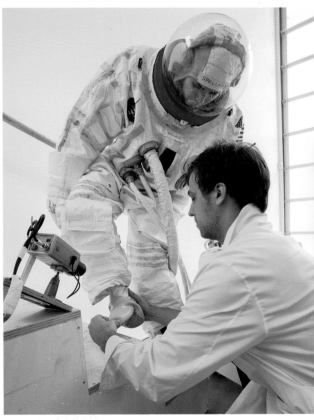

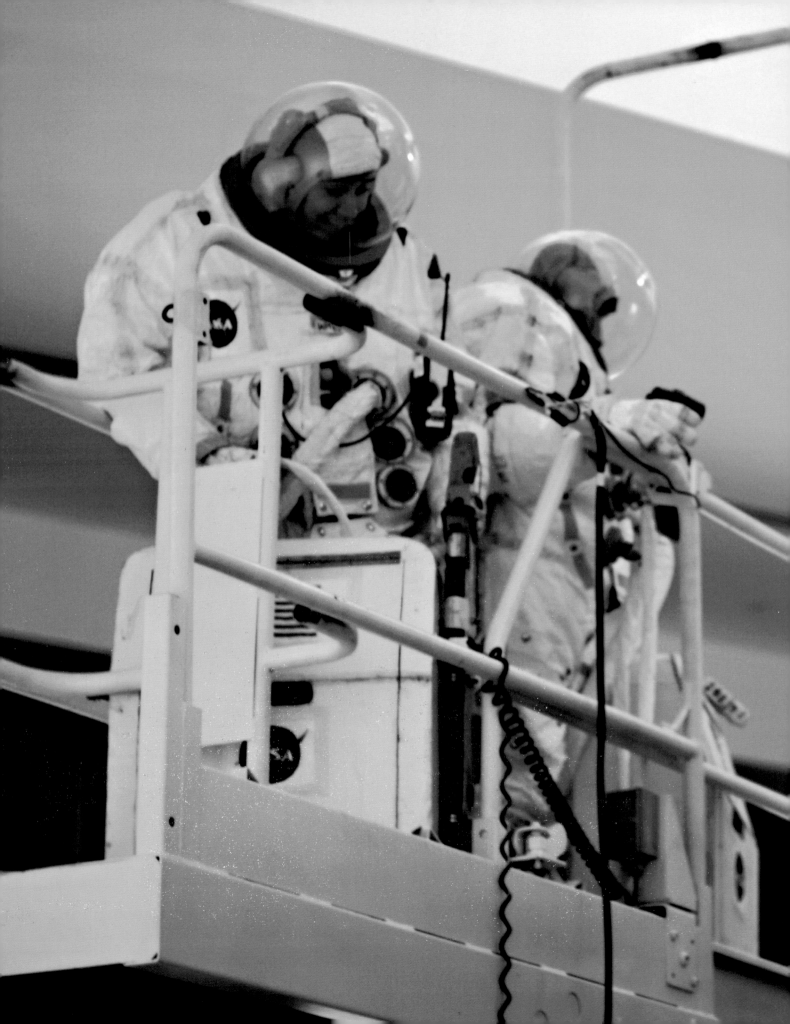

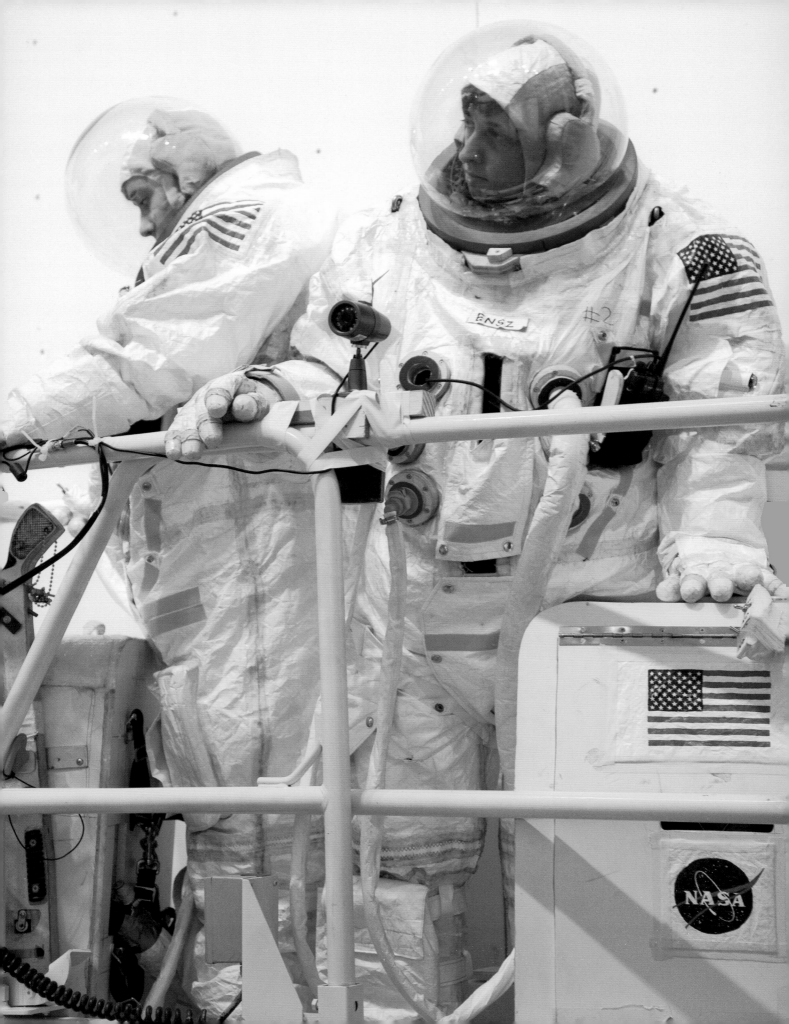

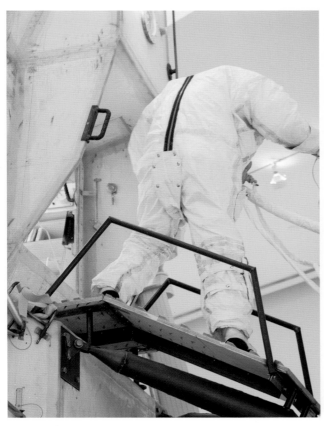

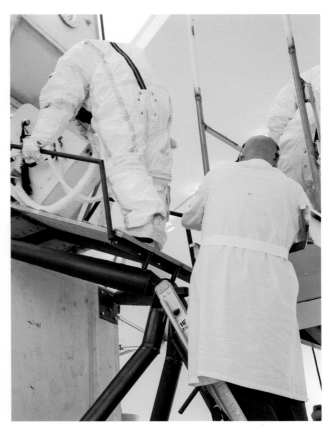

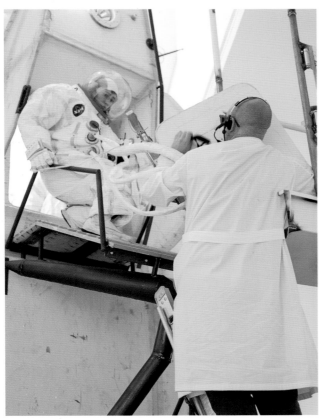

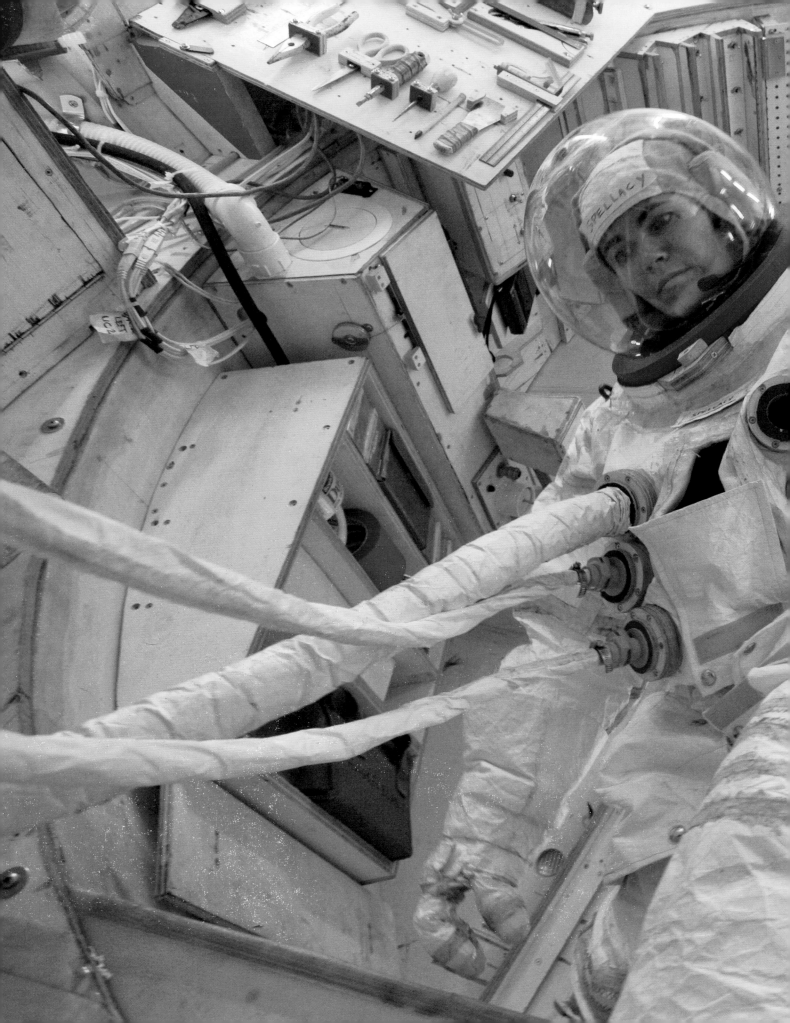

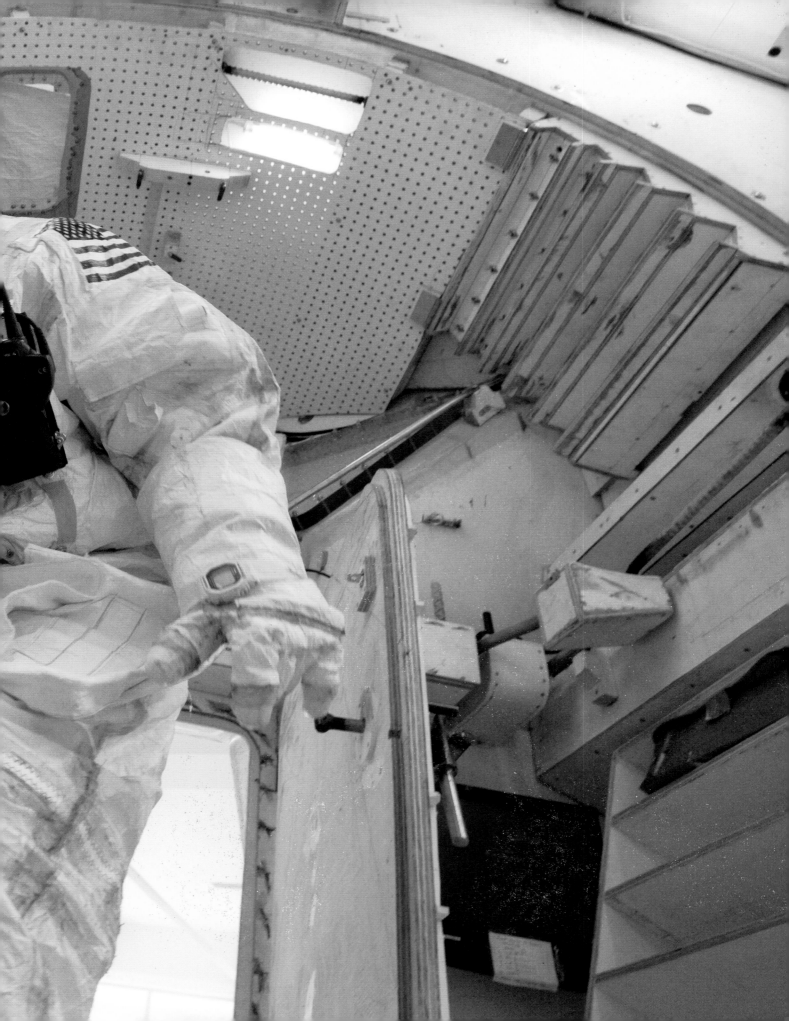

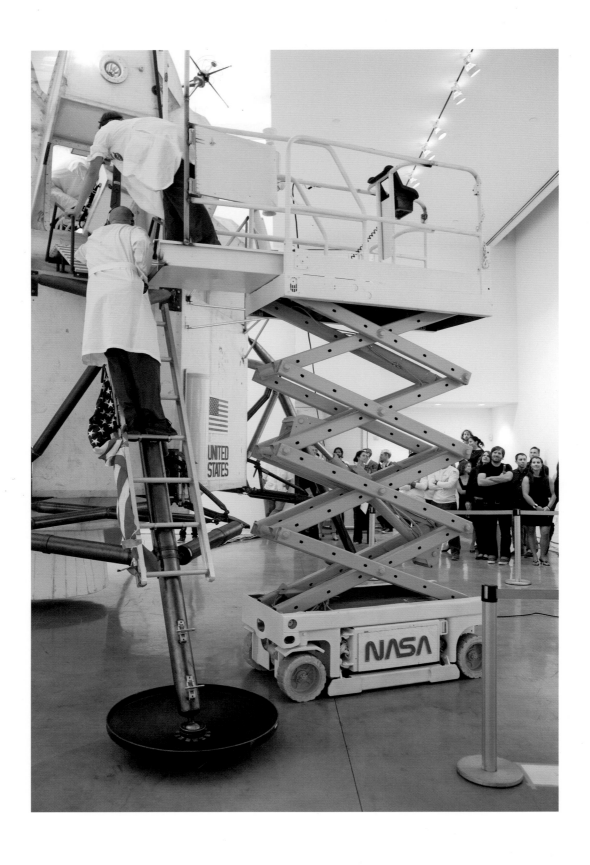

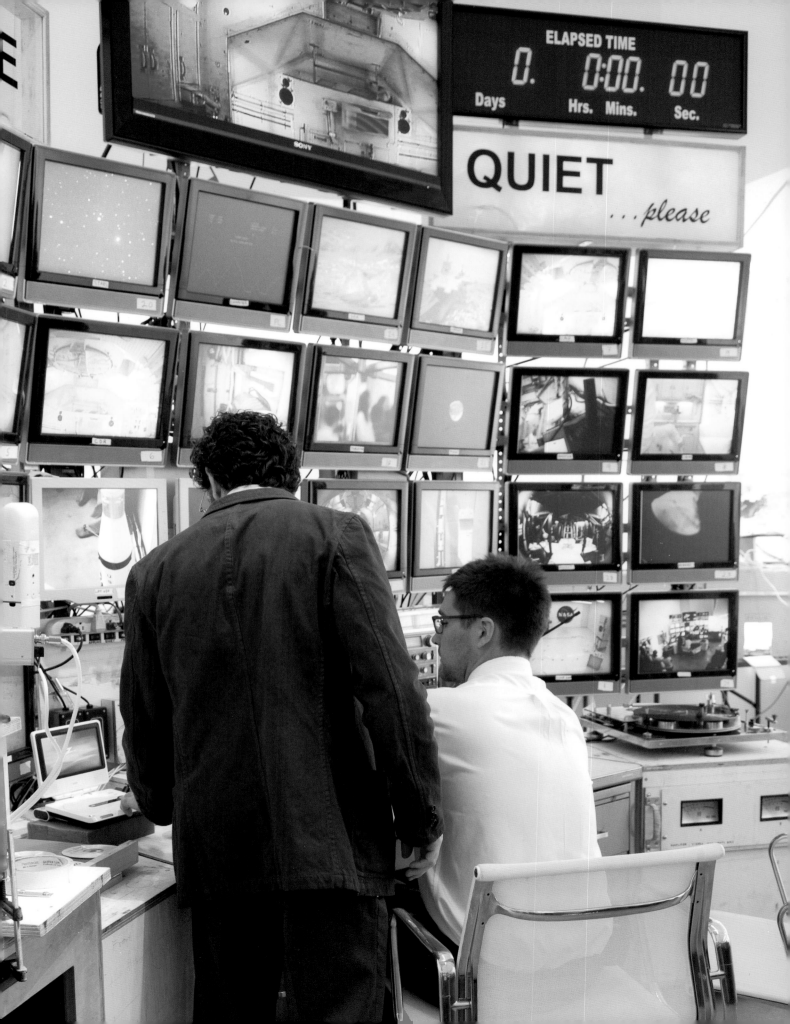

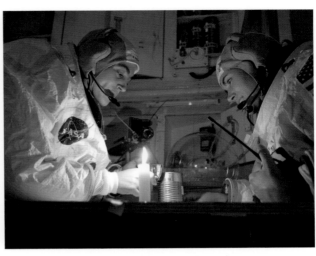
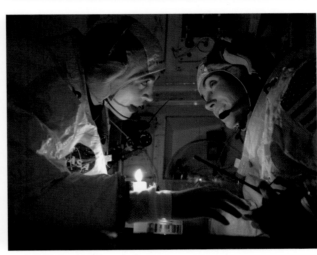
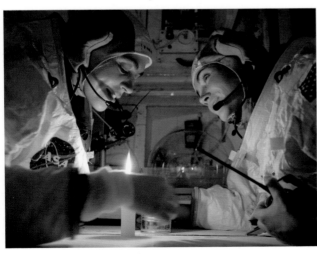
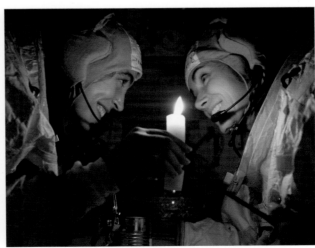

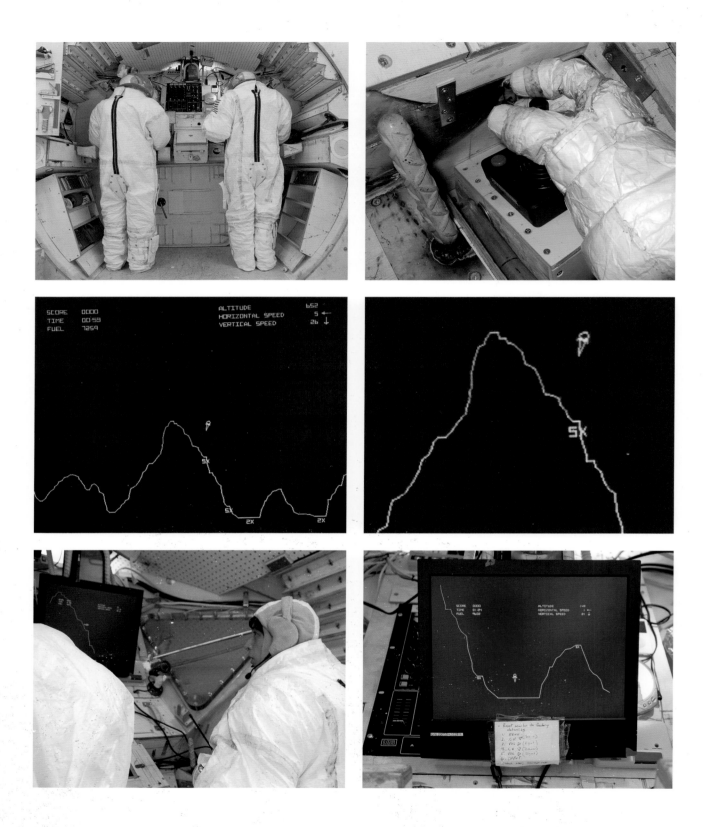

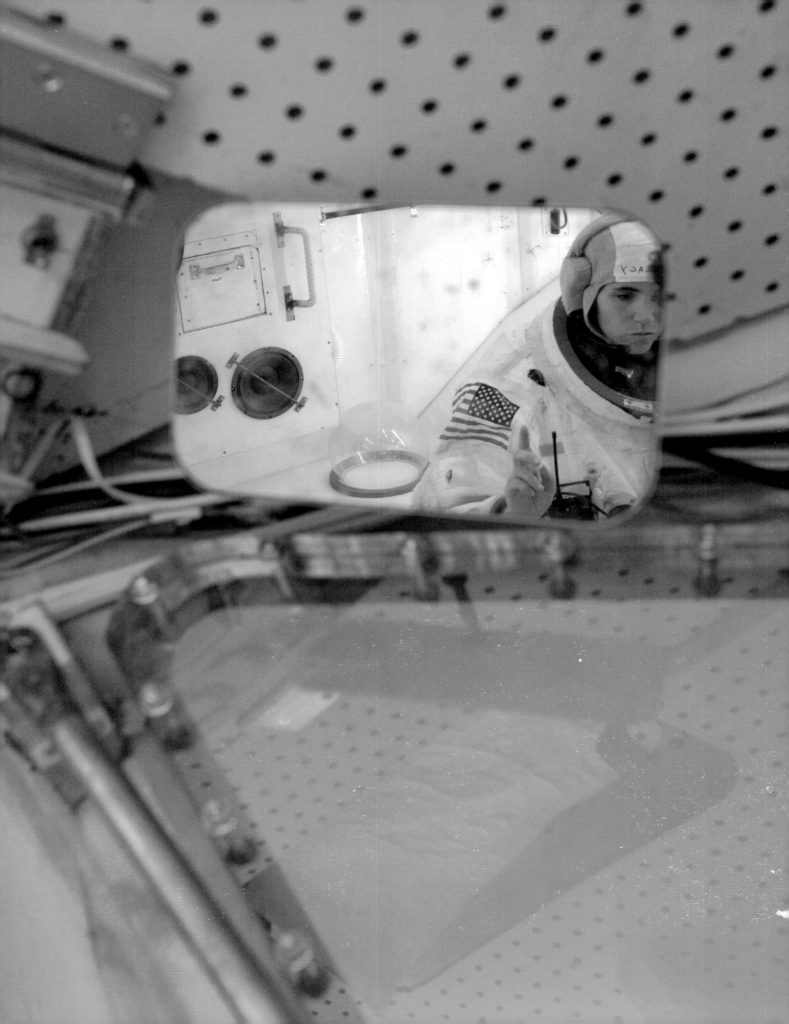

THIS PAGE INTENTIONALLY LEFT BLANK.

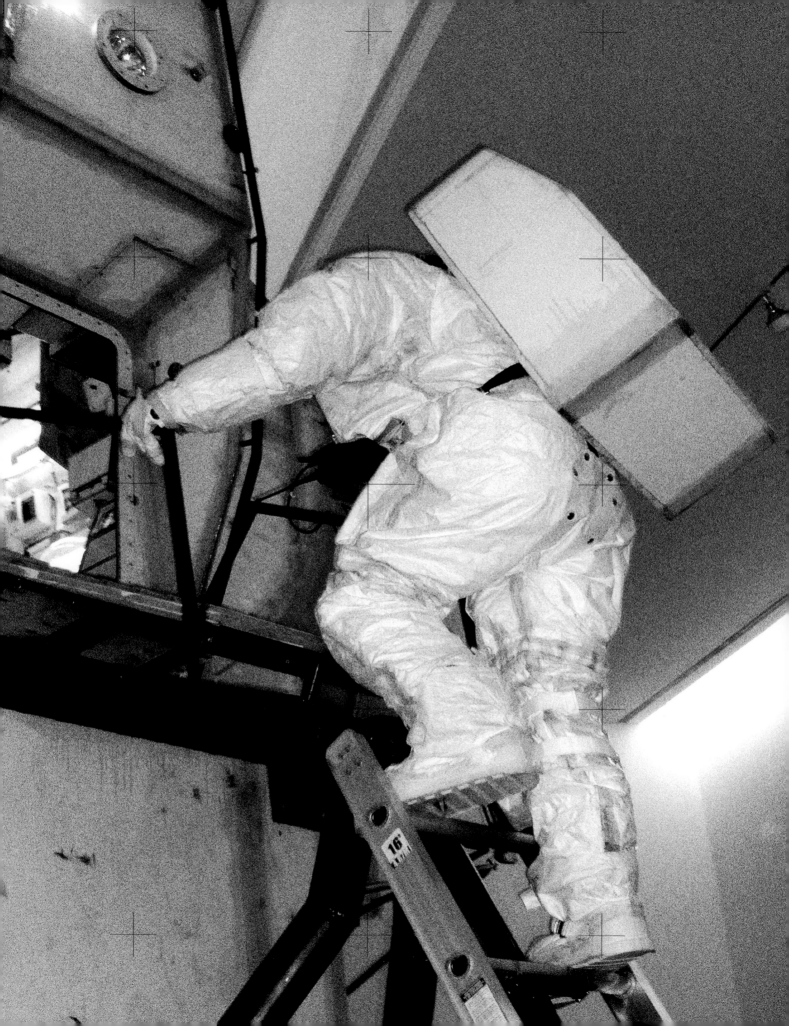

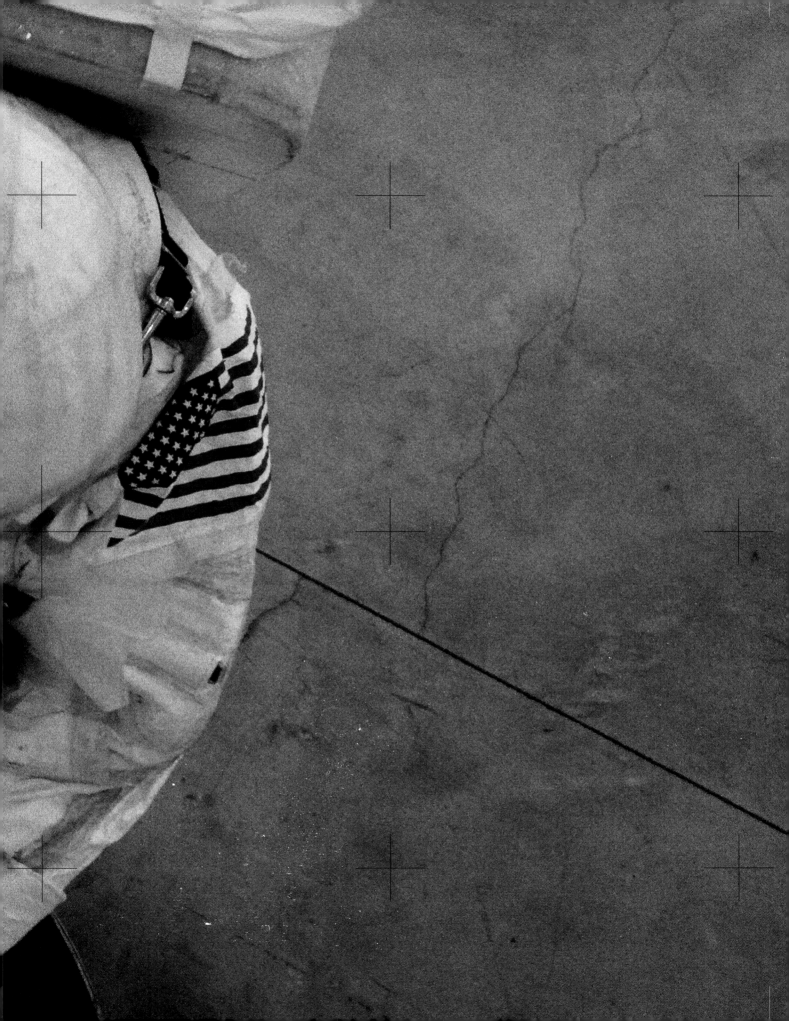

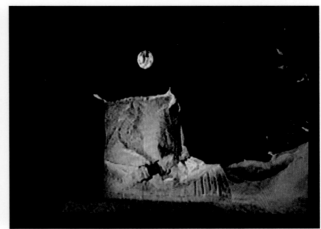
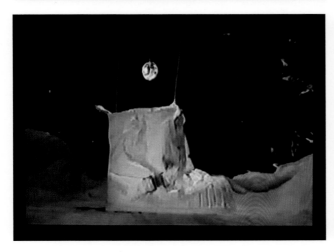

just do it motherfucker

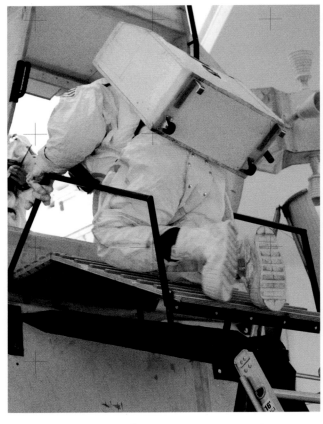

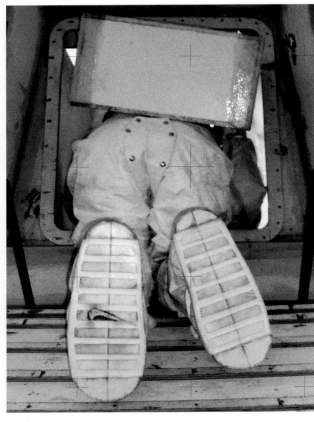

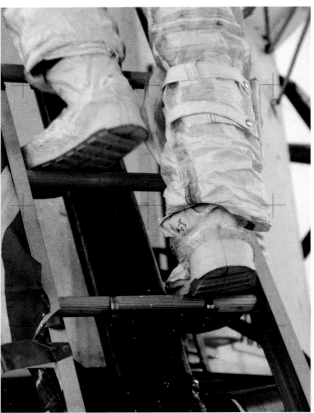

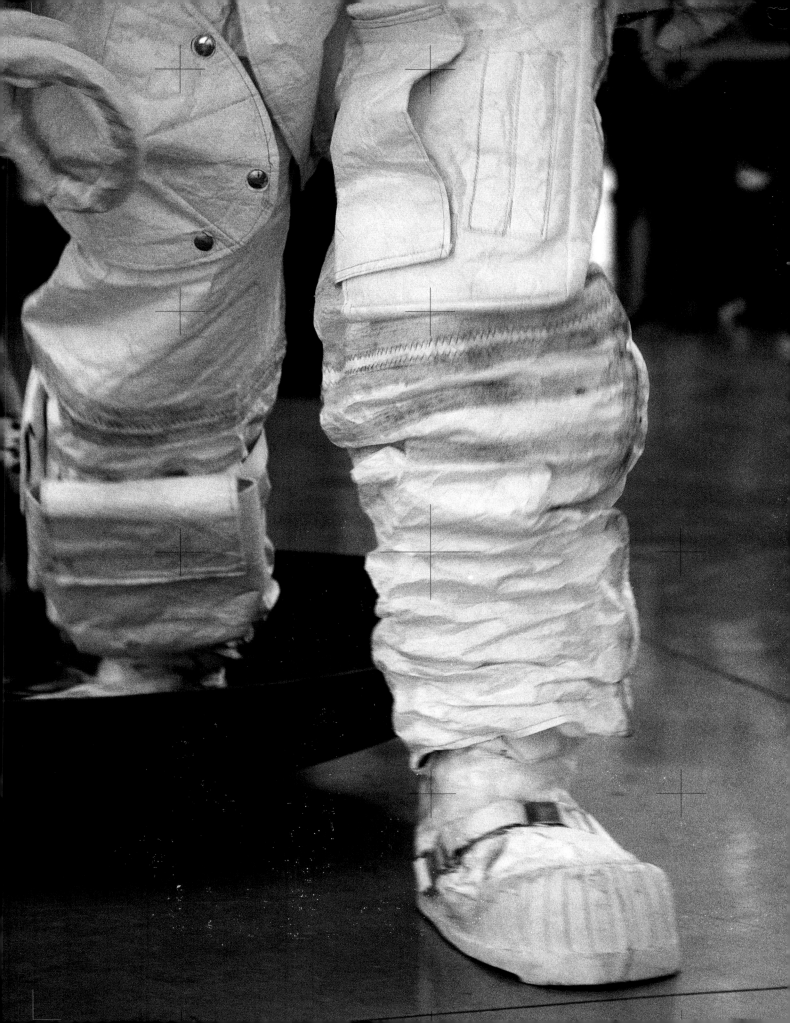

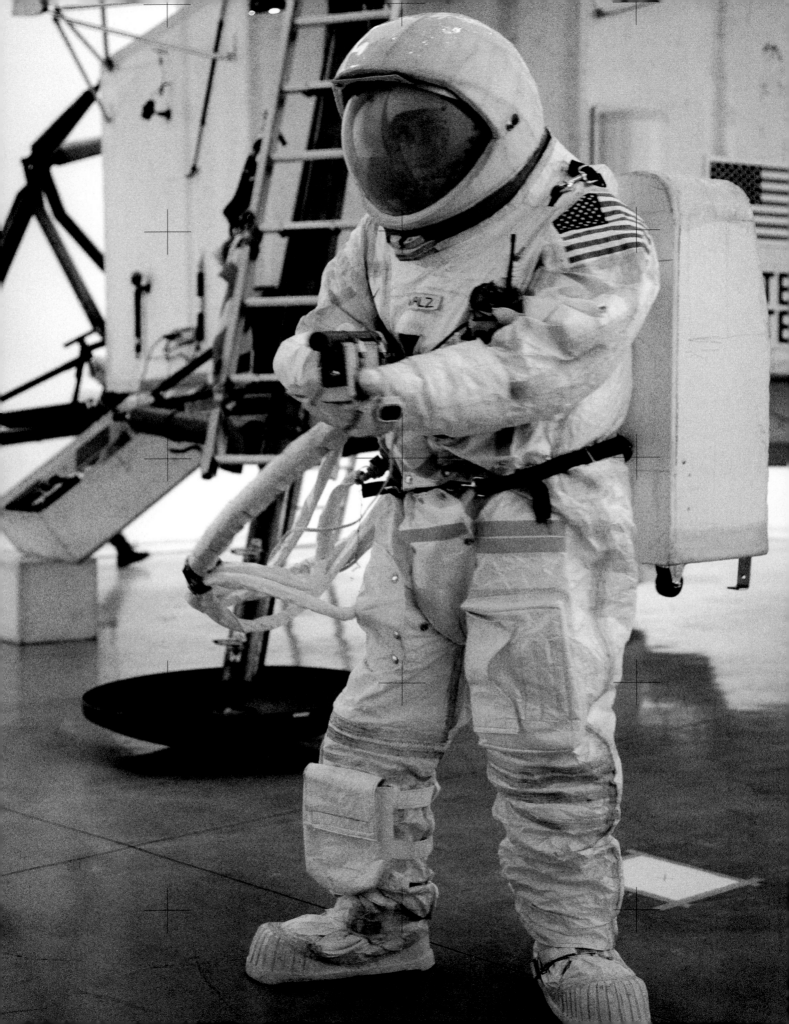

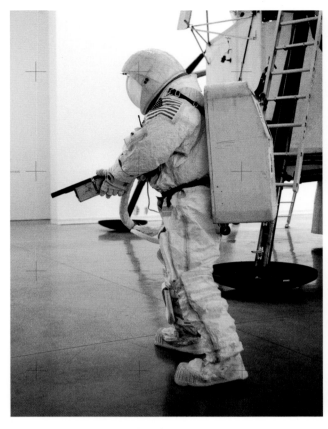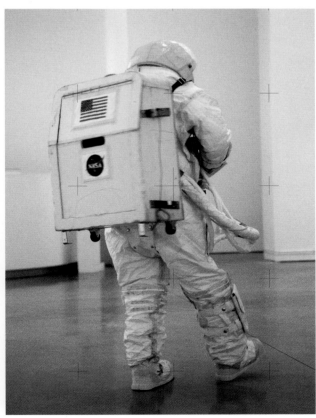

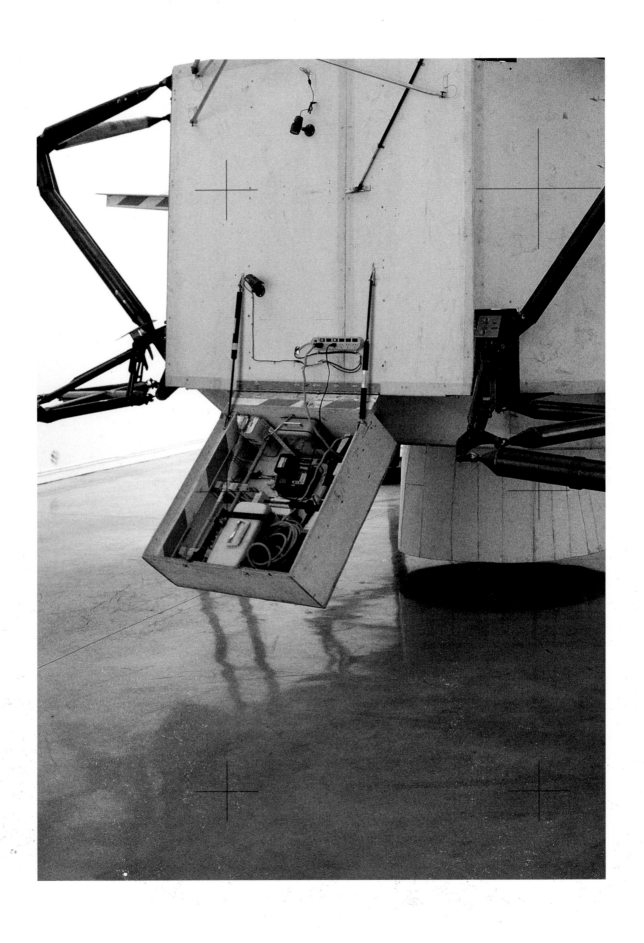

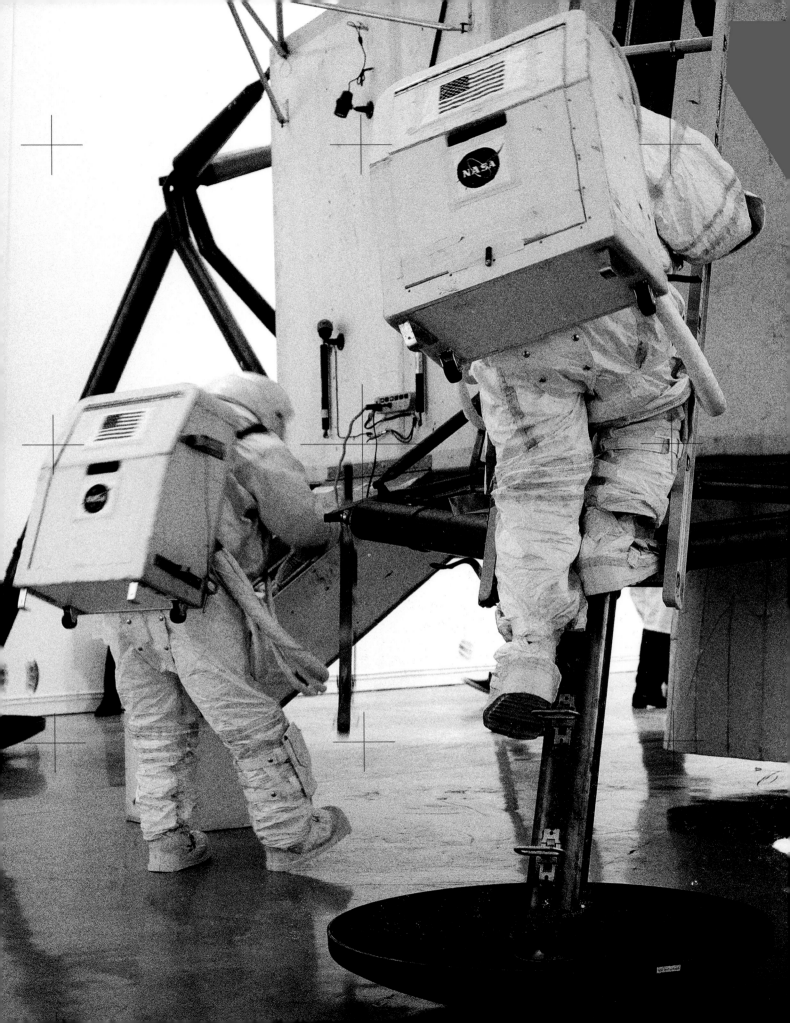

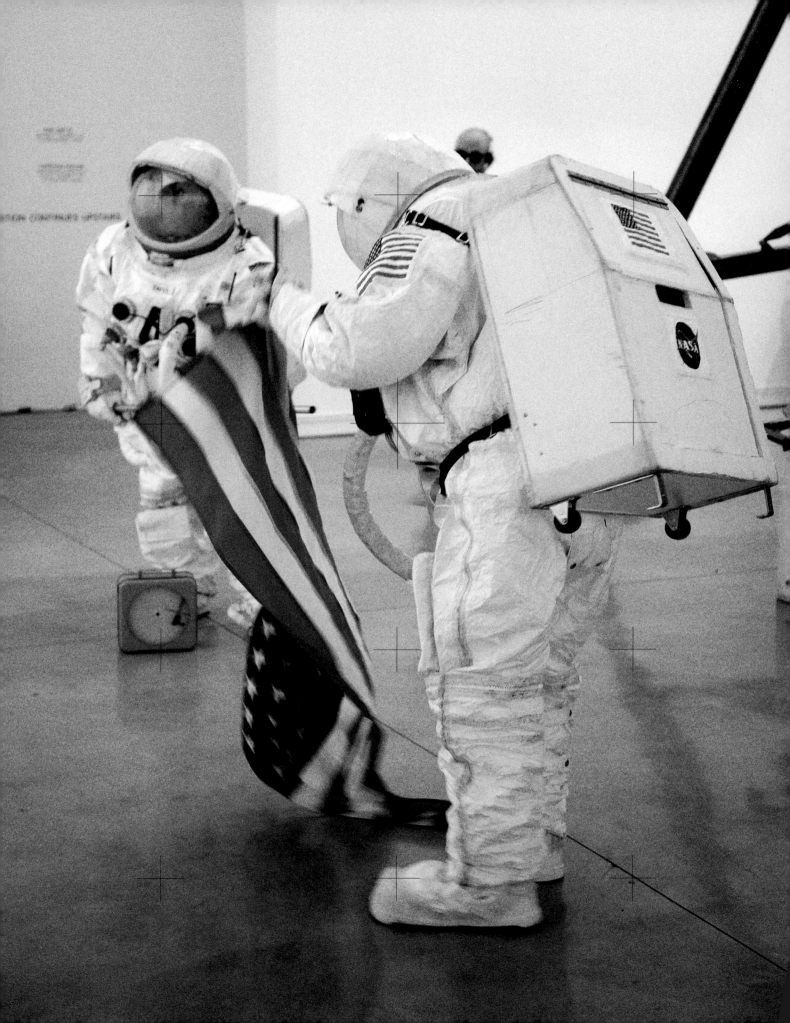

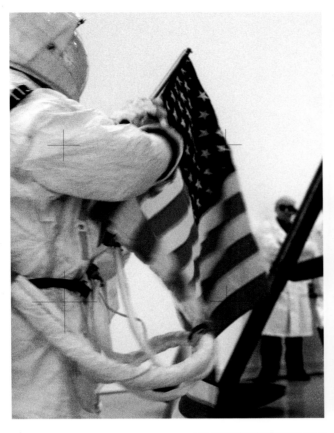

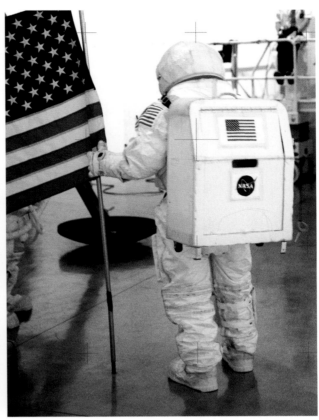

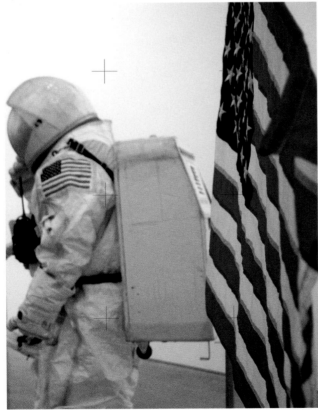

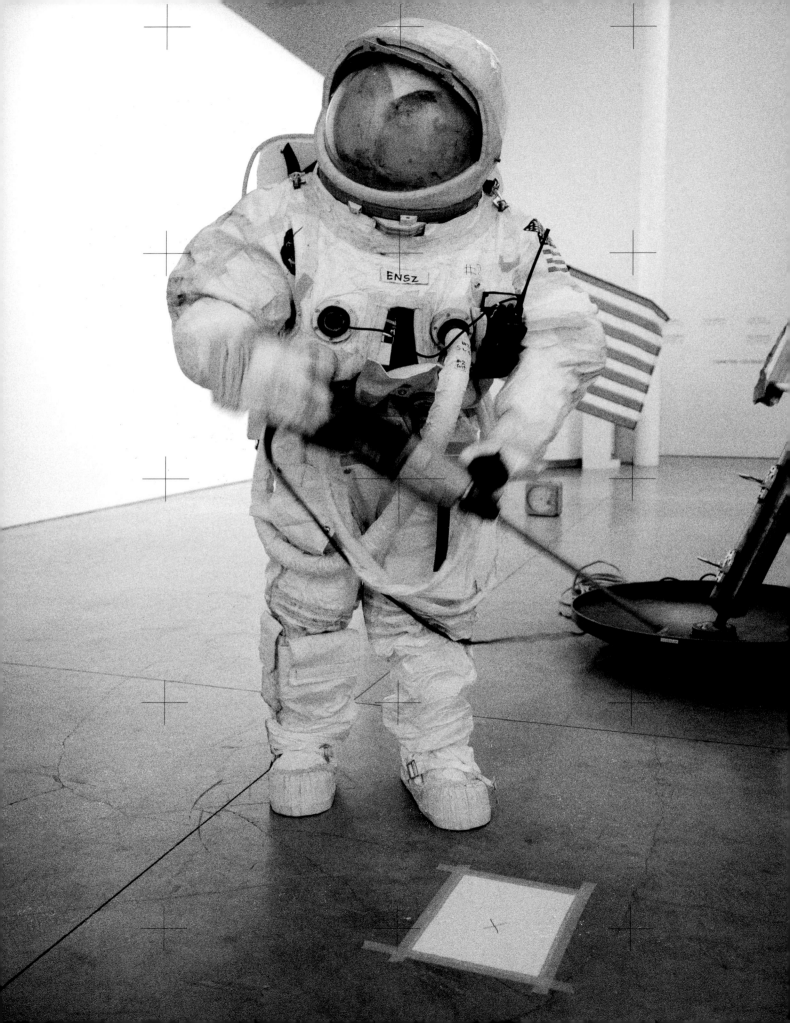

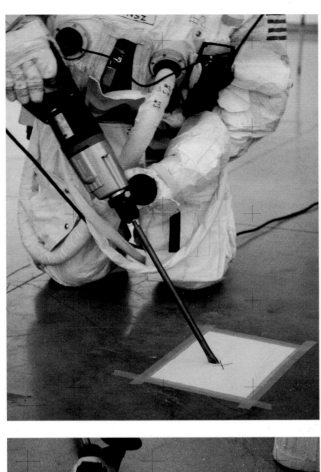
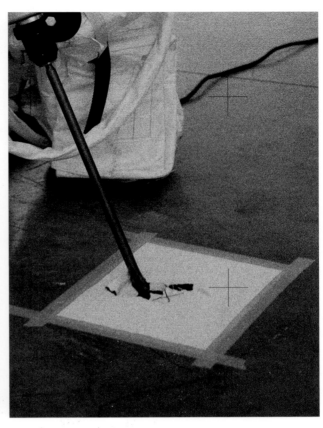
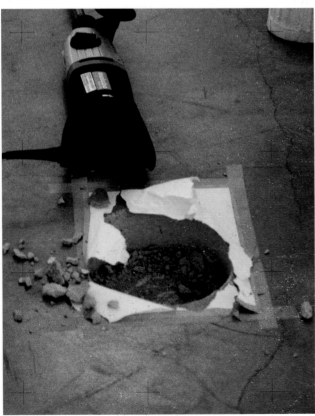

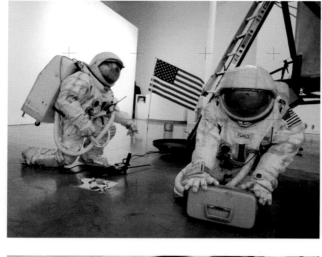

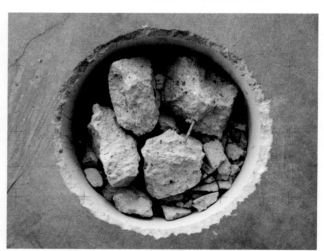

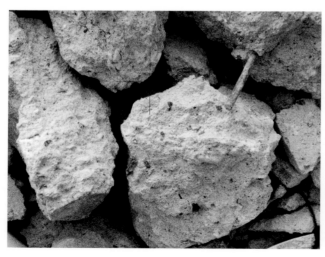

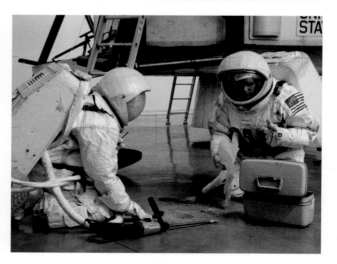

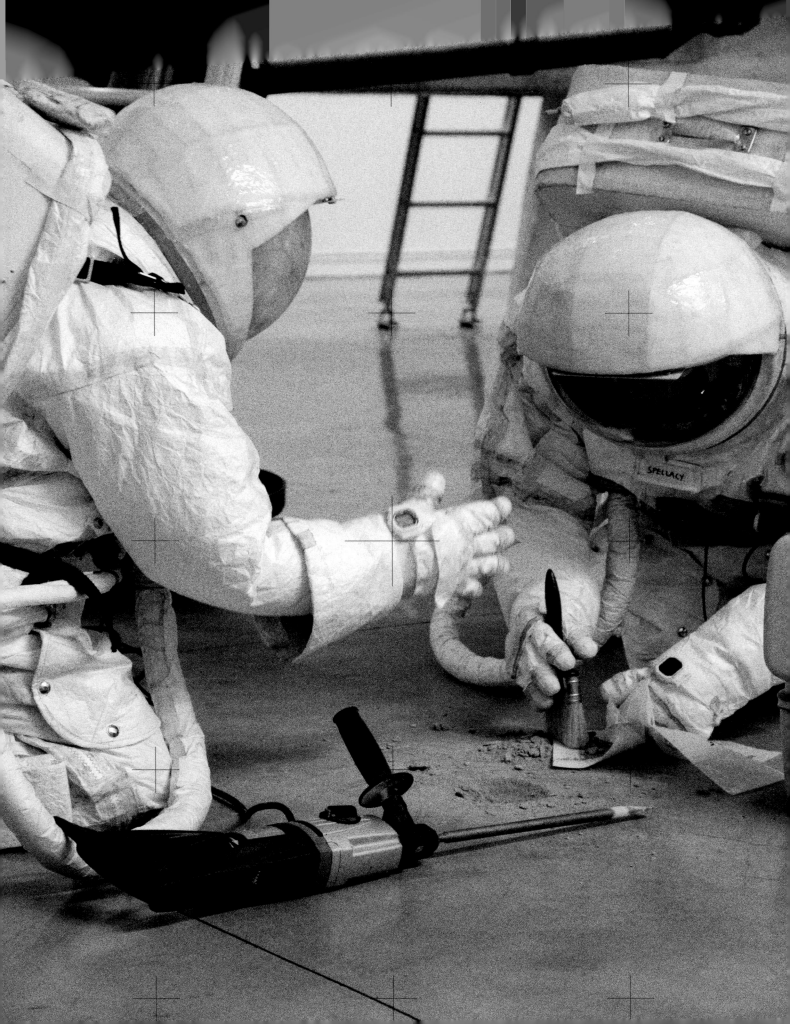

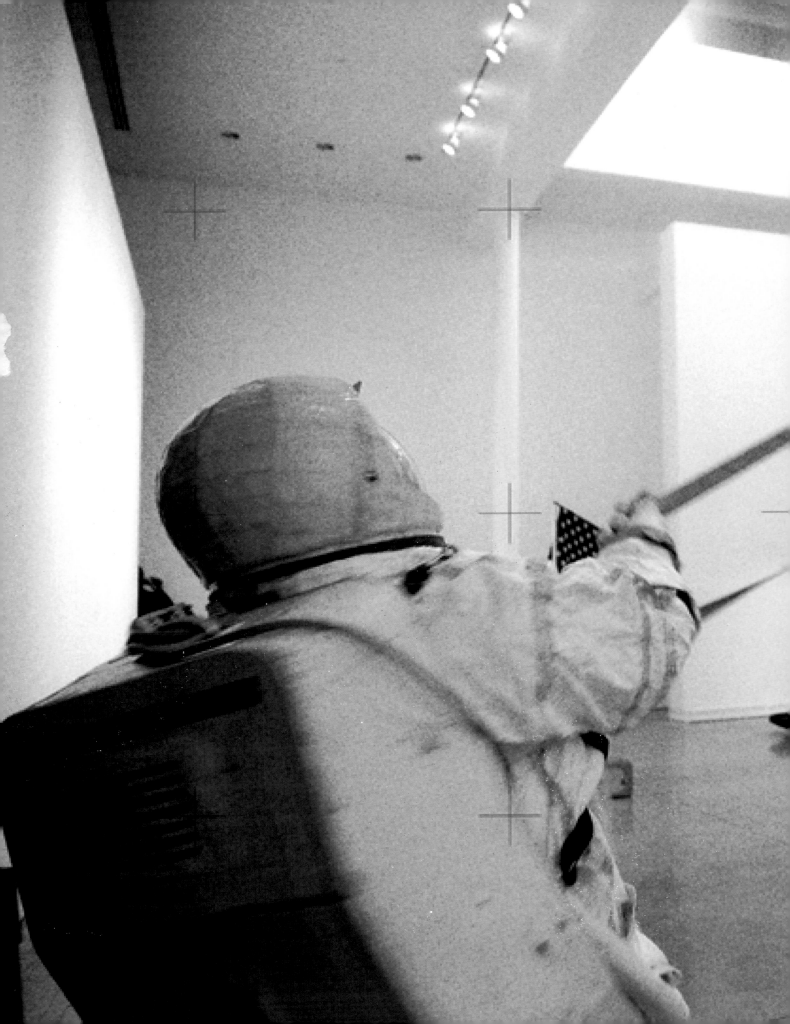

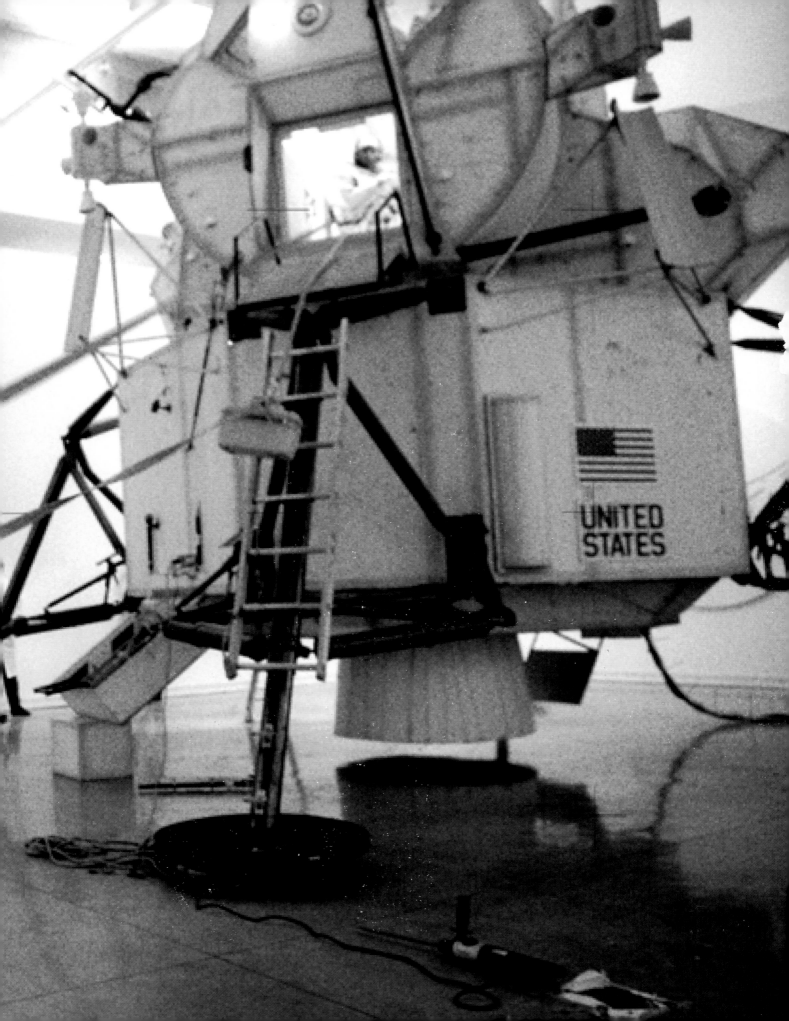

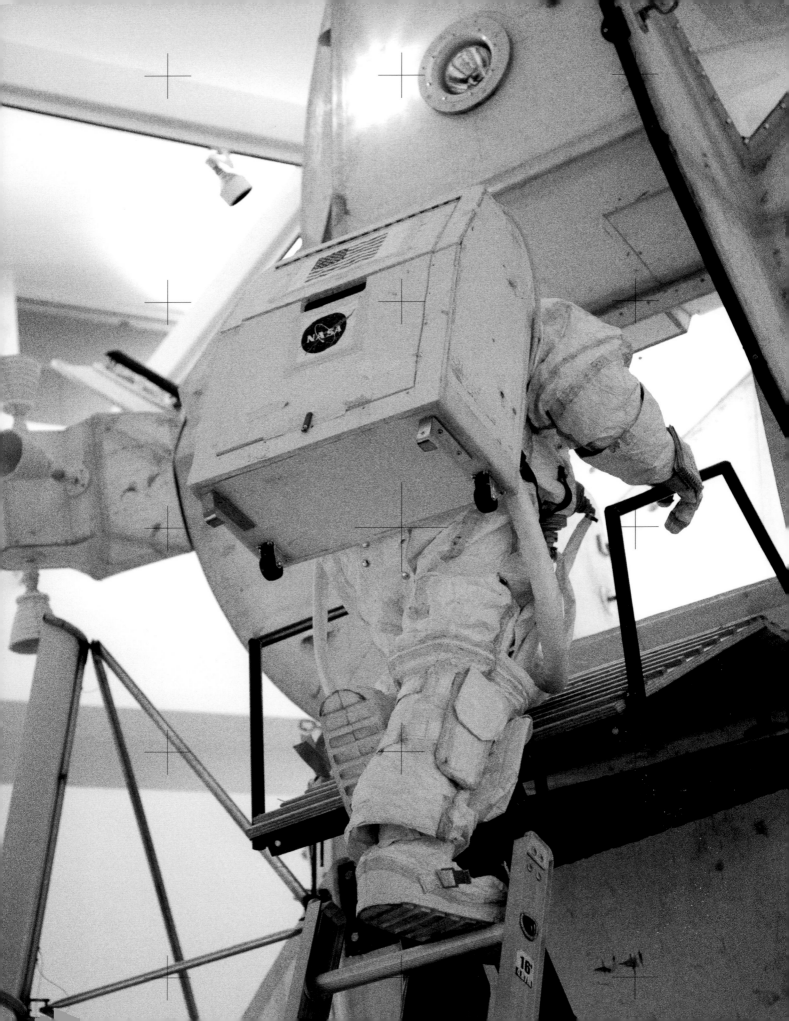

THIS PAGE INTENTIONALLY LEFT BLANK.

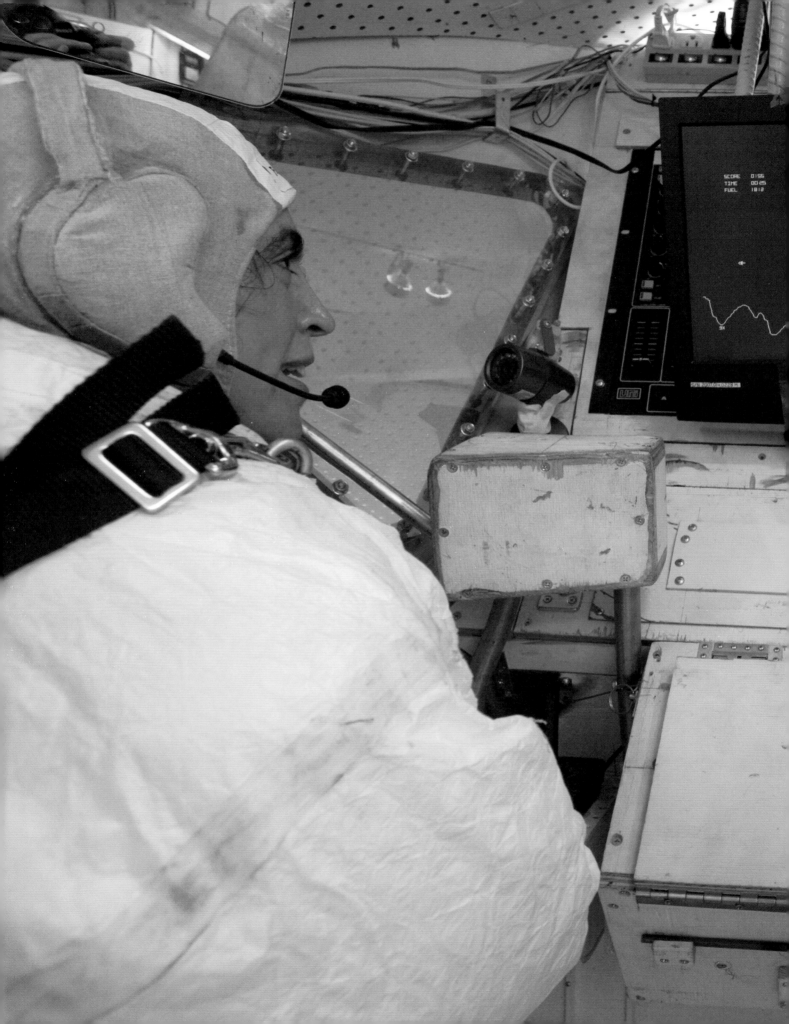

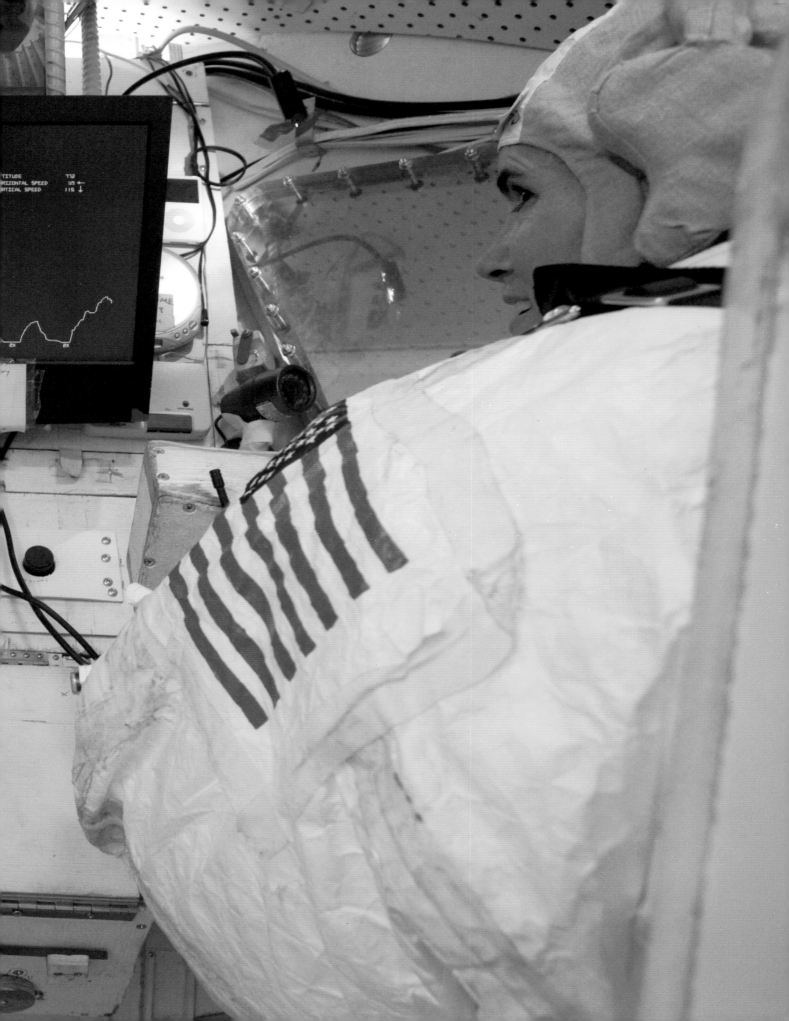

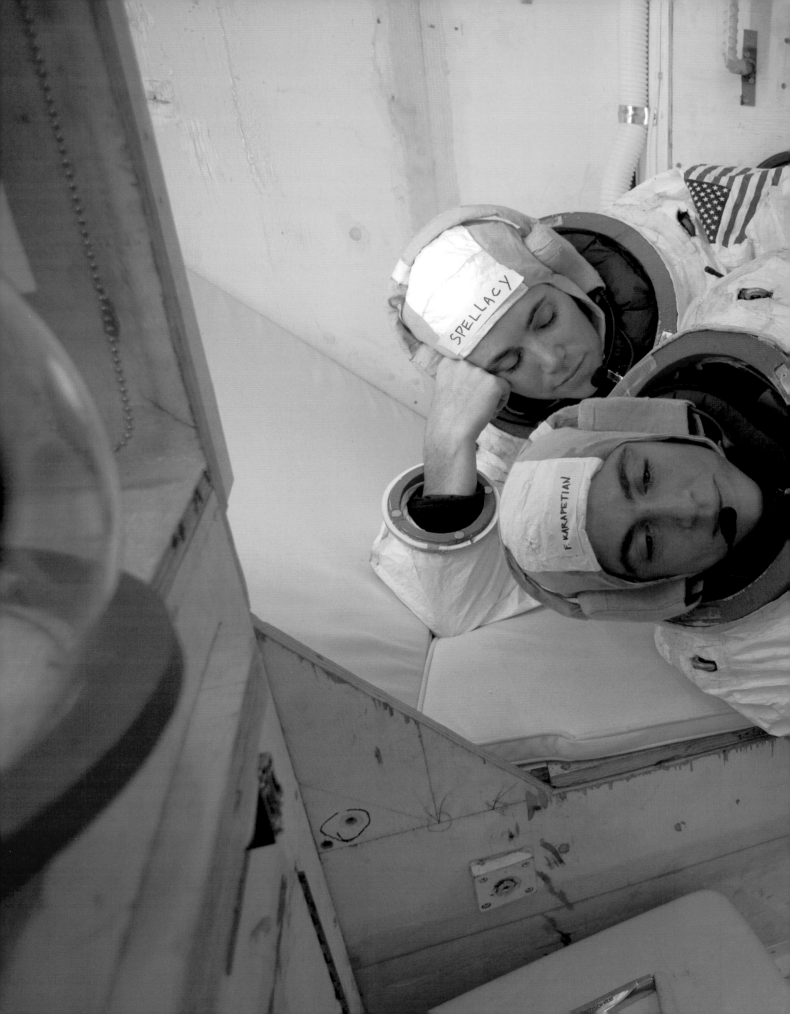

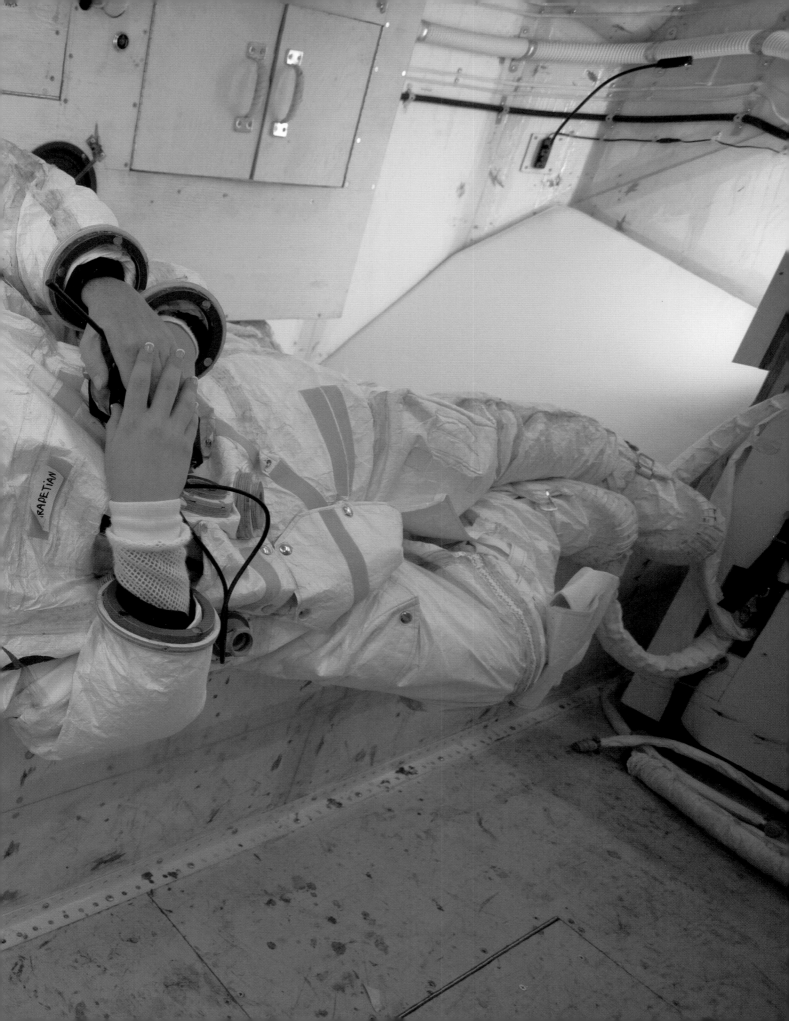

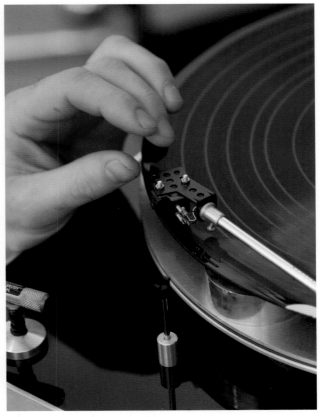

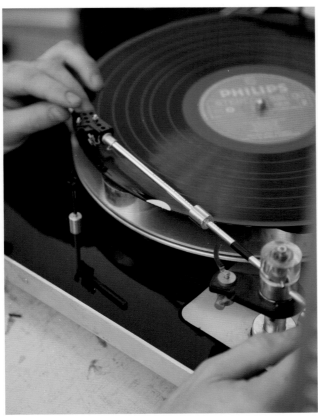

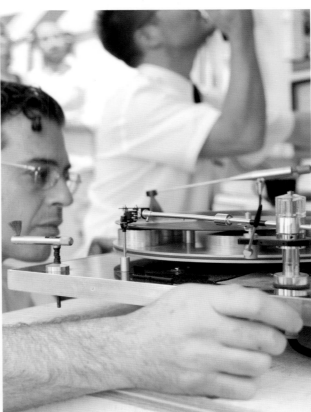

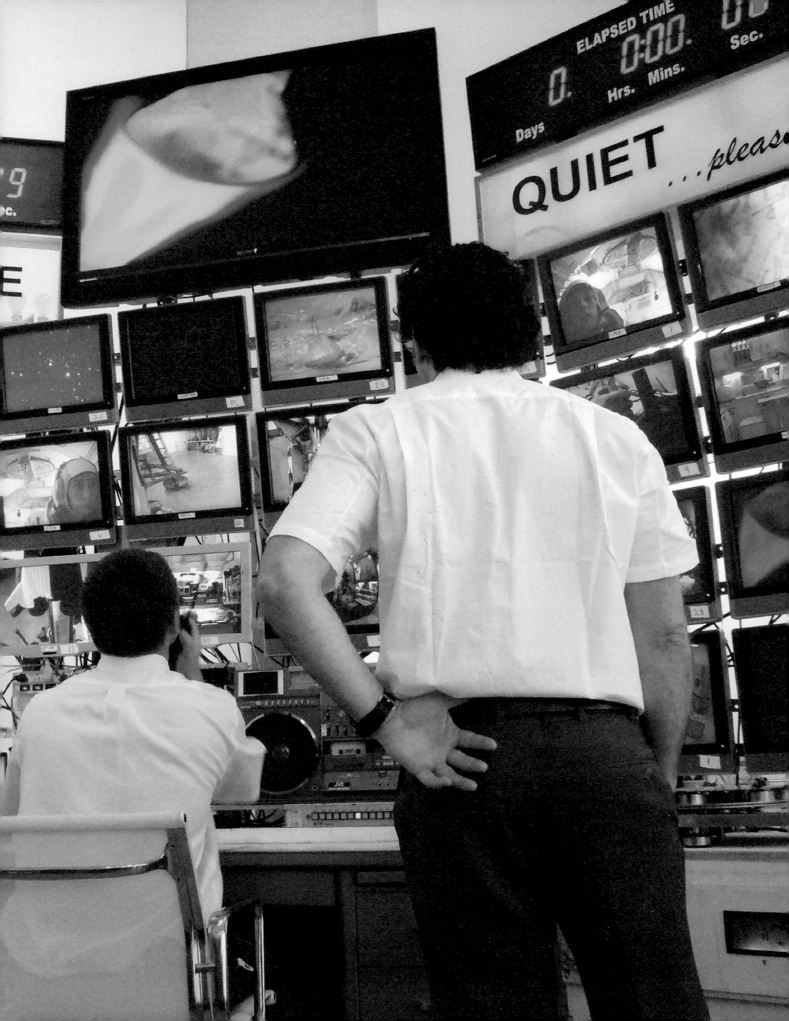

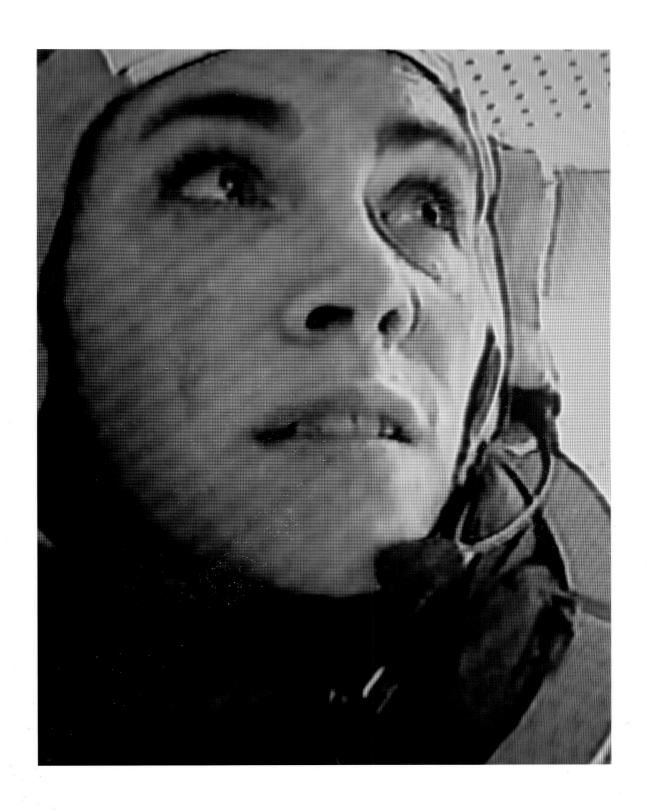

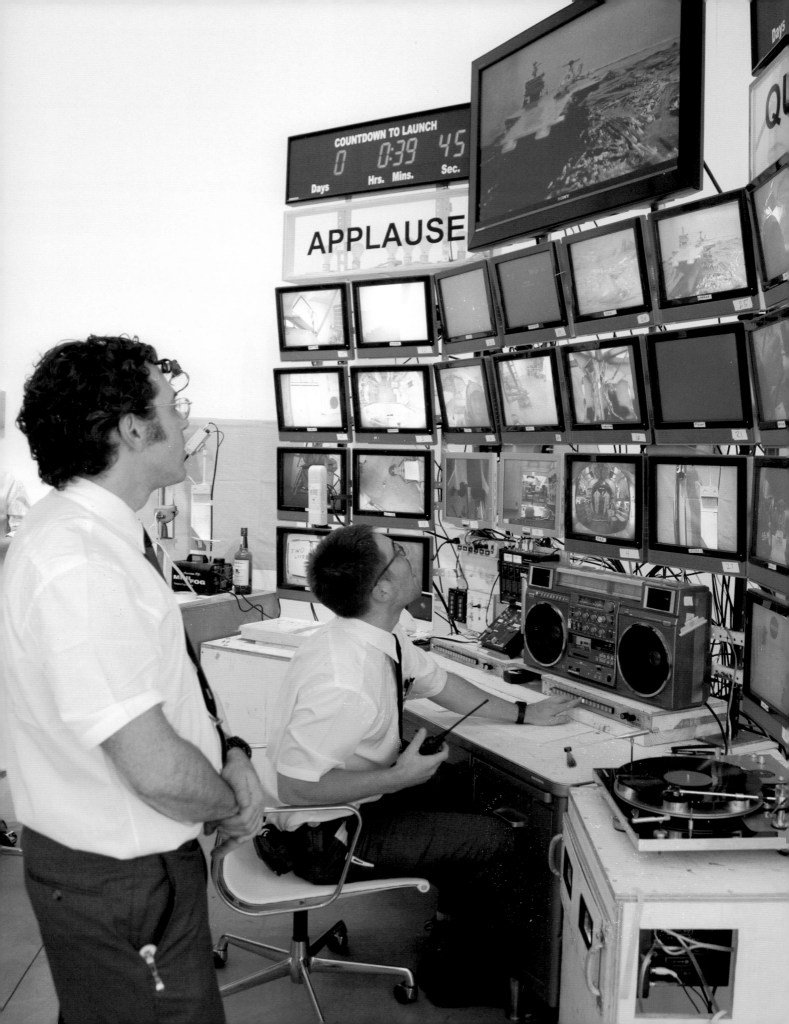

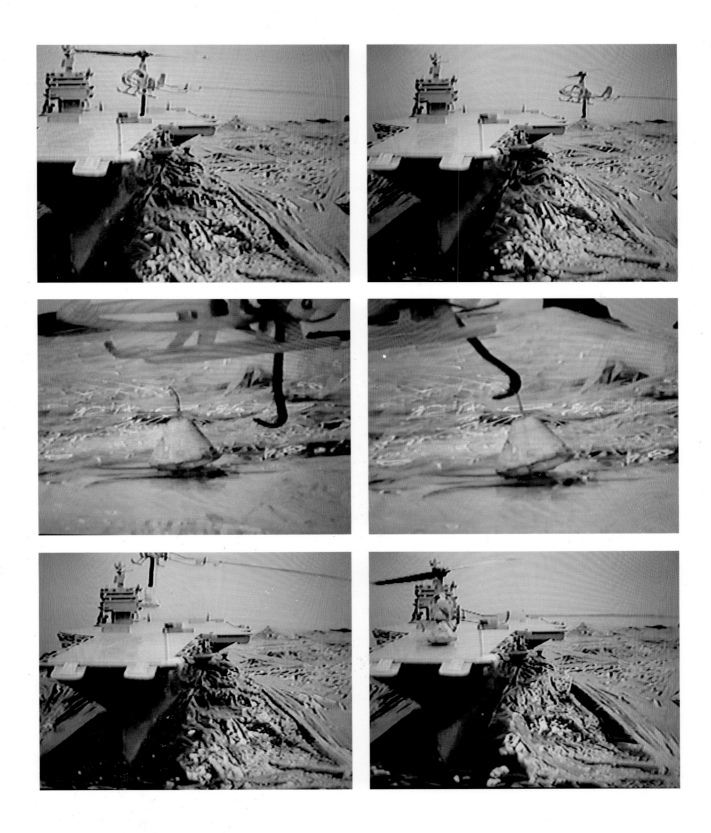

THIS PAGE INTENTIONALLY LEFT BLANK.

Space Suit

The activities performed when an astronaut is separated from his or her ship, known as Extravehicular Activities (EVA), are among the most daunting aspects of the Space Program, both technically and in terms of the demands made on the men and women who perform them. The astronaut is exposed directly to the rigors of space, without the physical and psychological protection of a surrounding spacecraft. The Extravehicular Mobility Unit (EMU, or space suit) must then be a kind of spaceship in its own right. In this particular mission, the EMU is required to protect the Lunar Excursion Module (LEM) crewmen from the effects of open space and its hard vacuum, as well as allowing them to accomplish a variety of objectives in the unknown conditions found on the lunar surface. The current version of the EMU, known as the A7L, has been used on all of the Apollo missions without major design changes. The first generation, the A5L, was used only in training; the next, the A6L, was the first to incorporate an integrated micrometroid protective layer and thermal protective layer. Each A7L EMU is made to fit the measurements of a particular astronaut and consists of three main layers. The outer Integrated Thermal Micrometeoroid Garment (ITMG) protects against solar radiation, micrometeor strike, and the more prosaic abrasion. Under that is the Torso Limb Suit Assembly (TLSA), which acts as a pressure garment and includes an assembly for attaching the fishbowl helmet as well as the Portable Life Support System (PLSS) backpack. The third, innermost layer, worn only by crew members who perform Moon walks, is the Liquid Cooling and Ventilation Garment (LCG). Together, the various components provide a complete and independent life-support system for up to eight hours.

While all the systems involved in achieving the goal of putting a man on the Moon and returning him safely are technologically exciting, none is more profound than the EMU. Spaceships may challenge the vastness of space, orbiting around the Earth and Moon and then returning safely home, but to accomplish the real dream of having a man walk, under his own power, across the face of another planet, or to float alone in the vacuum of space, an EMU is a necessity. It is also among the most iconic pieces of design ever built by the Space Program, signifying the drama and awe of man in space. Individual astronauts may not be known to most people, but a crewman in his EMU is instantly recognizable. The gold reflective foil of the fishbowl helmet has become the true face of the last frontiersman.

LIQUID COOLING AND VENTILATION GARMENT (LCG)

The Liquid Cooling and Ventilation Garment (LCG) is the layer worn closest to the astronaut's skin. It is made of silk for comfort and is constructed in two pieces, upper and lower, with medium-gauge nylon tubing attached to both sections. The tubing is used to continuously circulate cold water against the astronaut's skin, helping to maintain a comfortable and safe body temperature within the closed environment of the EMU. Many of the activities of the mission are quite strenuous—opening and assembling the Modular Equipment Stowage Assembly (MESA), collecting geological samples, and even simple movement within and outside the Lunar Excursion Module (LEM)—and the LCG works to moderate body temperature regardless of the astronaut's level of exertion and whether in the heat of full sun or the cold of lunar shadow.

The astronauts spend extended periods in the EMU and must constantly take in fluids in order to prevent dehydration. So, it is essential to provide a safe and comfortable way to dispose of urine. This layer includes a Texas Catheter Urine Collection Transfer Assembly (UCTA), made from a condom with tubing at the end of it. The UCTA will accept urine at rates as high as 30 cc per second, with no manual adjustment or operation by the crewman being required.

It should also be noted that only crew participating in the Extravehicular Activities (EVA) wear the LCG. The Command Module Pilot (CMP) wears a simple cotton unionsuit garment known as the Constant Wear Garment (CWG). Thus, the LCG is one of the primary signifiers of the Moon walk.

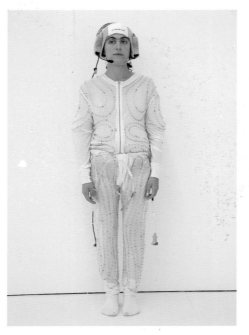

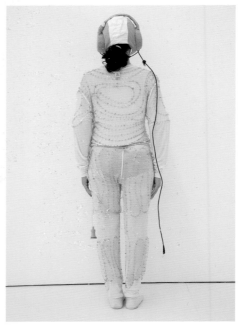

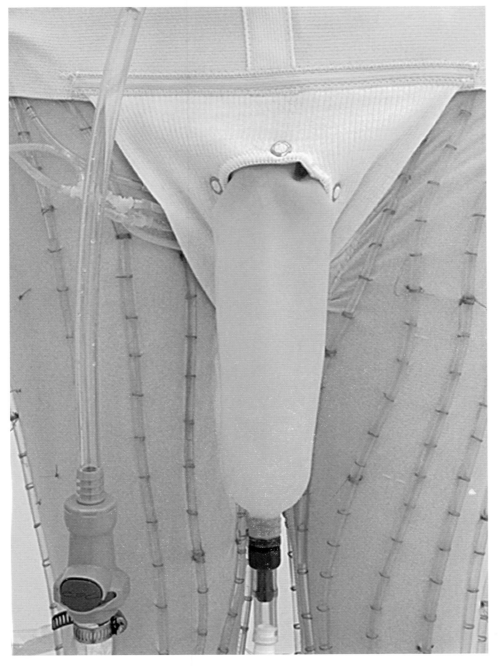

TORSO LIMB SUIT ASSEMBLY (TLSA)

The Torso Limb Suit Assembly (TLSA) is worn only by the two astronauts who perform the Moon walk. It is the most essential layer of the EMU, pressurized so the astronaut can complete mission tasks in vacuum ambient conditions, transforming the suit into a self-contained spaceship. It also acts as thermal insulation, with a down-filled layer protecting the torso and legs from extreme heat and cold. As with other parts of the EMU, each TLSA is sized for the individual. Around the neck is the helmet-attaching ring, connected to a come-along ratchet assembly, which holds the helmet in position against the pull of the Portable Life Support System (PLSS). The upper PLSS attachment harness is at the rear of the suit.

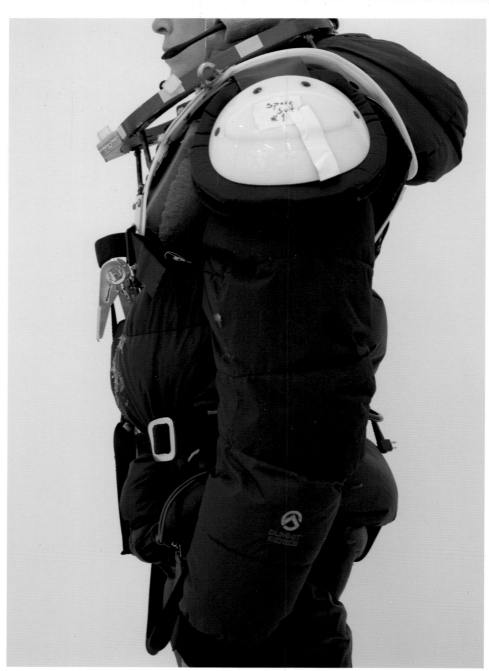

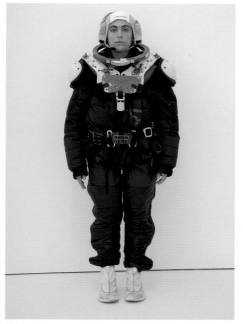

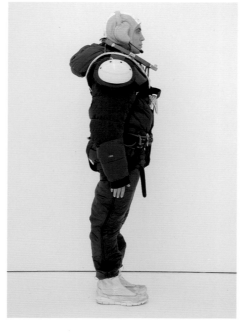

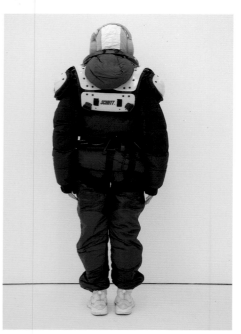

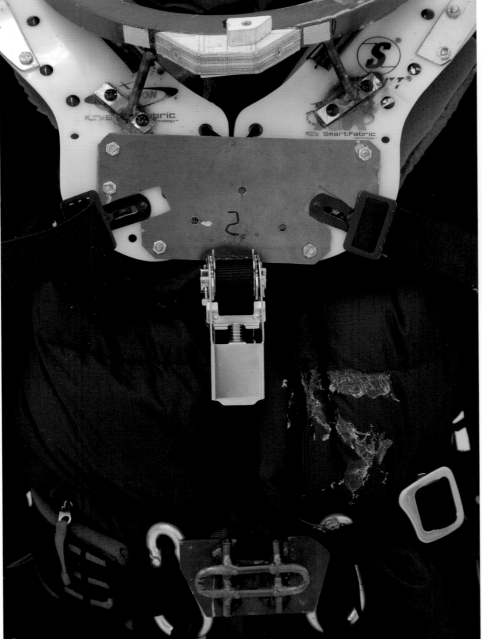

INTEGRATED THERMAL MICROMETEOROID GARMENT (ITMG)

The Integrated Thermal Micrometeoroid Garment (ITMG), the outer layer of the EMU, is designed to protect the Torso Limb Suit Assembly (TLSA) from abrasion and to protect the crew member from thermal solar radiation. The white coloration of the suit reflects heat, while the tough Tyvek it is constructed from resists tearing during Extravehicular Activities (EVA) and holing from micrometeoroid impact. The Tyvek is typically used in industrial applications, such as constructing mailing containers. The ITMG is seamed together with gaffer's tape, hot glue, and Velcro. Six valves on the front of the suit provide connection points for gas inlet and outlet, electrical systems, and water. Two sets of boots are worn on the feet. A yellow inner boot, which is worn in the clean room and while the astronauts are transported to the Lunar Excursion Module (LEM) via the Scissor Lift (SL), is built to nuclear-grade specs (meets American Society of Mechanical Engineers Nuclear Assurance-1 standards). The outer shoe, put on once the astronaut is in the LEM, is double-wide to prevent the astronaut from sinking into the lunar dust, which was of unknown softness.

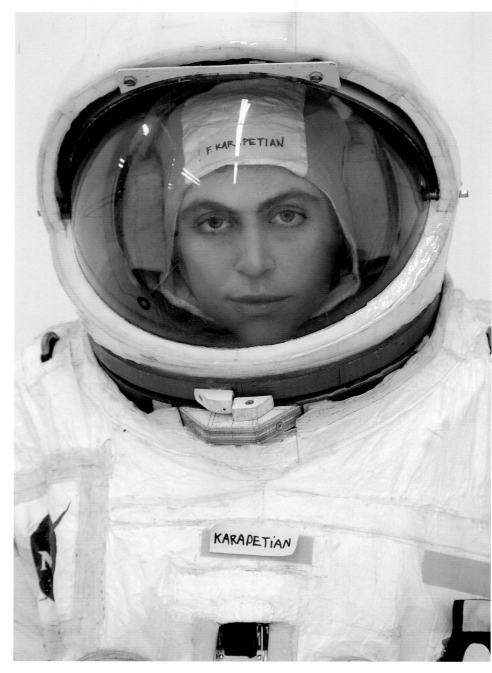

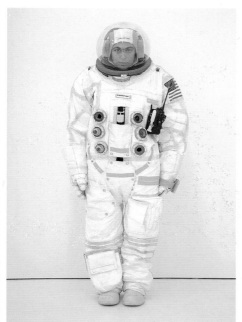

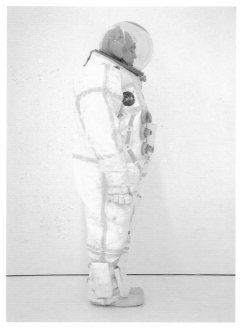

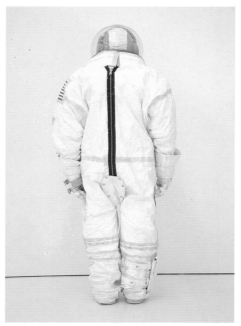

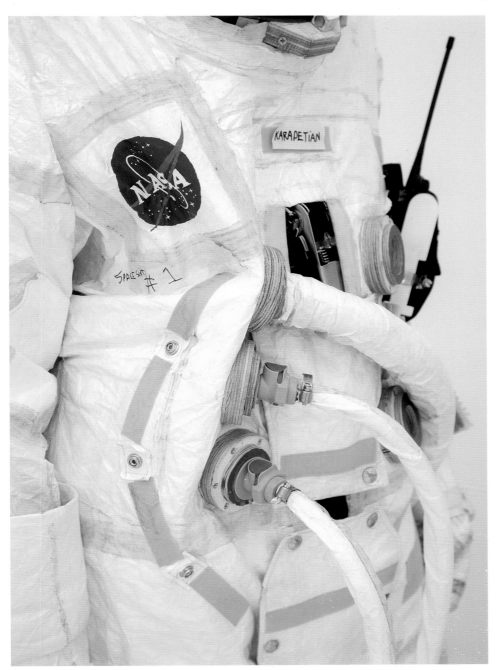

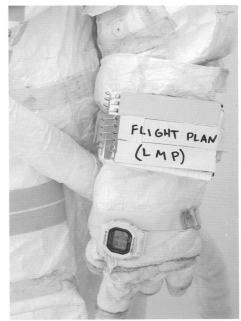

PORTABLE LIFE SUPPORT SYSTEM (PLSS)

The Portable Life Support System (PLSS) contains both the cooling and the circulation systems for the EMU. A self-priming peristaltic blood pump is used to move fluid from a thermal vacuum container through the tubes covering the Liquid Cooling and Ventilation Garment (LCG), and then back to the PLSS, where it is cooled and recirculated. Because of the nature of the peristaltic pump, the cooling fluid moves in a completely closed system: at no point does it come into contact with the air or with any moving part. This minimizes the possibility of leakage and evaporation, and helps to ensure that it is always possible to maintain a safe body temperature for the crew members.

As an additional security measure, the Commander (CDR) has been issued a shotgun, which is attached to the side of the PLSS. The shotgun fires a single shotgun shell of twenty led pellets, after which it must be reloaded.

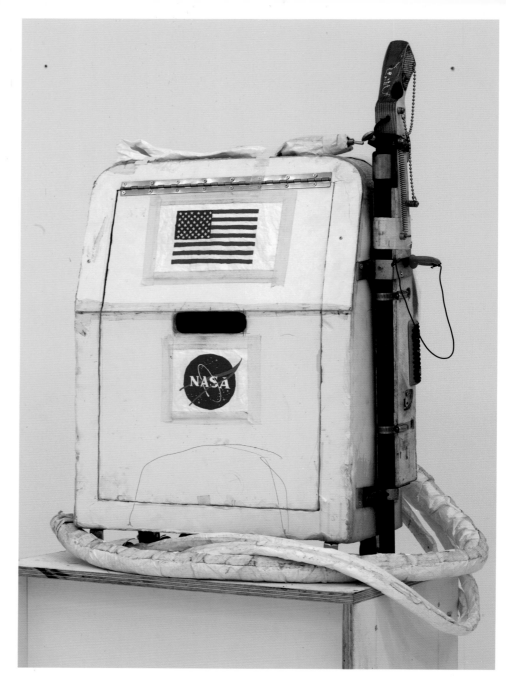

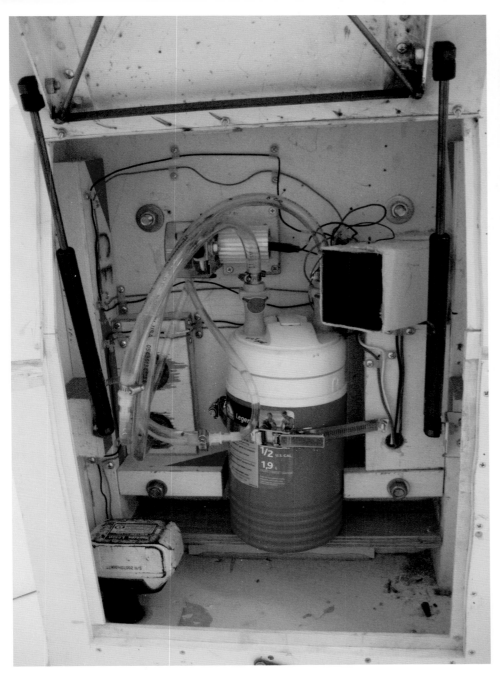

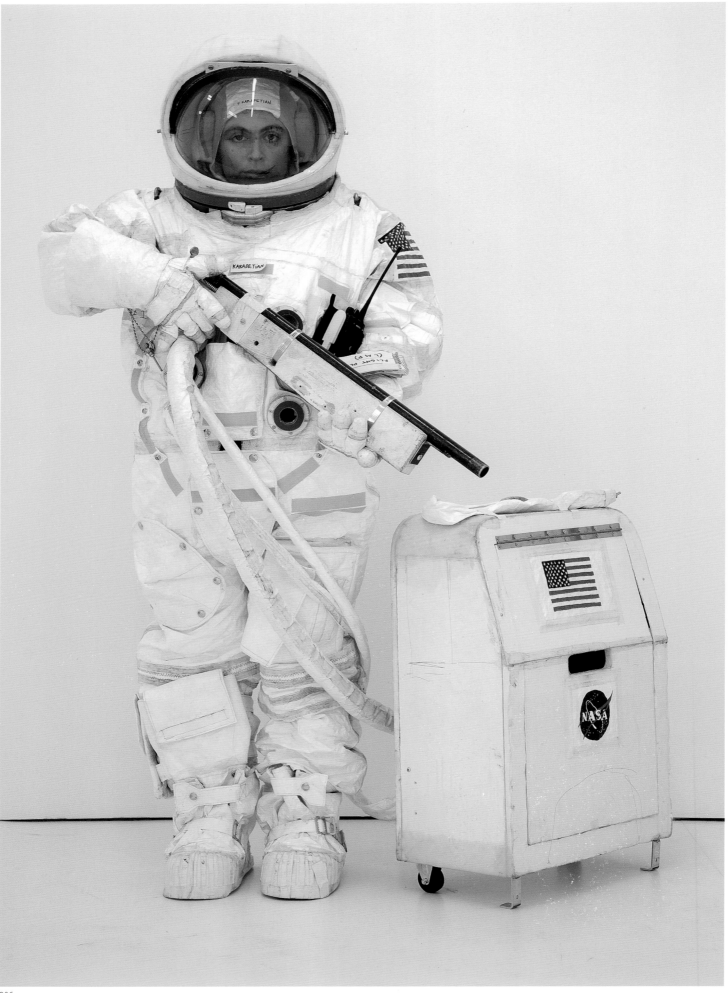

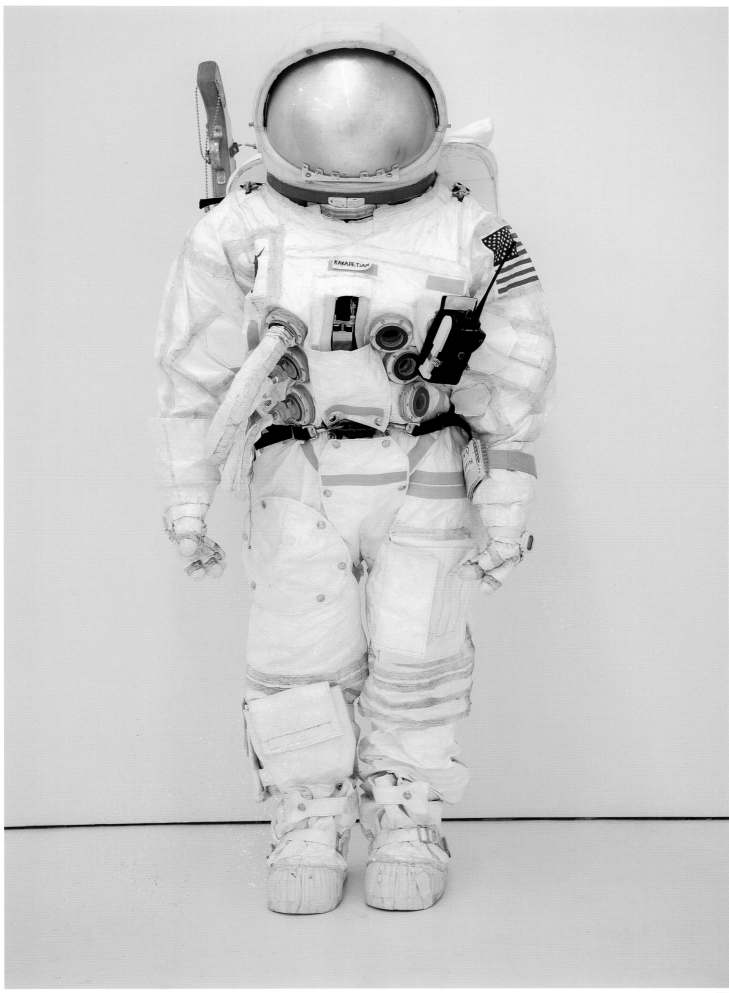

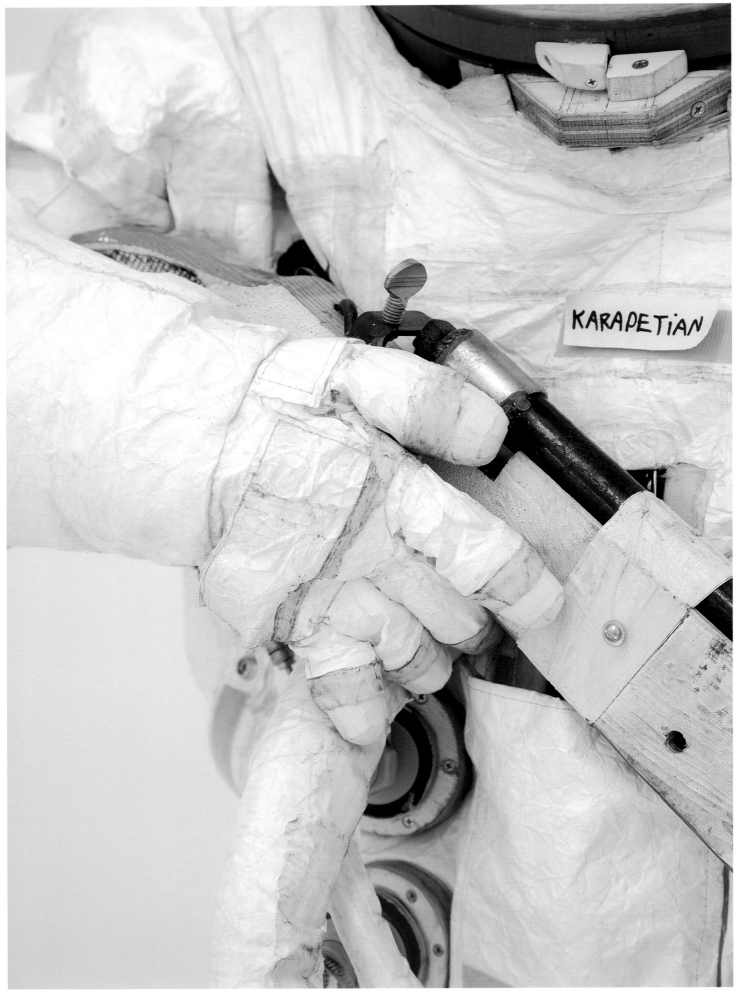

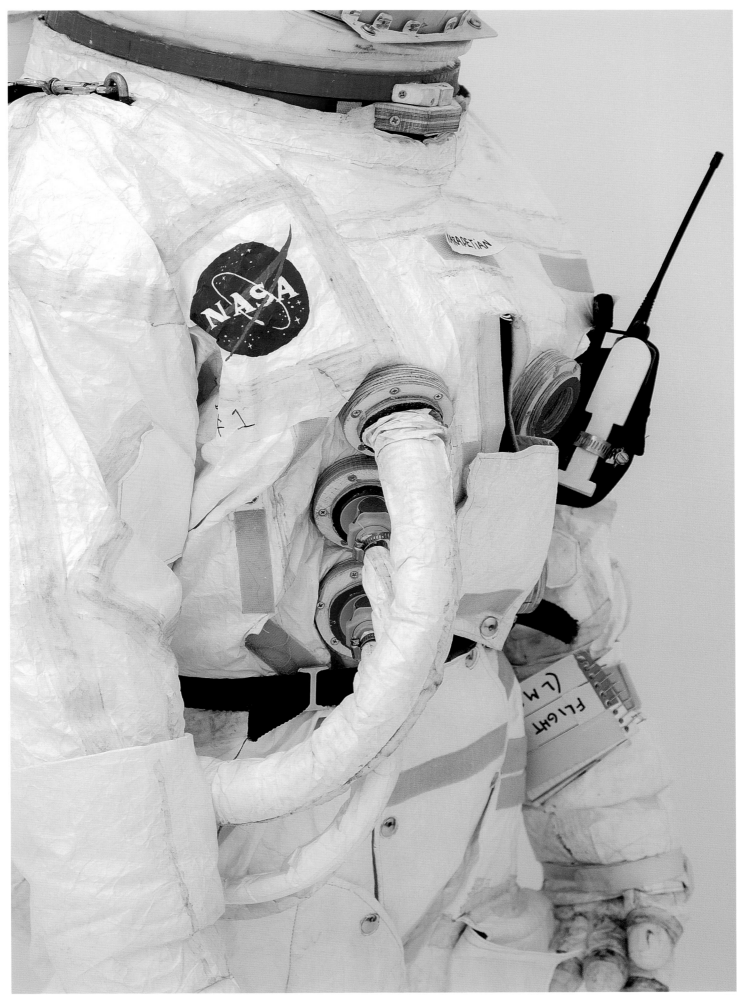

THIS PAGE INTENTIONALLY LEFT BLANK.

USEFUL ACRONYMS

AEA: Aft Equipment Assembly
AFS: American Flag Stand
AGC: Apollo Guidance Computer
AGS: Abort Guidance System
AHS: Aft Heat Shield
ALSEP: Apollo Lunar Surface Experiment Package
AM: Ascent Module
AS: Ascent Stage
ASS: Auxiliary Support System
ATF: Alcohol Tobacco Firearms
A/V: Audiovisual
BCH: Bench
CAPCOM: Capsule Communicator
 (voice of mission control)
CDR: Commander (astronaut)
CF: Champagne Fridge
CH: Cunt Hair (1/64 inch nominally)
CL: Cooling Layer
CM: Command Module
CMP: Command Module Pilot (astronaut)
CR: Coatrack
CRT: Cathode-Ray Tube
CS: Communications Subsystems ("C-sub")
CSM: Command Service Module
CWG: Constant Wear Garment
DAC: Data Acquisition Camera
DJ: Disc Jockey
DM: Descent Module
DS: Descent Stage
ECS: Environmental Control System
EFM: Ephemera ("F' 'em")
EMK: Emergency Medical Kit
EMU: Extravehicular Mobility Unit (space suit)
EV: Extravehicular
EVA: Extravehicular Activities
FBA: Forward Bulkhead Assembly
FMS: Food Management System
FP: Flight Plan
GET: Ground Elapsed Time
GNES: Guidance Navigation and Entertainment System
GOAL: Ground Operations Aerospace Language
GPES: Goal Performance Evaluation System
H20: Water
HAC: Heuristically Programmed Algorithmic Computer
HNDS: Hot Nuts Delivery System
HRC: Hasselblad Reflex Camera
HS: Heat Shield
ICBM: Intercontinental Ballistic Missile
ID: Inside Diameter
IMU: Inertial Measurement Unit
ITMG: Integrated Thermal Micrometeoroid Garment
KNF: Knife
LCD: Liquid Crystal Display
LCG: Liquid Cooling and Ventilation Garment
LED: Light-Emitting Diode
LEM: Lunar Excursion Module
LG: Landing Gear
LM: Lunar Module
LME: Lunar Moon Effect

LMP: Lunar Module Pilot (astronaut)
LRL: Lunar Receiving Laboratory
LSD: Lunar Surface Drill
LSS: Life Support System
MA: Moon Rock Analyzer
MAD: Mutually Assured Destruction
MC: Master of Ceremonies
MCC: Mission Control Center
MESA: Modular Equipment Stowage Assembly
MR: Moon Rock
MRE: Meals Ready to Eat
MSA: Mid-Section Assembly
OL: Outer Layer
PAR: Parabolic Aluminum Reflection
PLSS: Portable Life Support System
PPL: Pulley/Pressure Layer
PST: Prostitution
PT: Prototype
QB: Quarterback
RCH: Red Cunt Hair (1/128 inch nominally)
RCS: Reaction Control System ("Racks")
RCU: Remote Control Unit
RRA: Rendezvous Radar Antenna
RSM: Resume
RUT: Resource Utilization Time
SAEF: Spacecraft Assembly and
 Encapsulation Facility
SL: Scissor Lift
SLA: Support and Logistics Areas
SM: Service Module
SRC: Lunar Sample Return Container
SS(A): Space Suit (A)
SS(B): Space Suit (B)
STW: Stowage
TA: Turtle Analyzer
TDS: Tequila Delivery System
TEI: Transearth Injection
 (from Moon orbit to Earth)
TLI: Translunar Injection
 (from Earth orbit to Moon)
TLS: Tools
TLSA: Torso Limb Suit Assembly
UCD: Urine Collection Device
UCTA: Urine Collection Transfer Assembly
UST: Universal Servicing Tool
UT: Umbilical Tower
VAB: Vehicle Assembly Building
VAC: Volts AC
VC: Visual Confirmation
VCG: Viet Cong
VCS: Voice Command System
V&DA: Video and Data Assembly
VDC: Volts DC
VDS: Vodka Delivery System
VSI: Video Simulation Interface
WDS: Water Delivery System
WMS: Waste Management System

GAGOSIAN GALLERY

GAGOSIAN GALLERY

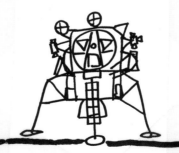

GAGOSIAN GALLERY

456 NORTH CAMDEN DRIVE BEVERLY HILLS CA 90210 T. 310.271.9400 F. 310.271.9420
INFO@GAGOSIAN.COM WWW.GAGOSIAN.COM

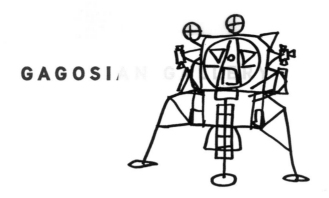

GAGOSIAN GALLERY

GAGOSIAN GALLERY

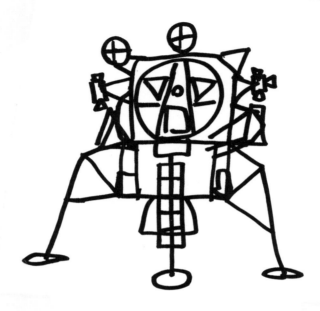

GAGOSIAN GALLERY

456 NORTH CAMDEN DRIVE BEVERLY HILLS CA 90210 T. 310.271.9400 F. 310.271.9420
INFO@GAGOSIAN.COM WWW.GAGOSIAN.COM

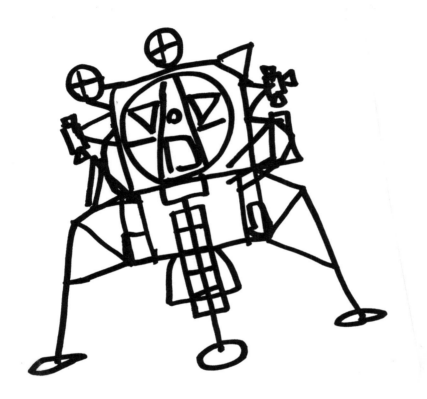

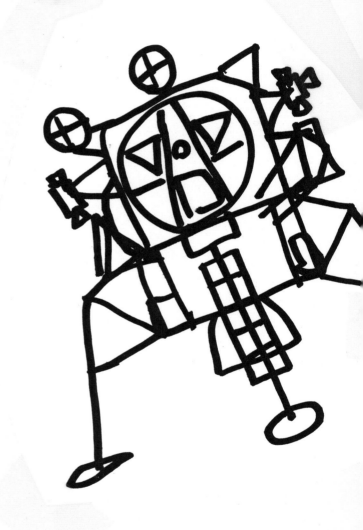

GAGOSIAN GALLERY

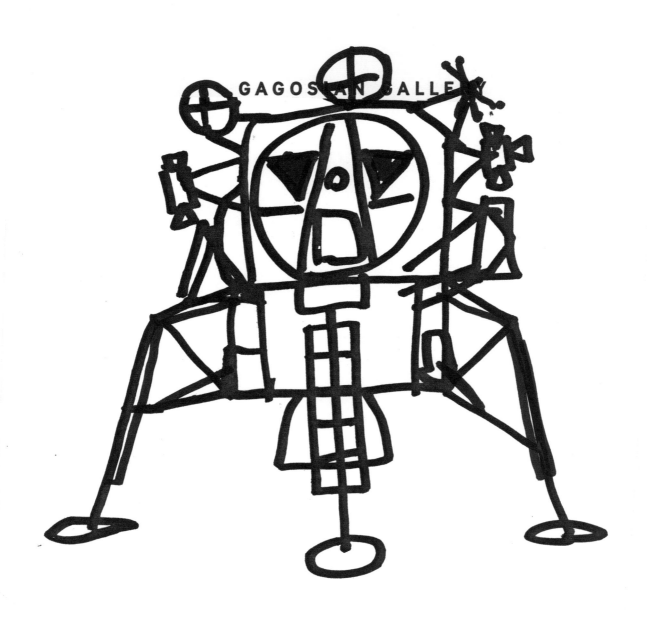

GAGOSIAN GALLERY

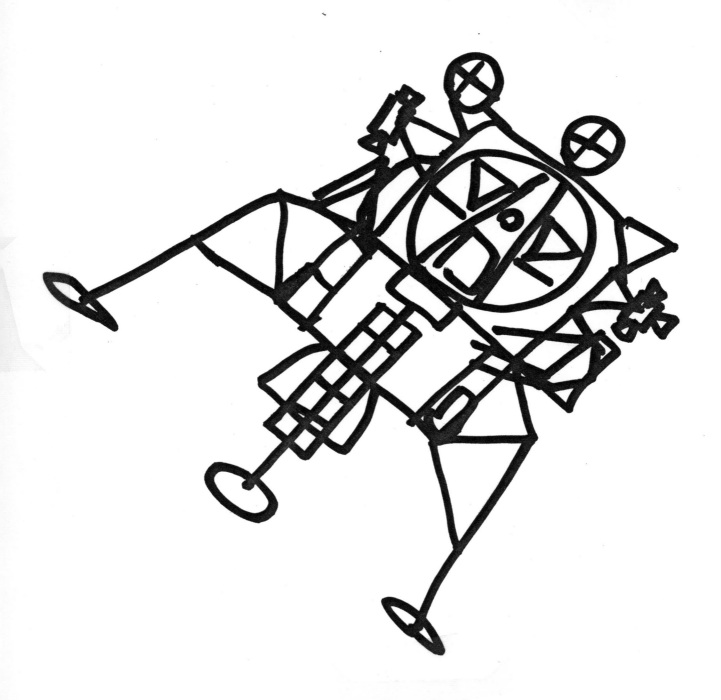

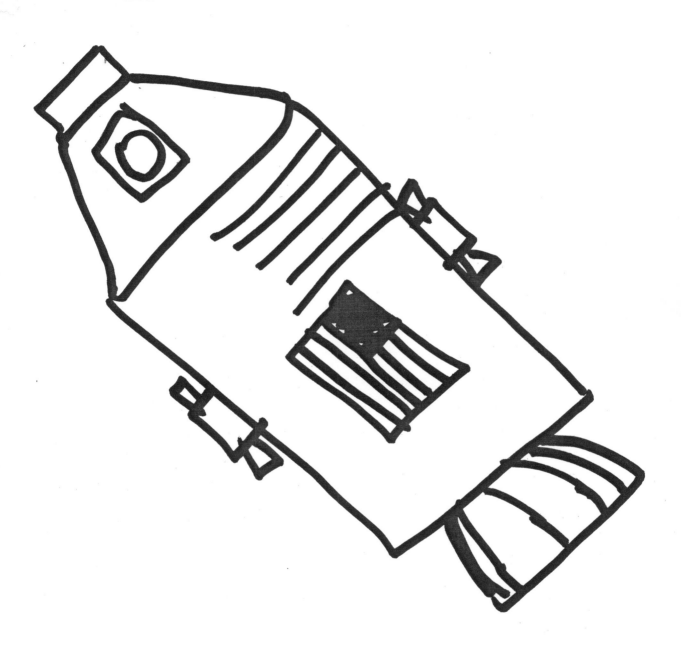

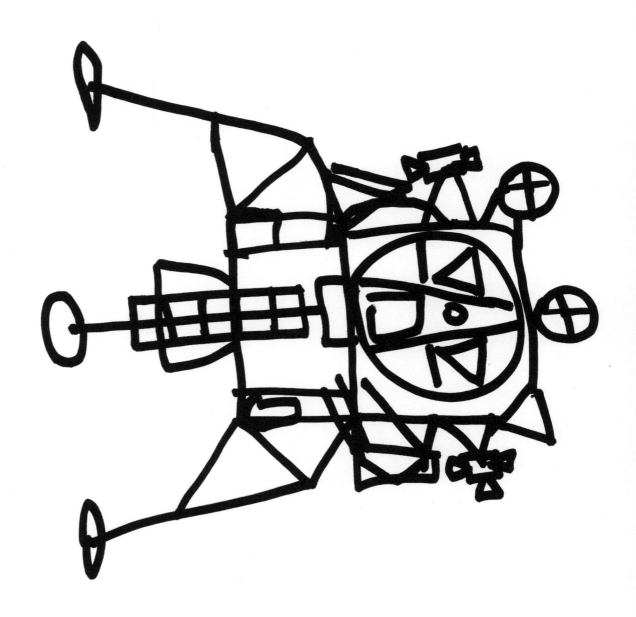

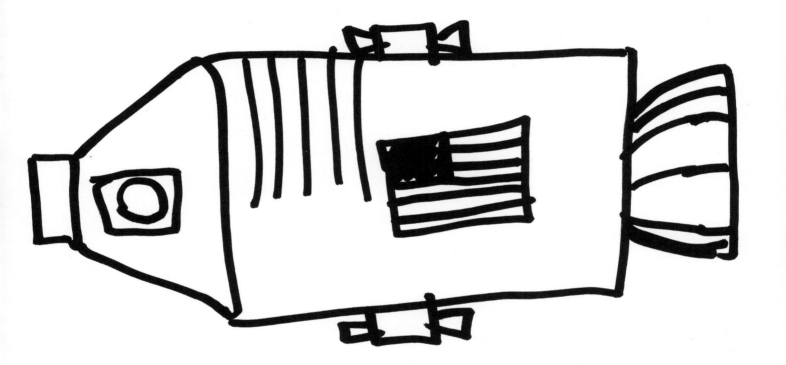

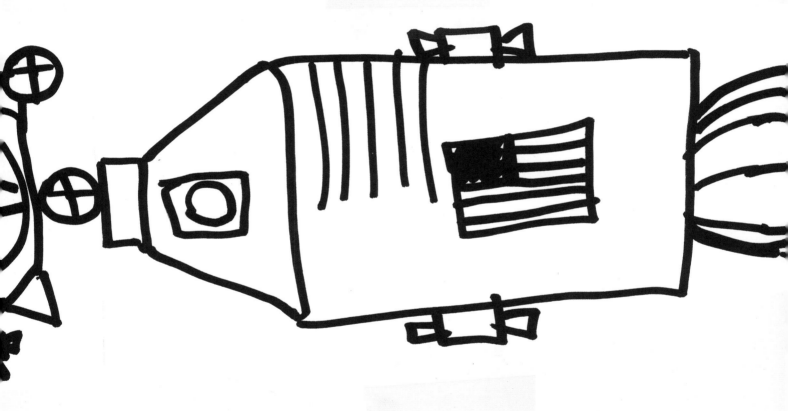

GAGOSIAN GALLERY

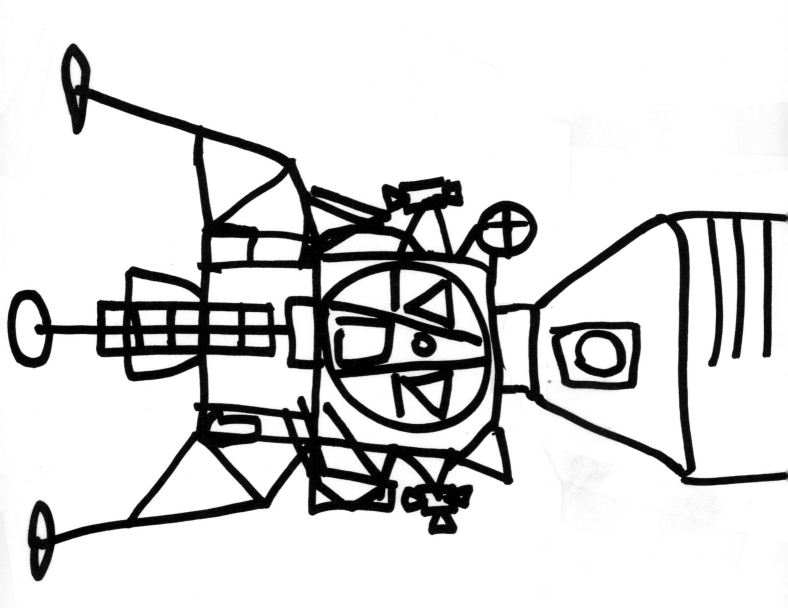

GAGOSIAN GALLERY

GAGOSIAN GALLERY

456 NORTH CAMDEN DRIVE BEVERLY HILLS CA 90210 T. 310.271.9400 F. 310.271.9420
INFO@GAGOSIAN.COM WWW.GAGOSIAN.COM

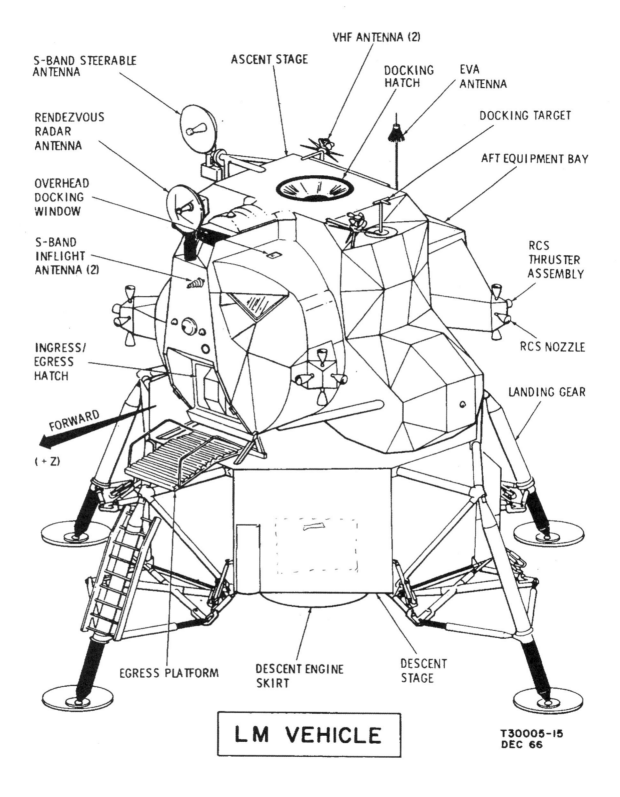

S-BAND STEERABLE ANTENNA

RENDEZVOUS RADAR ANTENNA

OVERHEAD DOCKING WINDOW

S-BAND INFLIGHT ANTENNA (2)

INGRESS/ EGRESS HATCH

FORWARD

(+Z)

ASCENT STAGE

VHF ANTENNA (2)

DOCKING HATCH

EVA ANTENNA

DOCKING TARGET

AFT EQUIPMENT BAY

RCS THRUSTER ASSEMBLY

RCS NOZZLE

LANDING GEAR

EGRESS PLATFORM

DESCENT ENGINE SKIRT

DESCENT STAGE

LM VEHICLE

T30005-15
DEC 66

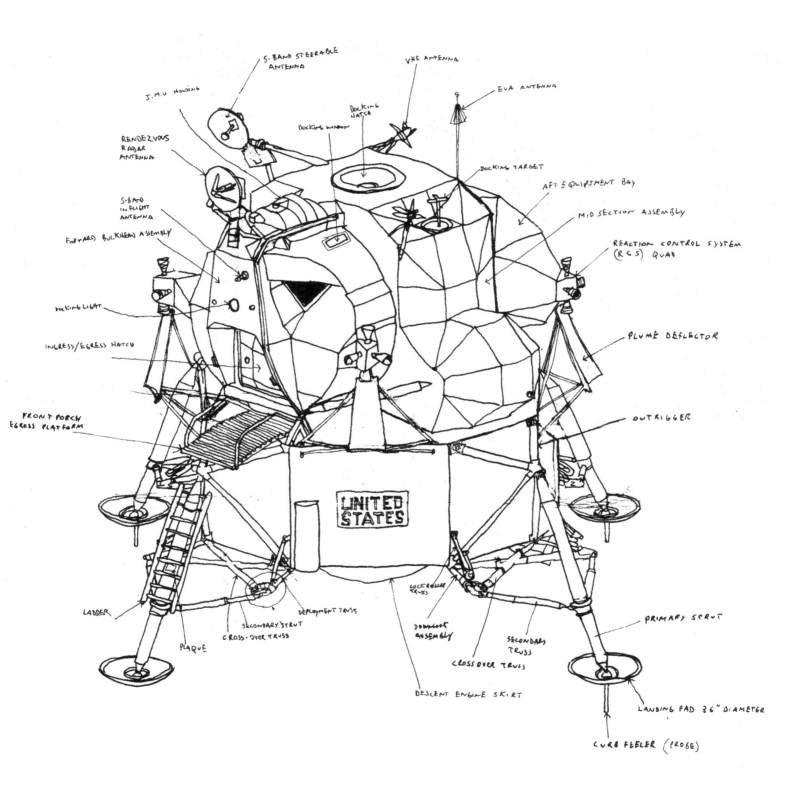

S-BAND STEERABLE ANTENNA

VHF ANTENNA

EVA ANTENNA

J.M.U HOUSING

DOCKING HATCH

DOCKING WINDOW

DOCKING TARGET

RENDEZVOUS RADAR ANTENNA

AFT EQUIPMENT BAY

MID SECTION ASSEMBLY

S-BAND IN FLIGHT ANTENNA

REACTION CONTROL SYSTEM (RCS) QUAD

FORWARD BULKHEAD ASSEMBLY

DOCKING LIGHT

INGRESS/EGRESS HATCH

PLUME DEFLECTOR

FRONT PORCH EGRESS PLATFORM

OUTRIGGER

UNITED STATES

LADDER

LOCK ROLLER TRUSS

PRIMARY STRUT

DEPLOYMENT TRUSS

SECONDARY STRUT

DOWNLOCK ASSEMBLY

SECONDARY TRUSS

CROSS-OVER TRUSS

PLAQUE

CROSSOVER TRUSS

DESCENT ENGINE SKIRT

LANDING PAD 36" DIAMETER

CURB FEELER (PROBE)

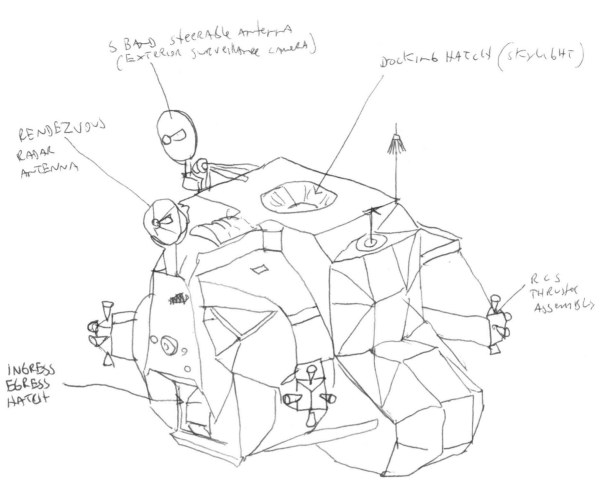

S BAND STEERABLE ANTENNA (EXTERIOR SURVEILLANCE CAMERA)

DOCKING HATCH (SKYLIGHT)

RENDEZVOUS RADAR ANTENNA

RCS THRUSTER ASSEMBLY

INGRESS EGRESS HATCH

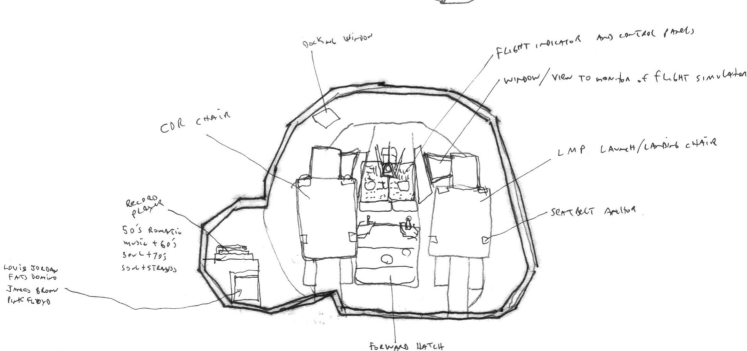

DOCKING WINDOW

FLIGHT INDICATOR AND CONTROL PANELS

WINDOW / VIEW TO MONITOR OF FLIGHT SIMULATOR

CDR CHAIR

LMP LAUNCH/LANDING CHAIR

RECORD PLAYER
50'S ROMANTIC MUSIC + 60'S SOUL + 70'S SOUL + STRAUSS

SEATBELT SHELTER

LOUIS JORDAN FATS DOMINO
JAMES BROWN PINK FLOYD

FORWARD HATCH

ASCENT STAGE (SECTION LOOKING FORWARD)

ASCENT STAGE

238

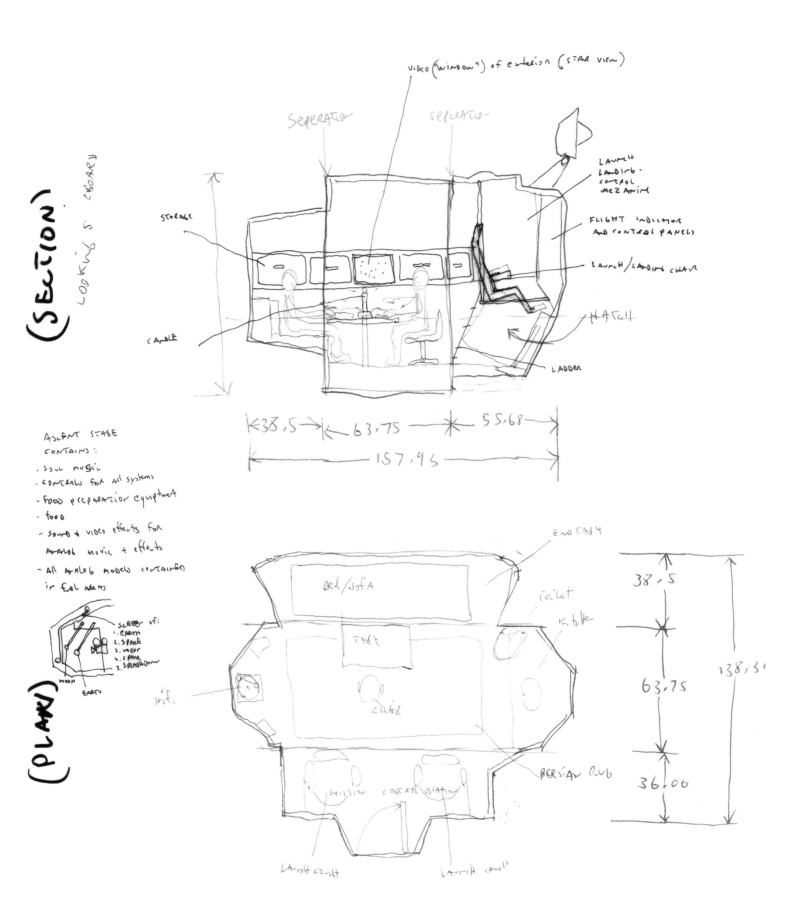

(SECTION)

LOOKING S. (BOARD)

Seperation Seperatoin

VIDEO ("WINDOW") of exterior (STAR VIEW)

STORAGE

CANDLE

LAUNCH
LANDING
CONTROL
MEZANINE

FLIGHT INDICATOR
AND CONTROL PANELS

LAUNCH/LANDING CHAIR

HATCH

LADDER

|←38.5→|← 63.75 —|—— 55.68 ——|

|←———————— 157.95 ————————→|

ASCENT STAGE
CONTAINS:
· SOUL MUSIC
· CONTROLS FOR ALL SYSTEMS
- FOOD PREPARATION EQUIPMENT
- FOOD
- SOUND & VIDEO EFFECTS FOR
 ANALOG MOVIE + EFFECTS
- ALL ANALOG MODELS CONTAINED
 IN FUEL AREAS

MOON

EARTH

SCREEN OF:
1. EARTH
2. SPACE
3. MOON
4. SPACE
5. SPLASHDOWN

HIFI

(PLAN)

END CAPSY

BED / SOFA

TASK

CHAIR

TOILET

K. Table

BERSIAN RUG

MISSION CONTROL STATION

LAUNCH CONDIT LAUNCH CONDIT

38.5

63.75

138.31

36.00

239

INBOARD ➤

R-8

Typical Micrometeoroid Protection

The micrometeoroid shield, outboard of the thermal blanket, is a sheet of aluminum that varies in thickness from 0.004 to 0.008 inch, depending on micrometeoroid-penetration vulnerability. It is attached to the same standoffs as the thermal blankets. Various thermal control coatings are applied to the outer surface of the shield to provide an additional temperature boundary for vehicle insulation against space environment.

DESCENT STAGE

The descent stage is the unmanned portion of the LM; it represents approximately two-thirds of the weight of the LM at the earth-launch phase. This is because the descent engine is larger than the ascent engine and it requires a much larger propellant load. Additionally, its larger proportion of

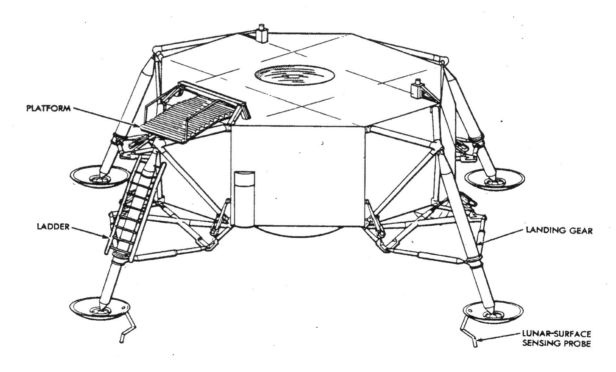

R-9

Descent Stage

240

DESCENT STAGE TAXONOMY

EARTH

SUCK BLOW

MESA SUPPORT

B

W

MOON

STARS

TOILET

ENTRANCE

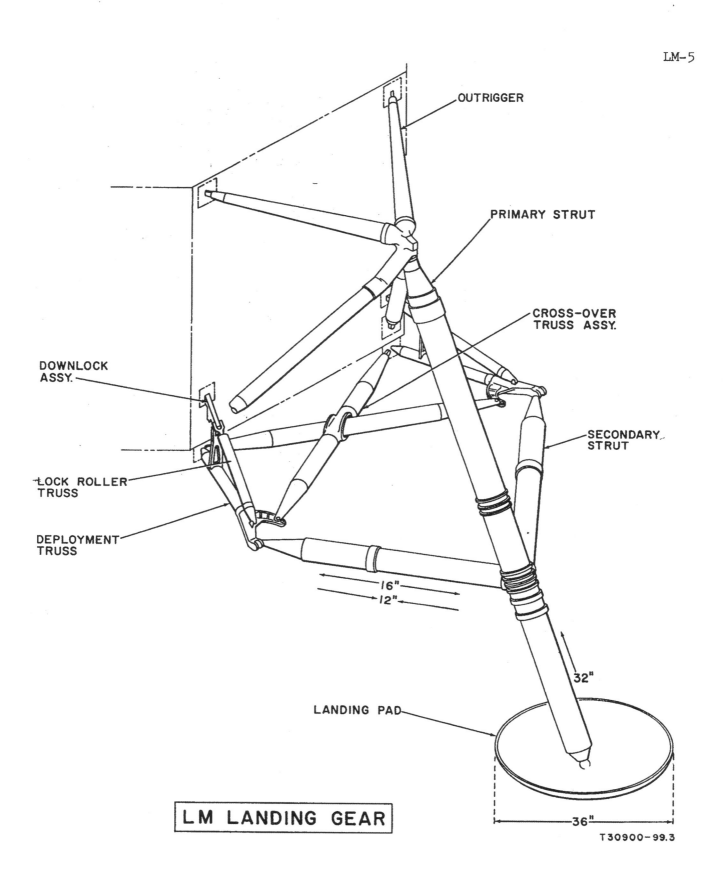

OUTRIGGER

PRIMARY STRUT

CROSS-OVER
TRUSS ASSY.

DOWNLOCK
ASSY.

SECONDARY
STRUT

LOCK ROLLER
TRUSS

DEPLOYMENT
TRUSS

16"

12"

32"

LANDING PAD

LM LANDING GEAR

36"

T30900-99.3

FOR TRAINING PURPOSES ONLY

6/19/06

white leather

NASA MEATBALL LOGO

EMU overshoe

1994 JORDANS

Attaches to descent stage structure

side frame

DEPLOY

SECONDARY STRUT

Deployment and Downlock Assembly

THE LOCK CAN NOT BE OPENED

MONROE

PRIMARY STRUT

CROSS member Assembly

footpad

LANDING GEAR

LUNAR SENSING PROBE

RESTLESS LEGS SYNDROME ?

2.11.7.3 Window Shades.

Window shades are used for the overhead docking window and forward windows. The window shade material is Aclar with a deposit of Iconel, resulting in light transmissibility of approximately 0.1%. The surface facing outside the cabin has a highly reflective metallic coating. The shade is secured at the bottom (rolled position). To cover the window, the shade is unrolled, flattened against the frame area and secured with snap fasteners.

2.11.7.4 DELETED.

2.11.7.5 Modularized Equipment Stowage Assembly.

The Modularized Equipment Stowage Assembly (MESA) pallet (see figures 2.11-13, 2.11-14 and 2.11-15) is located in quad 4 of the descent stage. The pallet is deployed by the extravehicular astronaut when the LM is on the lunar surface. The pallet contains fresh PLSS batteries and LiOH cartridges, a TV camera, tripod, cable, tools for obtaining lunar geological samples, containers in which to store the samples, and other scientific devices. It also contains a folding work table which also serves as a bracket on which the equipment transfer bag, used to transfer the PLSS batteries and LiOH cartridges to the cabin, is hung.

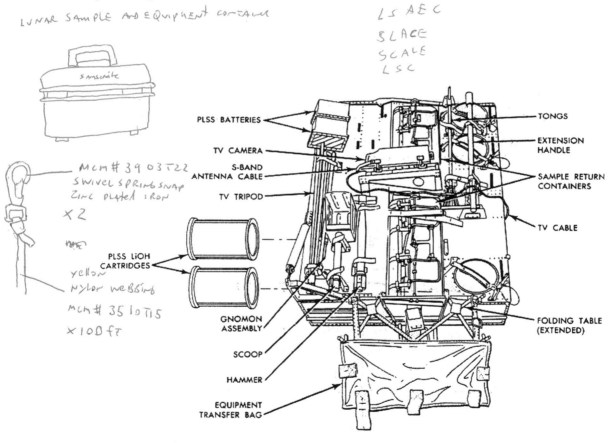

Figure 2.11-13. Modularized Equipment Stowage Assembly

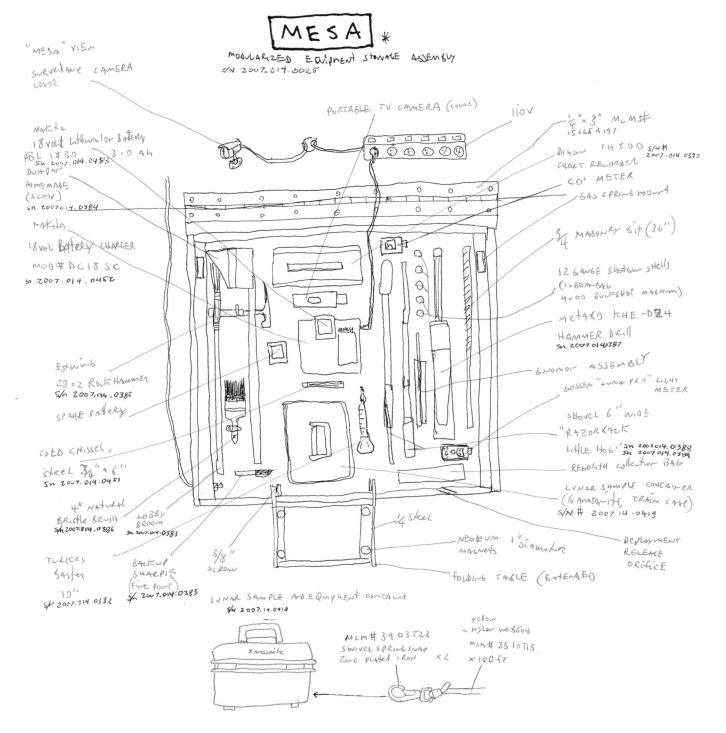

MESA *

MODULARIZED EQUIPMENT STOWAGE ASSEMBLY
S/N 2007.014.0025

"MESA" VIEW
SURVEILLANCE CAMERA
COLOR

PORTABLE TV CAMERA (COLOR) 110V

MAKITA
18 VOLT LITHIUM ION BATTERY
HBL 1830 3.0 Ah
Sn 2007.014.0453
OUTPUT
HOMEMADE
(SLOOV)
Sn 2007.014.0384

MAKITA
18 VOLT BATTERY CHARGER
MOD# DC18SC
Sn 2007.014.0452

¼" × 3" MCM#
56654197

DIXON TH800 S/N#
2007.014.0390
CHART RECORDER
CO₂ METER
GAS SPRING MOUNT

¾ MASONRY BIT (36")

12 GAUGE SHOTGUN SHELLS
(1×BEAN BAG
4×00 BUCKSHOT MAGNUM)

METABO KHE-D24
HAMMER DRILL
Sn 2007.014.0387

GNOMON ASSEMBLY
GOSSEN "LUNA PRO" LIGHT
METER

SHOVEL 6" WIDE
"RAZORBACK
LITTLE HOG" Sn 2007.014.0388
Sn 2007.014.0389
REGOLITH COLLECTOR BAG

LUNAR SAMPLE CONTAINER
(SAMSONITE TRAIN CASE)
S/N# 2007.14.0419

ESTWING
E9 02 ROCK HAMMER
S/N 2007.014.0385

SPARE BATTERY

COLD CHISEL,
STEEL ¾" × 6"
Sn 2007.014.0451

4" NATURAL
BRISTLE BRUSH
S/N 2007.014.0386

LOBBY
BROOM
Sn 2007.014.0383

¼ STEEL

NEODYM 1" DIAMETER
MAGNETS

DEPLOYMENT
RELEASE
ORIFICE

TURKEY
BASTER
10"
S/N 2007.014.0382

BACKUP
SHARPIE
(FINE POINT)
* 2007.014.0383

3/8"
SCREW

FOLDING TABLE (EXTENDED)

LUNAR SAMPLE AND EQUIPMENT CONTAINER
S/N 2007.14.0419

SAMSONITE

MCM# 3903522
SWIVEL SPRING SNAP
ZINC PLATED IRON ×2

YELLOW
NYLON WEBBING
MCM# 3510715
× 100 FT

MODULARIZED EQUIPMENT STOWAGE ASSEMBLY (MESA)

THE MODULARIZED EQUIPMENT STOWAGE ASSEMBLY (MESA) PALLET IS LOCATED IN QUAD 4 OF THE DESCENT STAGE. THE PALLET IS DEPLOYED BY THE EXTRAVEHICULAR ASTRONAUT WHEN THE LM IS ON THE LUNAR SURFACE. THE PALLET CONTAINS FRESH LITHIUM BATTERIES FOR THE PORTABLE LIFE SUPPORT SYSTEMS (PLSS), TV CAMERA, TRIPOD, CABLES, TOOLS FOR OBTAINING LUNAR GEOLOGICAL SAMPLES, CONTAINERS IN WHICH TO STORE THE SAMPLES, CHART RECORDER, AND OTHER SCIENTIFIC DEVICES. IT ALSO CONTAINS A FOLDING WORK TABLE THAT SERVES AS A BRACKET ON WHICH THE LUNAR SAMPLE CONTAINER, WHICH CONVEYS THE MOON-ROCKS TO THE CABIN, RESTS.

* DRAWING DOES NOT ILLUSTRATE BLOCKERS, STRAPS, TURN-BUTTONS OR OTHER STOWAGE HARDWARE ELEMENTS, AND IS A HYBRID OF PRESENT AND FUTURE EQUIPMENT ASSEMBLIES. Tom Sachs NYC, MARCH 13, 2008

MAIN GALLERY
1,902 sq. ft.

Entrance to building

28 ft. 5 in.

Wall height: 13 ft. 9 in.

8" diameter DEPTH

133.5"

230

OVERALL LENGTH 57'-6"

46'-0"

WALL HEIGHT 18'-0"

WALL HEIGHT 17'-11"

29'-6"

WALL HEIGHT 18'-0" TO LIGHT TRACK + 10'-0" TO CEILING

26'-11"

Overhang: 8 ft. 6 in. high

DOOR

The excavation is currently imperceptible but can be plotted at 133.5 inches due north and 230 due east from gallery wall.

0 5 10 feet

N

Fig-1 Sample location for TS Space Program landing site

ACP 245 Centre St. New York City NY 10013

246

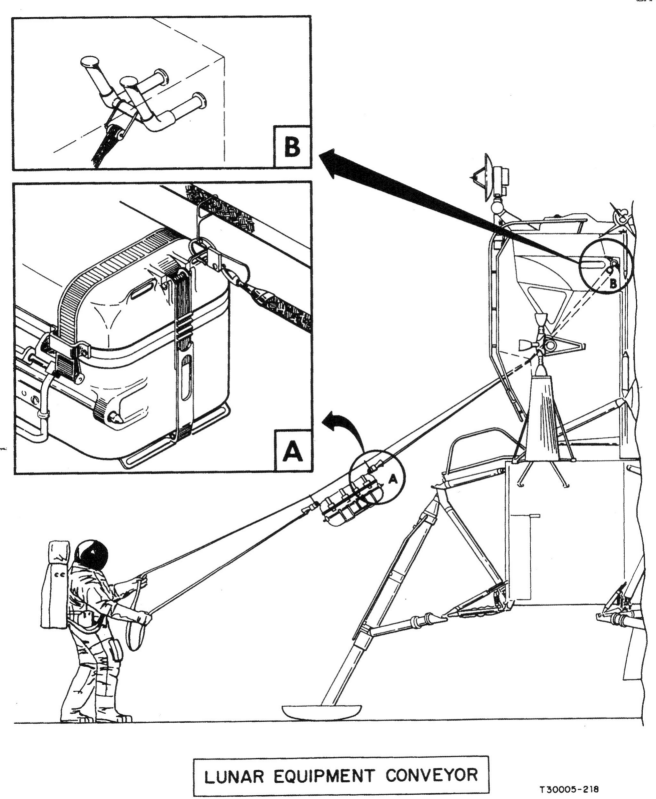

LUNAR EQUIPMENT CONVEYOR

T30005-218

FOR TRAINING PURPOSES ONLY

247

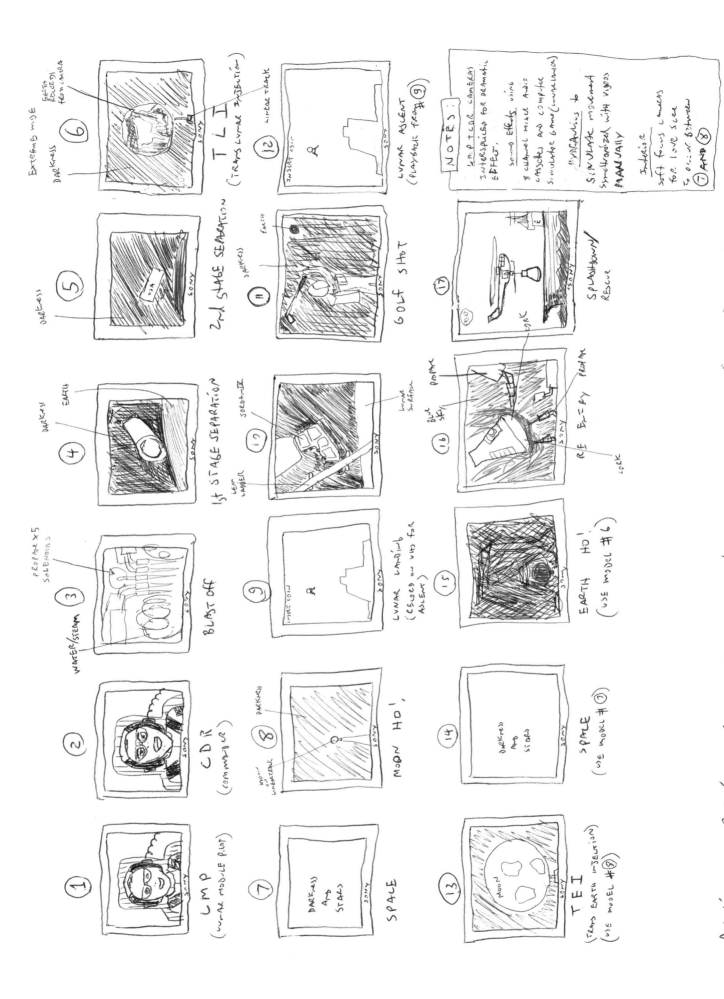

ANIMATRONIC AND LIVE ACTION CAMERAS (FIXED) 8/1/06

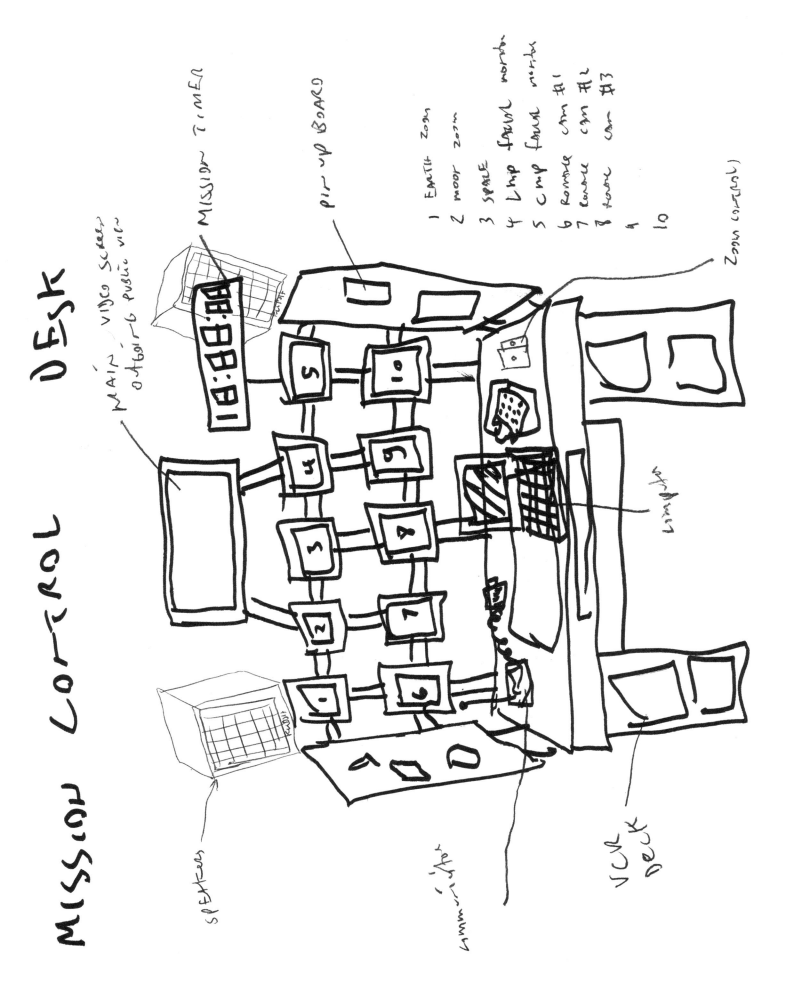

MISSION CONTROL DESK

MAIN VIDEO SCREEN
outgoing public vic

MISSION TIMER

PIN UP BOARD

1 EARTH zoom
2 MOON zoom
3 SPACE
4 LMP front monitor
5 CMP front monitor
6 Remote cam #1
7 remote cam #2
8 home cam #3
9
10

Zoom control

communicator

SPEAKERS

skylight

VCR DECK

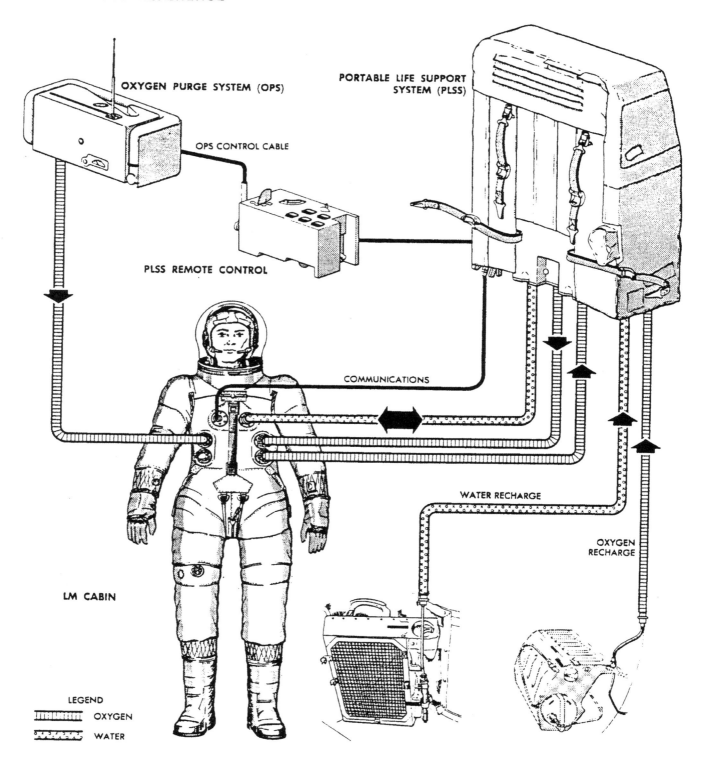

OXYGEN PURGE SYSTEM (OPS)

OPS CONTROL CABLE

PORTABLE LIFE SUPPORT
SYSTEM (PLSS)

PLSS REMOTE CONTROL

COMMUNICATIONS

WATER RECHARGE

OXYGEN
RECHARGE

LM CABIN

LEGEND

OXYGEN

WATER

R-24

Diagram of the Portable Life Support System

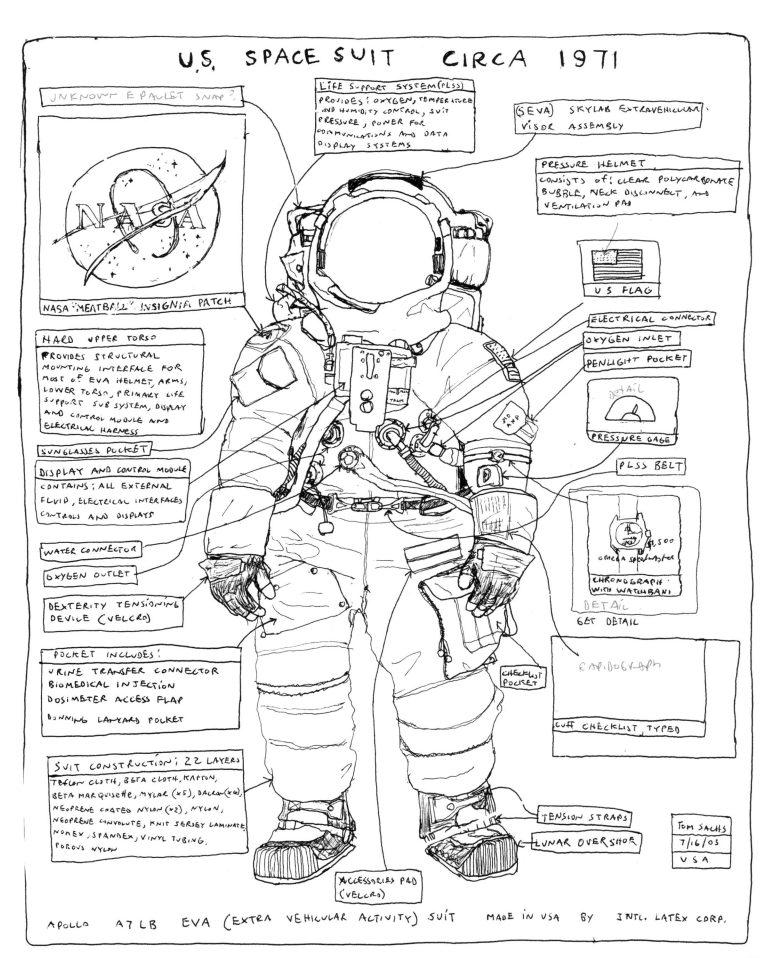

U.S. SPACE SUIT CIRCA 1971

UNKNOWN EPAULET SNAP?

NASA "MEATBALL" INSIGNIA PATCH

LIFE SUPPORT SYSTEM (PLSS)
PROVIDES: OXYGEN, TEMPERATURE AND HUMIDITY CONTROL, SUIT PRESSURE, POWER FOR COMMUNICATIONS AND DATA DISPLAY SYSTEMS

(SEVA) SKYLAB EXTRAVEHICULAR VISOR ASSEMBLY

PRESSURE HELMET
CONSISTS OF: CLEAR POLYCARBONATE BUBBLE, NECK DISCONNECT, AND VENTILATION PAD

U.S. FLAG

ELECTRICAL CONNECTOR
OXYGEN INLET
PENLIGHT POCKET

DETAIL
PRESSURE GAGE

HARD UPPER TORSO
PROVIDES STRUCTURAL MOUNTING INTERFACE FOR MOST OF EVA HELMET, ARMS, LOWER TORSO, PRIMARY LIFE SUPPORT SUB SYSTEM, DISPLAY AND CONTROL MODULE AND ELECTRICAL HARNESS

PLSS BELT

SUNGLASSES POCKET

DISPLAY AND CONTROL MODULE
CONTAINS: ALL EXTERNAL FLUID, ELECTRICAL INTERFACES CONTROLS AND DISPLAYS

OMEGA SPEEDMASTER $1,500
CHRONOGRAPH WITH WATCHBAND

DETAIL
GET DETAIL

WATER CONNECTOR

OXYGEN OUTLET

DEXTERITY TENSIONING DEVICE (VELCRO)

CHECKLIST POCKET

RAPIDOGRAPH

CUFF CHECKLIST, TYPED

POCKET INCLUDES:
URINE TRANSFER CONNECTOR
BIOMEDICAL INJECTION
DOSIMETER ACCESS FLAP
DONNING LANYARD POCKET

SUIT CONSTRUCTION: 22 LAYERS
TEFLON CLOTH, BETA CLOTH, KAPTON, BETA MARQUISETTE, MYLAR (×5), DACRON (×4), NEOPRENE COATED NYLON (×2), NYLON, NEOPRENE CONVOLUTE, KNIT JERSEY LAMINATE, NOMEX, SPANDEX, VINYL TUBING, POROUS NYLON

TENSION STRAPS

LUNAR OVERSHOE

TOM SACHS
7/16/05
USA

ACCESSORIES PAD (VELCRO)

APOLLO A7LB EVA (EXTRA VEHICULAR ACTIVITY) SUIT MADE IN USA BY INTL. LATEX CORP.

MOON MISSION

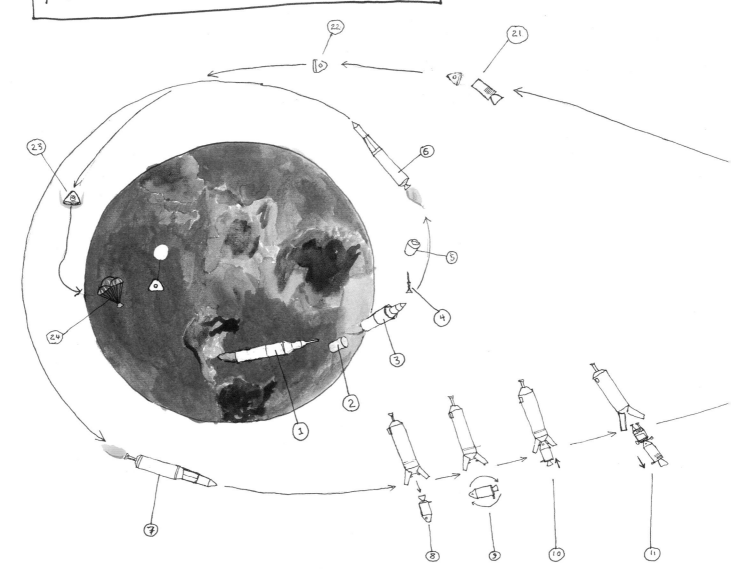

SEQUENCE OF EVENTS

1. LIFTOFF (FIRST STAGE)
2. FIRST STAGE SEPARATION
3. SECOND STAGE IGNITION
4. LAUNCH ESCAPE TOWER JETTISON
5. SECOND STAGE SEPARATION AND JETTISON
6. THIRD STAGE IGNITION
7. TRANSLUNAR INJECTION "GO" DECISION
8. CSM SEPARATION FROM LM ADAPTER
9. CSM 180° TURNAROUND
10. CSM DOCKING WITH LM/S-IVB
11. CSM/LM SEPARATION FROM S-IVB, S-IVB JETTISON

12. CSM/LM ENGINE IGNITION
13. LUNAR ORBIT INSERTION AND CREW TRANSFER (CDR+LMP)
14. CSM/LM SEPARATION, CM CONTINUES IN LUNAR ORBIT, LM DESCENT
15. TOUCHDOWN
16. LM (ASCENT STAGE) LIFTOFF
17. RENDEZVOUS AND DOCKING
18. TRANSFER CREW, EQUIPMENT AND LUNAR SAMPLES FROM LM TO CSM
19. CSM/LM SEPARATION AND JETTISON
20. TRANSEARTH INJECTION

21. CM/SM SEPARATION AND JETTISON
22. ORIENT CM FOR RE-ENTRY
23. 400,000 FT ALTITUDE PENETRATION ? COMMUNICATION BLACKOUT PERIOD
24. DEPLOY MAIN CHUTE AT 10,000 FT
25. SPLASHDOWN

- NOT TO SCALE -

ASCENT
&
RENDEZVOUS

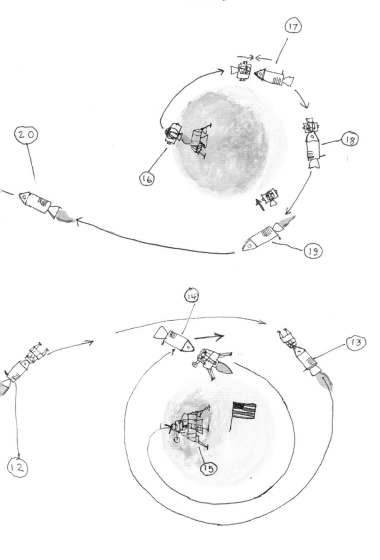

DESCENT

(LANDING)

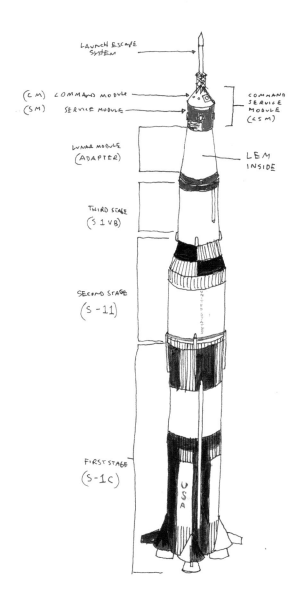

LAUNCH ESCAPE SYSTEM

(CM) COMMAND MODULE

(SM) SERVICE MODULE

COMMAND SERVICE MODULE (CSM)

LUNAR MODULE (ADAPTER)

LEM INSIDE

THIRD STAGE (S 1VB)

SECOND STAGE (S-11)

FIRST STAGE (S-1C)

USA

SATURN Ⅴ
MOON ROCKET

— NOT TO SCALE —

TOM SACHS 2008 MADE IN USA
SOURCE: THE INTERNATIONAL ENCYCLOPEDIA OF AVIATION
CROWN PUBLISHERS NEW YORK 1977

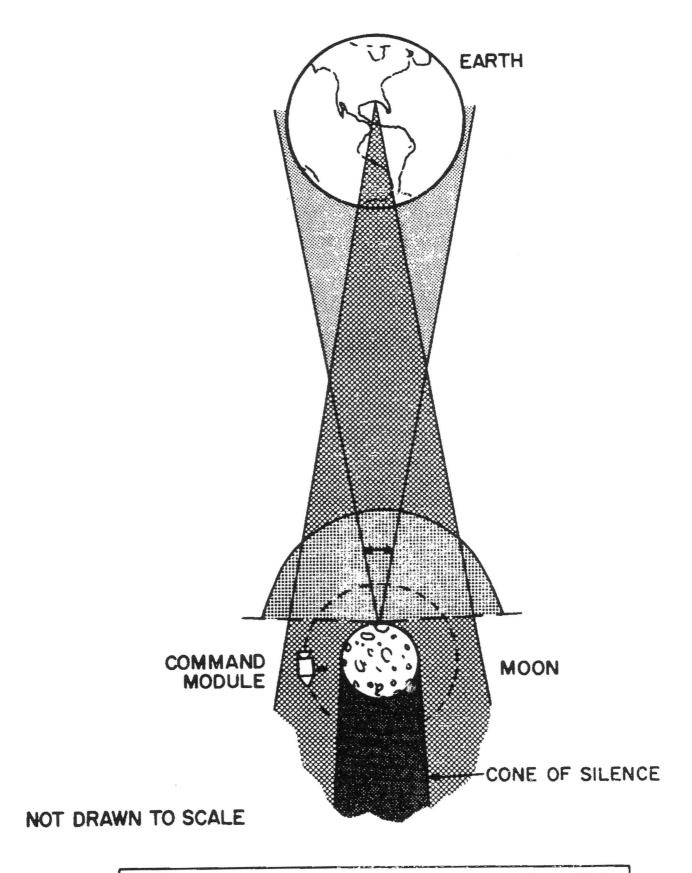

EARTH

COMMAND
MODULE

MOON

CONE OF SILENCE

NOT DRAWN TO SCALE

COMMUNICATIONS DURING LUNAR STAY

T30005-101
MAR 66

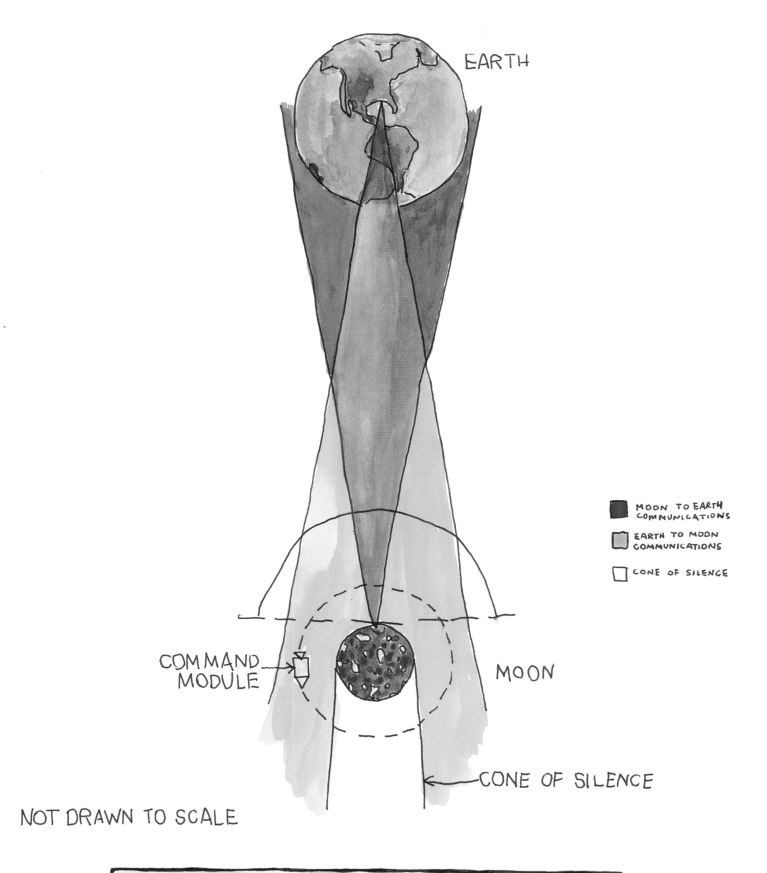

EARTH

MOON TO EARTH
COMMUNICATIONS

EARTH TO MOON
COMMUNICATIONS

CONE OF SILENCE

COMMAND
MODULE

MOON

CONE OF SILENCE

NOT DRAWN TO SCALE

COMMUNICATIONS DURING LUNAR STAY

S/N 2007.014.0002

S/N 2007.014.0003

S/N 2007.014.0004

S/N 2007.014.0005

S/N 2007.014.0007

S/N 2007.014.0008

S/N 2007.014.0009

S/N 2007.014.0010

S/N 2007.014.0012

S/N 2007.014.0013

S/N 2007.014.0014

S/N 2007.014.0015

S/N 2007.014.0016

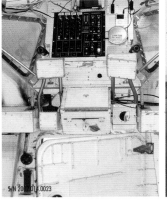

S/N 2007.014.0016 (DETAIL)

RENDEZVOUS RADAR

S/N 2007.014.0017

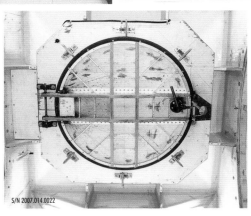

S/N 2007.014.0018-0021

S/N 2007.014.0022

S/N 2007.014.0023

S/N 2007.014.0025

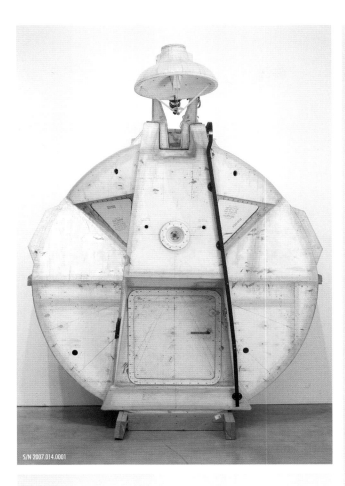

S/N 2007.014.0001

S/N 2007.014.0024

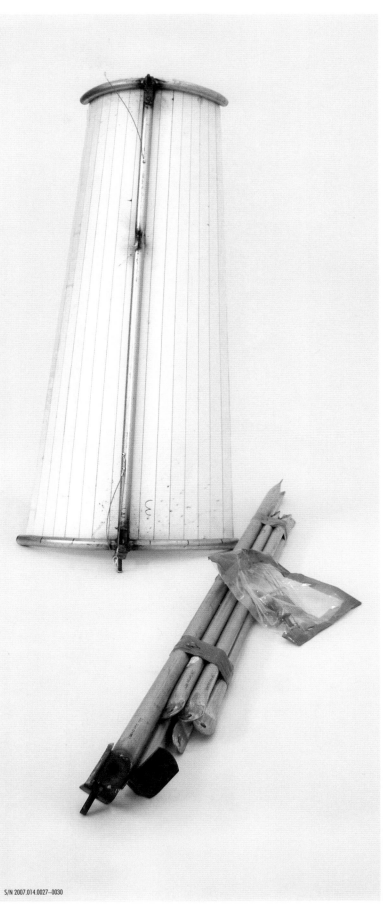

S/N 2007.014.0027—0030

S/N 2007.014.0032

S/N 2007.014.0033

S/N 2007.014.0034

S/N 2007.014.0035

S/N 2007.014.0038

S/N 2007.014.0031

S/N 2007.014.0036

S/N 2007.014.0037

S/N 2007.014.0039

S/N 2007.014.0040

S/N 2007.014.0041—0043

S/N 2007.014.0048—0050

S/N 2007.014.0051

S/N 2007.014.0052

S/N 2007.014.0053

S/N 2007.014.0054

S/N 2007.014.0055

S/N 2007.014.0056-0057

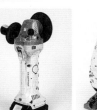

S/N 2007.014.0058

S/N 2007.014.0059—0060

S/N 2007.014.0062, 0068

S/N 2007.014.0064

S/N 2007.014.0066

S/N 2007.014.0069

S/N 2007.014.0061

S/N 2007.014.0063

S/N 2007.014.0065, 0067

S/N 2007.014.0070—0073

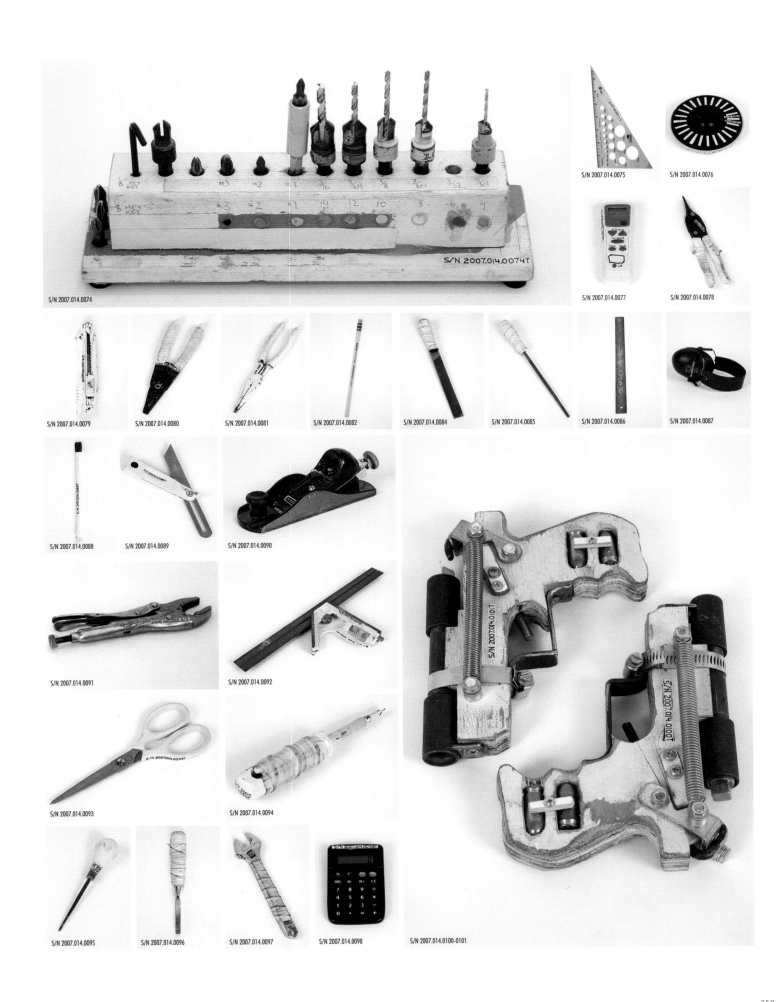

S/N 2007.014.0074

S/N 2007.014.0075

S/N 2007.014.0076

S/N 2007.014.0077

S/N 2007.014.0078

S/N 2007.014.0079

S/N 2007.014.0080

S/N 2007.014.0081

S/N 2007.014.0082

S/N 2007.014.0084

S/N 2007.014.0085

S/N 2007.014.0086

S/N 2007.014.0087

S/N 2007.014.0088

S/N 2007.014.0089

S/N 2007.014.0090

S/N 2007.014.0091

S/N 2007.014.0092

S/N 2007.014.0093

S/N 2007.014.0094

S/N 2007.014.0095

S/N 2007.014.0096

S/N 2007.014.0097

S/N 2007.014.0098

S/N 2007.014.0100-0101

S/N 2007.014.0102–0103

S/N 2007.014.0104–0118

S/N 2007.014.0119, 2007.138.0001

S/N 2007.014.0121–0128

S/N 2007.014.0129–0134, 0197

S/N 2007.014.0135–0140

S/N 2007.014.0141

S/N 2007.014.0142

S/N 2007.014.0143

S/N 2007.014.0144

S/N 2007.014.0145

S/N 2007.014.0146

S/N 2007.014.0147–0150

S/N 2007.014.0151–0152

S/N 2007.014.0153–0171

S/N 2007.014.0172

S/N 2007.014.0173

S/N 2007.014.0174

S/N 2007.014.0175

S/N 2007.014.0176

S/N 2007.014.0177

S/N 2007.014.0178

S/N 2007.014.0179

S/N 2007.014.0180

S/N 2007.014.0181

S/N 2007.014.0182

S/N 2007.014.0183

S/N 2007.014.0184

S/N 2007.014.0185

S/N 2007.014.0186

S/N 2007.014.0187

S/N 2007.014.0188

S/N 2007.014.0189

S/N 2007.014.0190

S/N 2007.014.0191

S/N 2007.014.0192–0193

S/N 2007.014.0194

S/N 2007.014.0195

S/N 2007.014.0196

S/N 2007.014.0198–0208

S/N 2007.014.0209–0212

S/N 2007.014.0214

S/N 2007.014.0215

S/N 2007.014.0213

S/N 2007.014.0216

S/N 2007.014.0217

S/N 2007.014.0218

S/N 2007.014.0219

S/N 2007.014.0220

S/N 2007.014.0221

S/N 2007.014.0222

S/N 2007.014.0223

S/N 2007.014.0224

S/N 2007.014.0225

S/N 2007.014.0226

S/N 2007.014.0227

S/N 2007.014.0262
S/N 2007.014.0263
S/N 2007.014.0264
S/N 2007.014.0265
S/N 2007.014.0268
S/N 2007.014.0269
S/N 2007.014.0270
S/N 2007.014.0271
S/N 2007.014.0272
S/N 2007.014.0273
S/N 2007.014.0274
S/N 2007.014.0276
S/N 2007.014.0277
S/N 2007.014.0278
S/N 2007.014.0279
S/N 2007.014.0280
S/N 2007.014.0281
S/N 2007.014.0282
S/N 2007.014.0284
S/N 2007.014.0285
S/N 2007.014.0286-0287
S/N 2007.014.0289-0295
S/N 2007.014.0296
S/N 2007.014.0297-0312
S/N 2007.014.0313
S/N 2007.014.0314
S/N 2007.014.0315-0318
S/N 2007.014.0315-0318 (DETAIL)
S/N 2007.014.0321
S/N 2007.014.0322

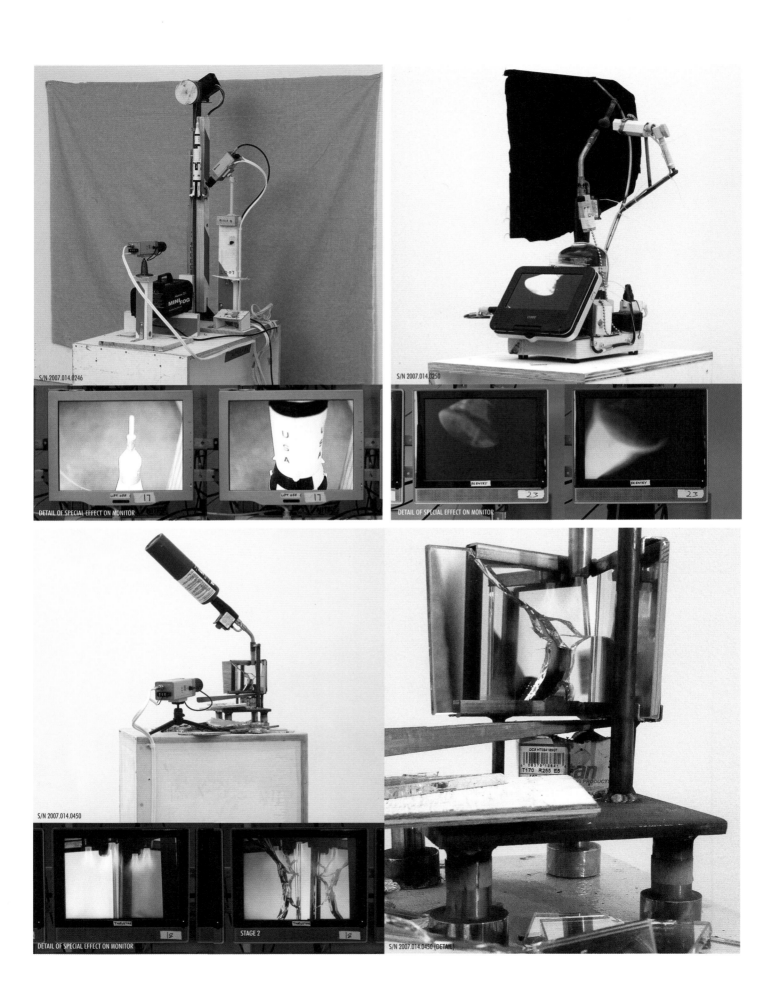

S/N 2007.014.0246

DETAIL OF SPECIAL EFFECT ON MONITOR

LIFT OFF 17

LIFT OFF 17

S/N 2007.014.0250

DETAIL OF SPECIAL EFFECT ON MONITOR

RE ENTRY 23

RE ENTRY 23

S/N 2007.014.0450

DETAIL OF SPECIAL EFFECT ON MONITOR

THRUSTING 8

STAGE 2 THRUSTING 8

S/N 2007.014.0450 (DETAIL)

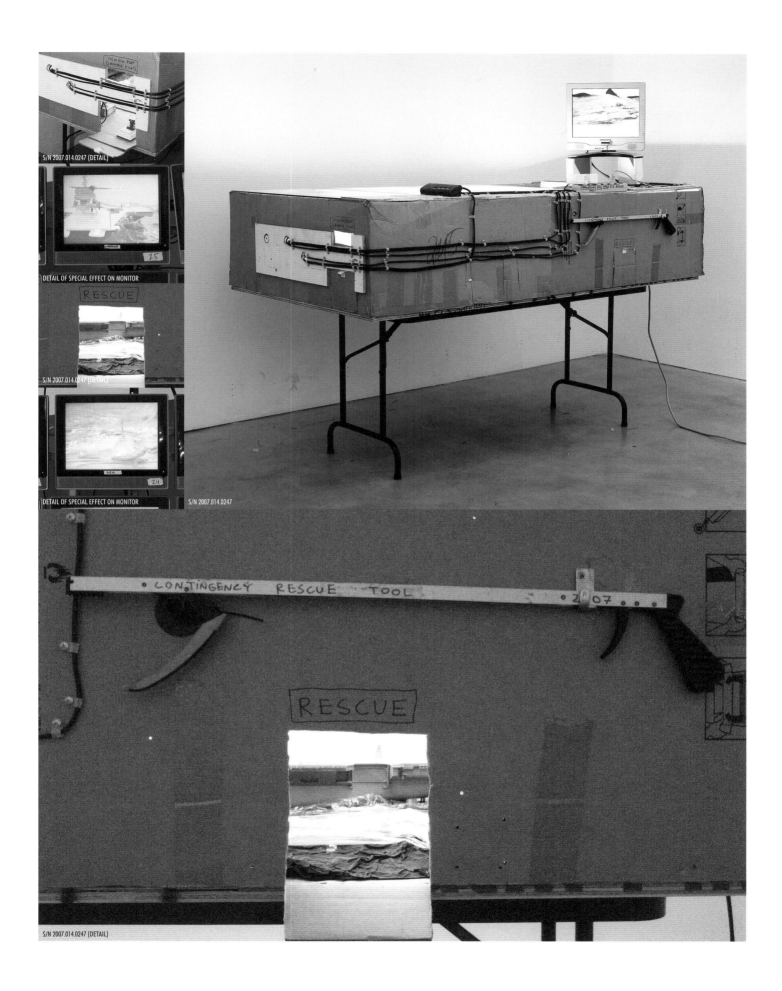

S/N 2007.014.0247 (DETAIL)

DETAIL OF SPECIAL EFFECT ON MONITOR

RESCUE

S/N 2007.014.0247 (DETAIL)

DETAIL OF SPECIAL EFFECT ON MONITOR S/N 2007.014.0247

CONTINGENCY RESCUE TOOL 2 07

RESCUE

S/N 2007.014.0247 (DETAIL)

S/N 2007.014.0323

S/N 2007.014.0327-0328

S/N 2007.014.0334

S/N 2007.014.0335—0337

S/N 2007.014.0338

S/N 2007.014.0339-0340

S/N 2007.014.0341

S/N 2007.014.0342

S/N 2007.014.0343

S/N 2007.014.0344

S/N 2007.014.0345

S/N 2007.014.0346

S/N 2007.014.0347

S/N 2007.014.0348

S/N 2007.014.0349

S/N 2007.014.0350

S/N 2007.014.0351

S/N 2007.014.0352

S/N 2007.014.0353

S/N 2007.014.0354

S/N 2007.014.0355

S/N 2007.014.0370

S/N 2007.014.0371

S/N 2007.014.0373

S/N 2007.014.0375

S/N 2007.014.0376

S/N 2007.014.0382

S/N 2007.014.0383-0384

S/N 2007.014.0374

S/N 2007.014.0385

S/N 2007.014.0386

S/N 2007.014.0387

S/N 2007.014.0388–0389

S/N 2007.014.0390

S/N 2007.014.0391

S/N 2007.014.0406

S/N 2007.014.0407

S/N 2007.014.0408–0418

S/N 2007.014.0421

S/N 2007.014.0422

S/N 2007.014.0423

S/N 2007.014.0424

S/N 2007.014.0425

S/N 2007.014.0426

S/N 2007.014.0427

S/N 2007.014.0428

S/N 2007.014.0429

S/N 2007.014.0430

S/N 2007.014.0431

S/N 2007.014.0432

S/N 2007.014.0433

S/N 2007.014.0434

S/N 2007.014.0435

S/N 2007.014.0436

S/N 2007.014.0440

S/N 2007.014.0441

S/N 2007.014.0442

S/N 2007.014.0443

S/N 2007.014.0444

S/N 2007.014.0446

S/N 2007.014.0454

S/N 2007.014.0445

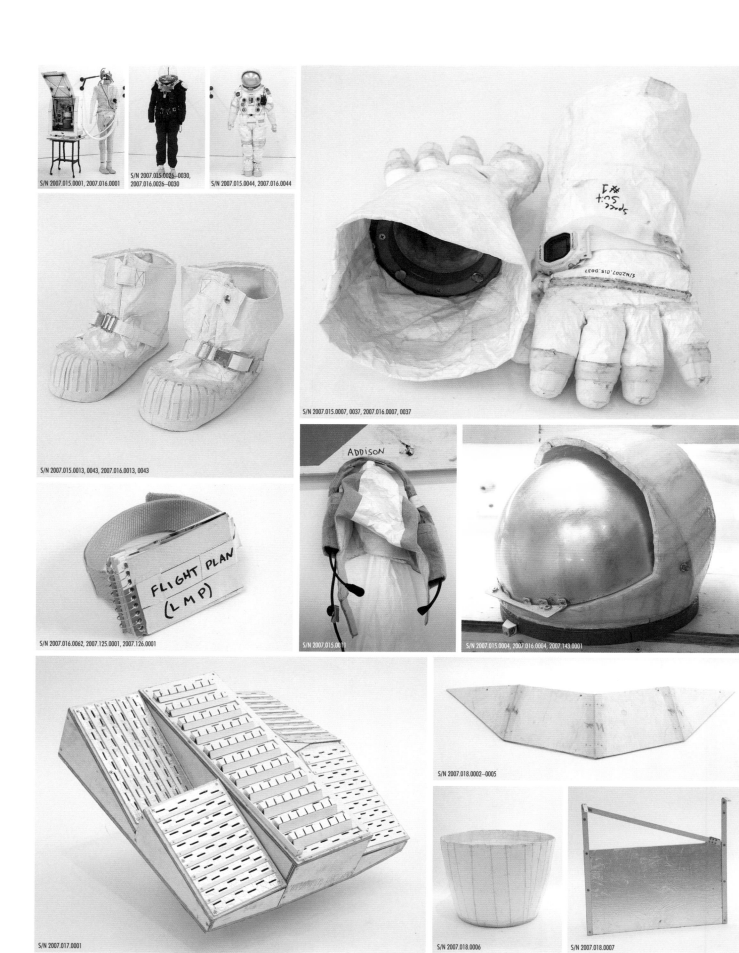

S/N 2007.015.0001, 2007.016.0001

S/N 2007.015.0026–0030,
2007.016.0026–0030

S/N 2007.015.0044, 2007.016.0044

S/N 2007.015.0007, 0037, 2007.016.0007, 0037

S/N 2007.015.0013, 0043, 2007.016.0013, 0043

S/N 2007.016.0062, 2007.125.0001, 2007.126.0001

S/N 2007.015.0011

S/N 2007.015.0004, 2007.016.0004, 2007.143.0001

S/N 2007.017.0001

S/N 2007.018.0002–0005

S/N 2007.018.0006

S/N 2007.018.0007

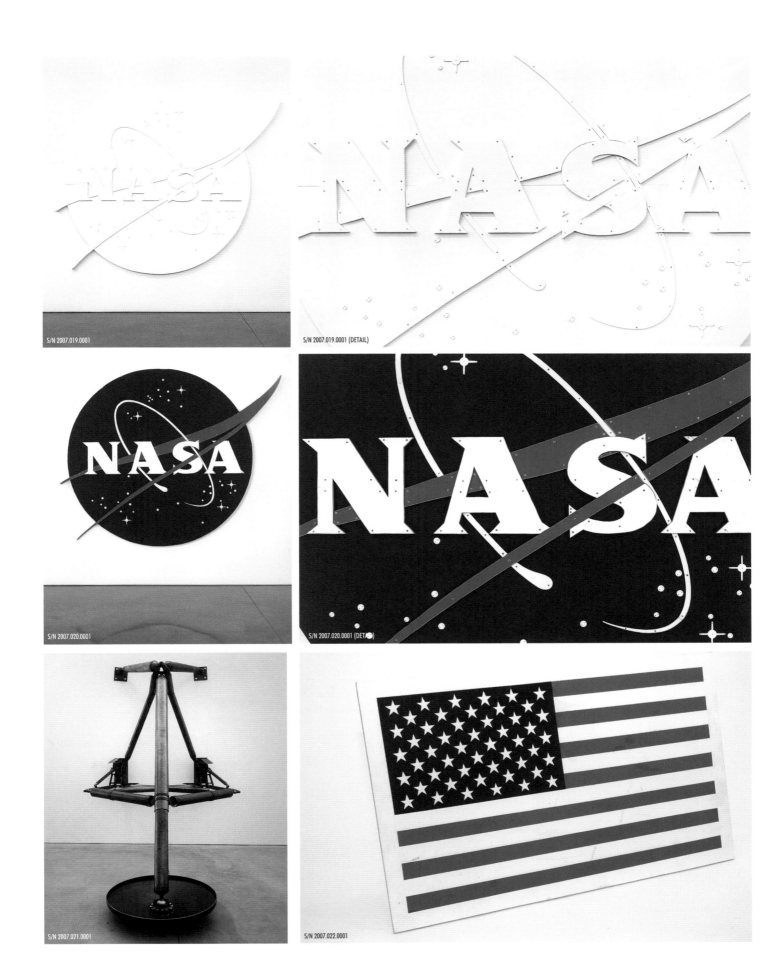

S/N 2007.019.0001

S/N 2007.019.0001 (DETAIL)

S/N 2007.020.0001

S/N 2007.020.0001 (DETAIL)

S/N 2007.021.0001

S/N 2007.022.0001

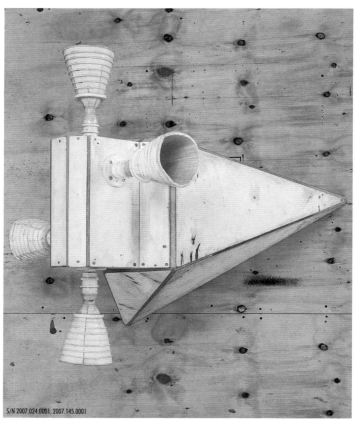

S/N 2007.024.0001, 2007.145.0001

S/N 2007.024.0002–0005

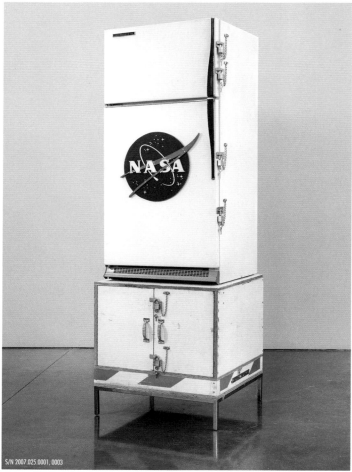

S/N 2007.025.0001, 0003

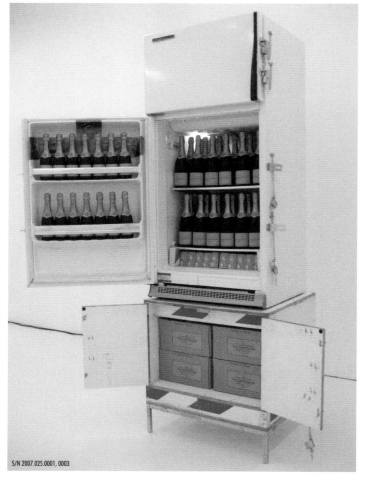

S/N 2007.025.0001, 0003

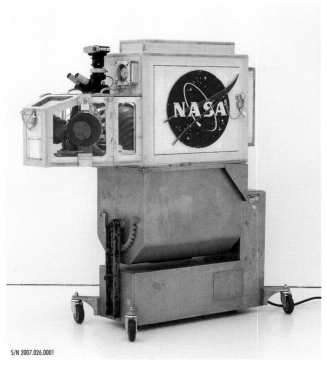

S/N 2007.026.0001

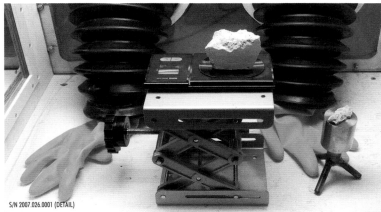

S/N 2007.026.0001 (DETAIL)

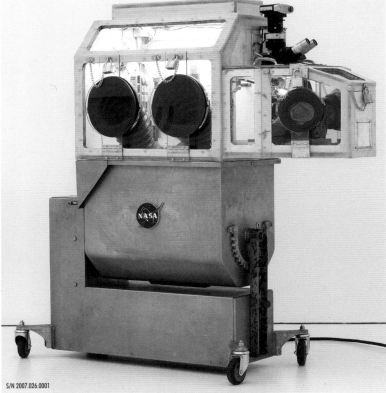

S/N 2007.026.0001

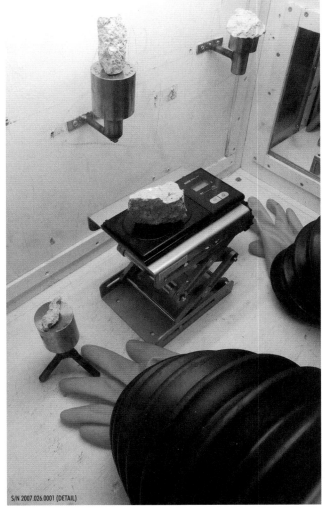

S/N 2007.026.0001 (DETAIL)

S/N 2007.026.0001 (DETAIL)

S/N 2007.026.0001 (DETAIL), 2007.086.001

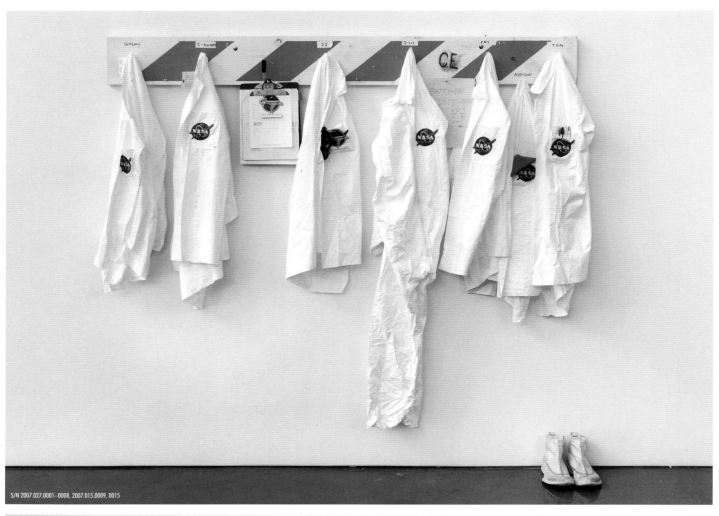

S/N 2007.027.0001–0008, 2007.015.0009, 0015

S/N 2007.028.0001, 2007.139.0001, 2007.140.0001, 2007.141.0001

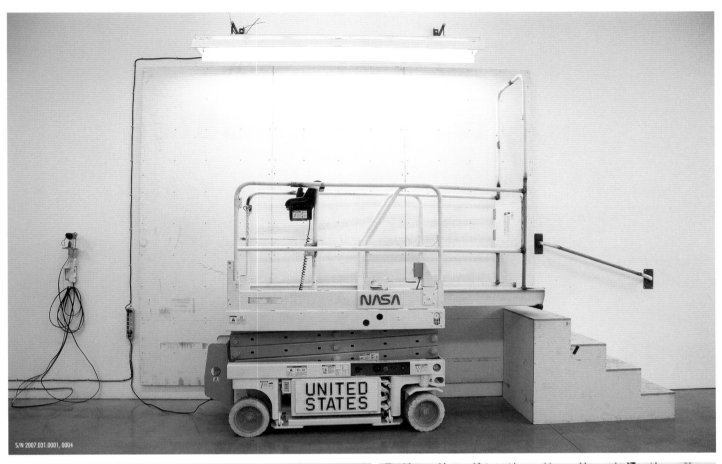

S/N 2007.031.0001, 0004

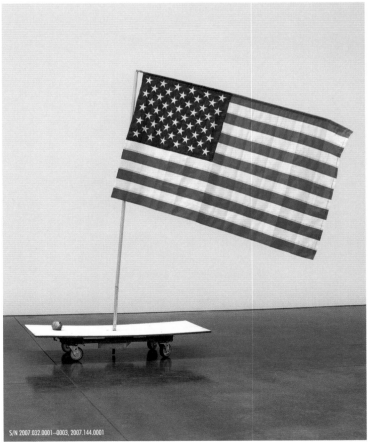

S/N 2007.032.0001–0003, 2007.144.0001

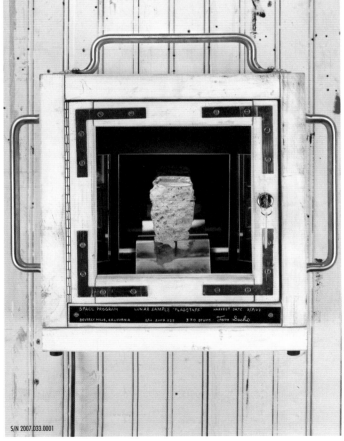

S/N 2007.033.0001

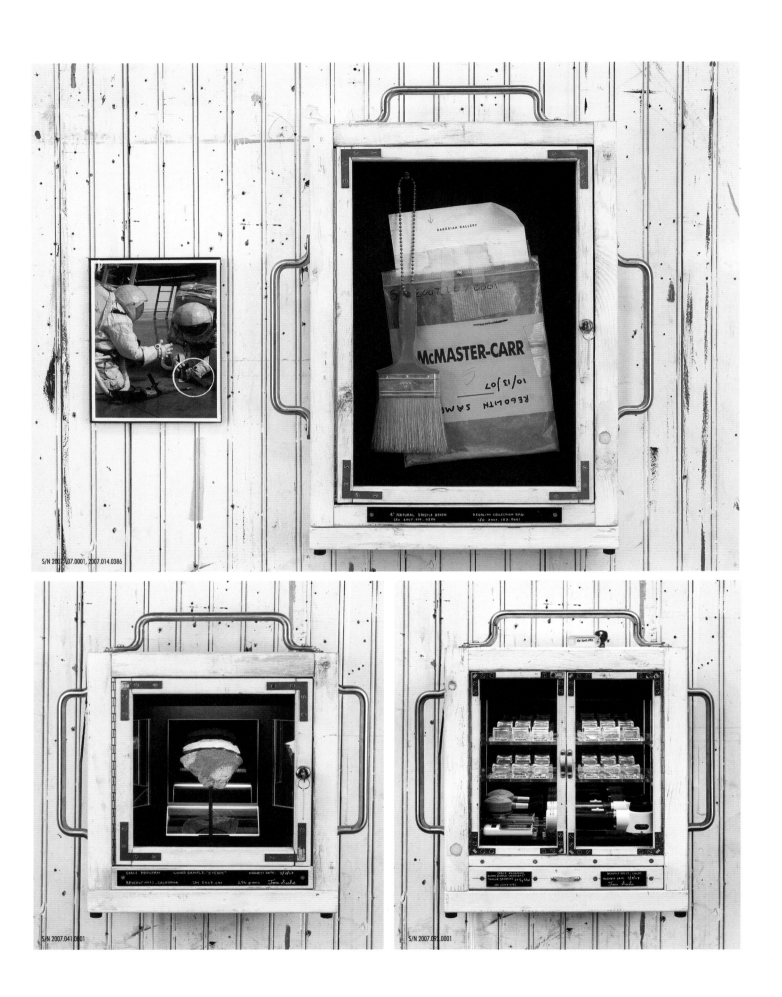

S/N 2007.107.0001, 2007.014.0386

S/N 2007.041.0001

S/N 2007.091.0001

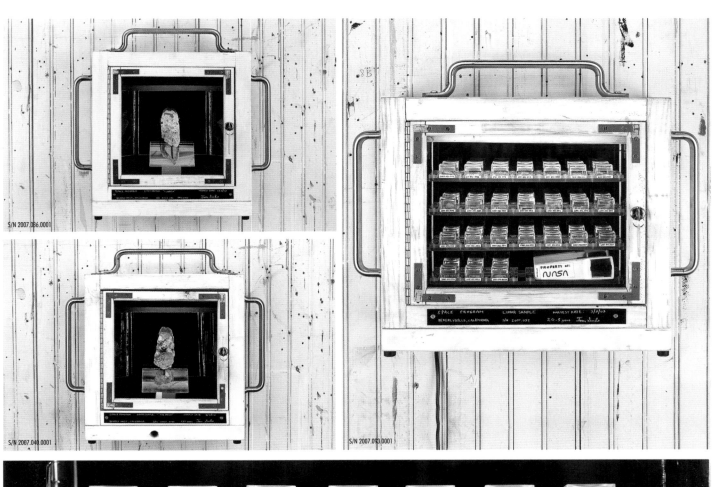

S/N 2007.086.0001

S/N 2007.040.0001

S/N 2007.093.0001

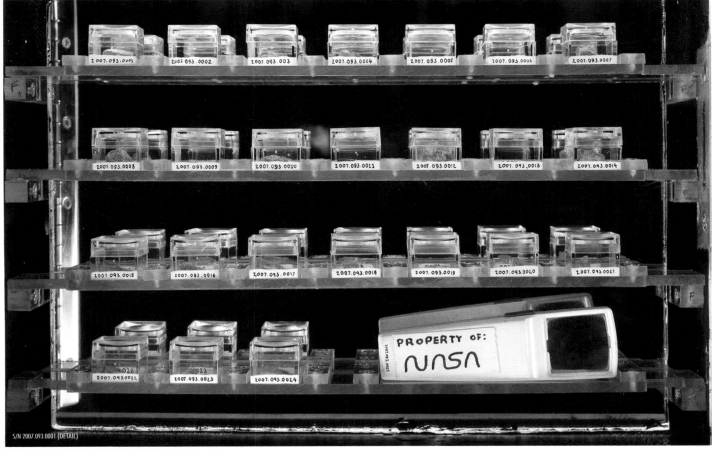

S/N 2007.093.0001 (DETAIL)

アール ジーエスノズル

S/N 2007.119.0001

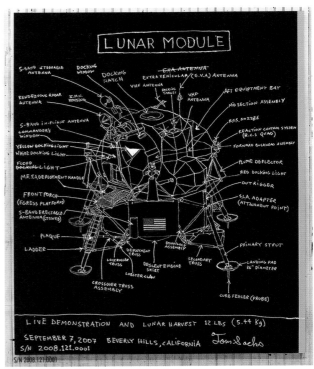

LUNAR MODULE

LIVE DEMONSTRATION AND LUNAR HARVEST 12 LBS (5.44 Kg)
SEPTEMBER 7, 2007 BEVERLY HILLS, CALIFORNIA Tom Sachs
S/N 2008.121.0001

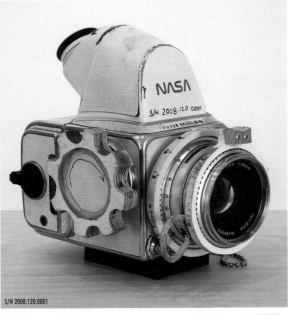

S/N 2008.120.0001

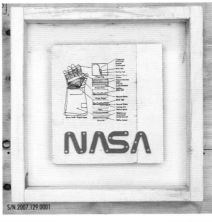

NASA

S/N 2007.129.0001

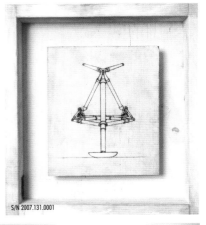

S/N 2007.131.0001

UNITED STATES

S/N 2007.023.0001

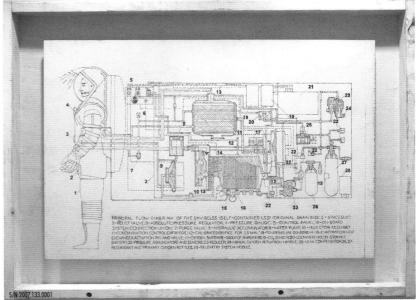

S/N 2007.133.0001

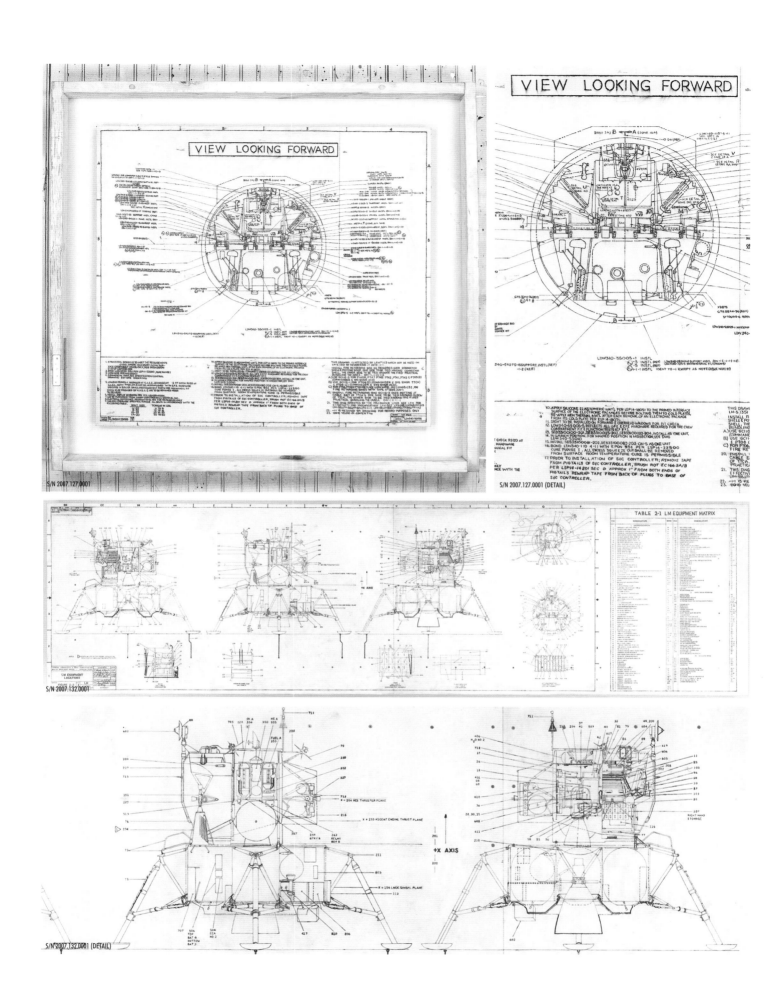

VIEW LOOKING FORWARD

VIEW LOOKING FORWARD

TABLE 2-1 LM EQUIPMENT MATRIX

S/N 2007.127.0001

S/N 2007.127.0001 (DETAIL)

S/N 2007.132.0001

S/N 2007.132.0001 (DETAIL)

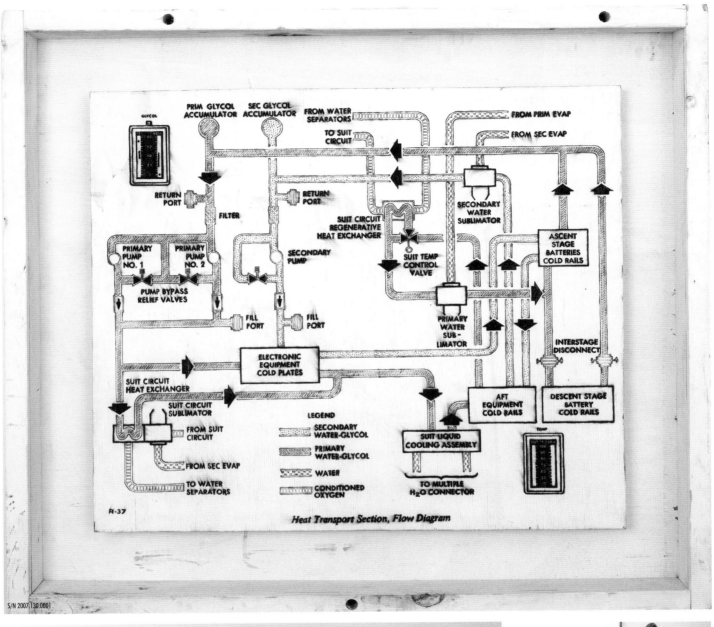

Heat Transport Section, Flow Diagram

R-37

SPACE PROGRAM

SEPTEMBER 8 – OCTOBER 13, 2007

Tom Sachs

Complete and up to date lists of the acronyms, S/N reference numbers, and Moon rock reports are posted on
www.tomsachs.org along with the current status of the Space Program, the archives and all future landing sites.

THANK YOU

Flight Director: Tom Sachs

Astronauts:
Liz Ensz
Farrah Karapetian
Allyson Spellacy
Addison Walz

Mission Control:
Jeremy Shockley
Jeremy Smith
Joshua White

Grumman Team Leader:
JJ Peet

Grumman Team:
Zak Cook
Jonathan deLima
Nick Doyle
Johannes Gardener "J Gard"
Gustavo Godoy**
Mike Koch
Pat McCarthy
John Neiggeman
Rich Sandomeno

Congressional Funding:
Larry Gagosian
Melissa Lazarov
Sam Orlofsky
Sarah Watson

Ground Support Beverly Hills, Spellacy Facility:
Eric Bonwitt
Candy Coleman
Shayna Gaffen
Jesse Green
William Hathaway
Graham Judson
Christoph Kasperkovitz
Steve Kayo
Lincoln Madley
Lauren McCaffrey
Deborah McLeod
Mark Rossi
Sharon Ryan
David Sigmund
Hanako Williams

Ground Support New York, Chinatown Facility:
Sivan Amar
Sarah "Birdhands" Bednarek
Michelle Butterfield
John Furgason
Genevieve Hanson
Emily Henretta
George Hogan
Joe Johnson
Leonard Kenyon
Eva Lewitt
Monkey
Mott
Brent "Hayseed" Owens

Caroline Potter
Brieana Ruais
Jesse Sachs
Ruby Sky Styler
Oksana Todorova
Kai Williams

Ground Support New York, McDonald Facility:
Jessica Arisohn
Emily Florido
Darlina Goldak
Garrick Gott
Nicole Heck
Kimberly Higby
Alison McDonald
Domenica Stagno

Ground Support New York, Smith Facility:
Adam Cohen
Grayson Cox
Brooke Daniels
Dietl International
Paul Duncan
Tom Duncan
Sarah Hoover
Brad Kaye
Jose Krapp
Matthew Marvel
More Specialized
Ryszarda Murphy
Louise Neri

David Pappaceno
Mark Parrish
Melissa Passman
Adam Payne
Rich Rivera
Kate Rosco
Nolan Simon
Allison Smith
Mark Taylor
Carlos Vela
Kate Wendell
Clay Woodruff

Landing Gear and Sanity:
Chris Bundy

Propaganda:
Brett Jutkiewicz
Daniel Karp
The Neistat Brothers
Red Bucket Films
Lever Ruhkin

Knives:
Spyderco

Lab coats:
Miuccia Prada

Neckties, Shirts, Trousers and Tie Clips:
Mordechai Rubenstein
Matt Singer
Andy Spade

Nike Team Regolith:
Tiffany Beers
Sandy Bodecker
Georgio Di Mitri
Mark Parker
Mark Smith

Thanks:
Phil and Shelley Aarons
Buzz and Lois Aldrin
Bihm
Steven Brower
Elena Bortolotti
Lisa Cannon
Mickey Cartin
Aimee Cavenecia
Concrete Coring Company
Susanna Dadd
Arthur C. Danto
Richard Edwards
Eric Jones
Marcus Kormann
David Leiber
Pat and Deb Manoccia

Tony Manzella
Charles Meiers
Paul and Lily Merage
Hector Murillo
Ned and Ellen Olivier
Anthony Petrillose
Christina Rasch
R. E. McCoy Company
Thaddaeus Ropac
Rusty Sena
Shapco Printing
Gian Enzo Sperone
Michael Stout
Beth Stromborg
Lisa Szymanski
John Thomas
Tony Servera Concrete Co.
Melissa Unger
Mark Van de Walle
Vertibird
Virtual LEM
Tyler Vlahovic
David Weeks
Barbara Westman
Amanda Young

**played with cleats

GAGOSIAN GALLERY

456 NORTH CAMDEN DRIVE BEVERLY HILLS CA 90210

T. 310.271.9400 F. 310.271.9420

INFO@GAGOSIAN.COM WWW.GAGOSIAN.COM